MARSDEN HARTLEY'S MAINE

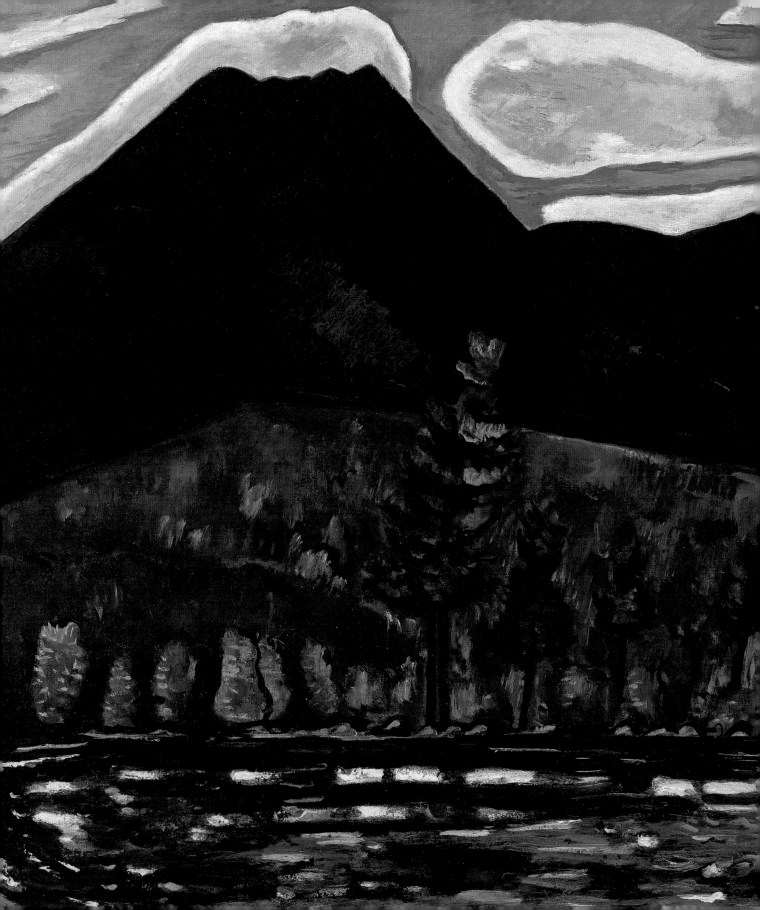

MARSDEN HARTLEY'S MAINE

Donna M. Cassidy • Elizabeth Finch • Randall R. Griffey

WITH CONTRIBUTIONS BY

Richard Deming • Isabelle Duvernois • Andrew Gelfand • Rachel Mustalish

THE MET The Metropolitan Museum of Art, New York

DISTRIBUTED BY YALE UNIVERSITY PRESS, NEW HAVEN AND LONDON

This catalogue is published in conjunction with "Marsden Hartley's Maine," on view at The Metropolitan Museum of Art, New York, from March 15 through June 18, 2017, and at the Colby College Museum of Art, Waterville, Maine, from July 8 through November 12, 2017.

At The Met, the exhibition is made possible by the Barrie A. and Deedee Wigmore Foundation, the Henry Luce Foundation, the William Randolph Hearst Foundation, and the Jane and Robert Carroll Fund.

At the Colby College Museum of Art, the exhibition is made possible by the Henry Luce Foundation, Bank of America, Betsy Cohen and Edward Cohen/Aretê Foundation, the National Endowment for the Arts, and the Everett P. and Florence H. Turner Exhibition Fund.

The exhibition is organized by The Metropolitan Museum of Art and the Colby College Museum of Art.

This publication is made possible by The Andrew W. Mellon Foundation.

Published by The Metropolitan Museum of Art, New York
Mark Polizzotti, Publisher and Editor in Chief
Gwen Roginsky, Associate Publisher and General Manager of Publications
Peter Antony, Chief Production Manager
Michael Sittenfeld, Senior Managing Editor

Edited by Emily Radin Walter
Designed by Christopher Kuntze
Production by Paul Booth
Bibliography edited by Jean Wagner
Image acquisitions and permissions by Elizabeth De Mase

Photographs of works in The Metropolitan Museum of Art's collection are by the Imaging Department, The Metropolitan Museum of Art, unless otherwise noted.

Additional photography credits appear on page 184.

Typeset in Whitman and Neutraface
Printed on 150 gsm Condat Matt Perigord
Separations by Professional Graphics, Inc., Rockford, Illinois
Printed by Brizzolis, Madrid, Spain
Bound by Ramos, Madrid, Spain
Printing and binding coordinated by Ediciones El Viso, S.A., Madrid, Spain

Jacket illustrations: front, *Knotting Rope*, 1939–40 (detail of fig. 124); back, *The Dark Mountain*, 1909 (detail of fig. 13)

Page 2: *Mount Katahdin, Autumn No. 1*, 1939–40 (detail of fig. 131); page 6: *Hall of the Mountain King*, ca. 1908–9 (detail of fig. 32); page 13: *Maine Woods*, 1908 (detail of fig. 40)

The Metropolitan Museum of Art
1000 Fifth Avenue
New York, New York 10028
metmuseum.org

Distributed by
Yale University Press, New Haven and London
yalebooks.com/art
yalebooks.co.uk

Library of Congress Cataloging-in-Publication Data

Names: Cassidy, Donna, author. | Finch, Elizabeth (Elizabeth J.), 1967- author. | Griffey, Randall R., author. | Deming, Richard, 1970- writer of added text. | Duvernois, Isabelle, writer of added text. | Gelfand, Andrew P., writer of added text. | Mustalish, Rachel, writer of added text. Hartley, Marsden, 1877-1943. Paintings. Selections. | Metropolitan Museum of Art (New York, N.Y.), host institution, issuing body. | Colby College. Museum of Art, host institution.
Title: Marsden Hartley's Maine / Donna M. Cassidy, Elizabeth Finch, Randall R. Griffey ; with contributions by Richard Deming, Isabelle Duvernois, Andrew Gelfand, Rachel Mustalish.
Description: New York : The Metropolitan Museum of Art, [2017] | "This catalogue is published in conjunction with 'Marsden Hartley's Maine,' on view at The Metropolitan Museum of Art, New York, from March 15 through June 18, 2017, and at Colby College Museum of Art, Waterville, Maine, from July 8 through November 12, 2017." | Includes bibliographical references and index.
Identifiers: LCCN 2016048625 | ISBN 9781588396136 (hardcover)
Subjects: LCSH: Hartley, Marsden, 1877-1943—Themes, motives—Exhibitions. | Maine—In art—Exhibitions.
Classification: LCC ND237.H3435 A4 2017 | DDC 759.13—dc23
LC record available at https://lccn.loc.gov/2016048625

ISBN 978-1-58839-613-6

CONTENTS

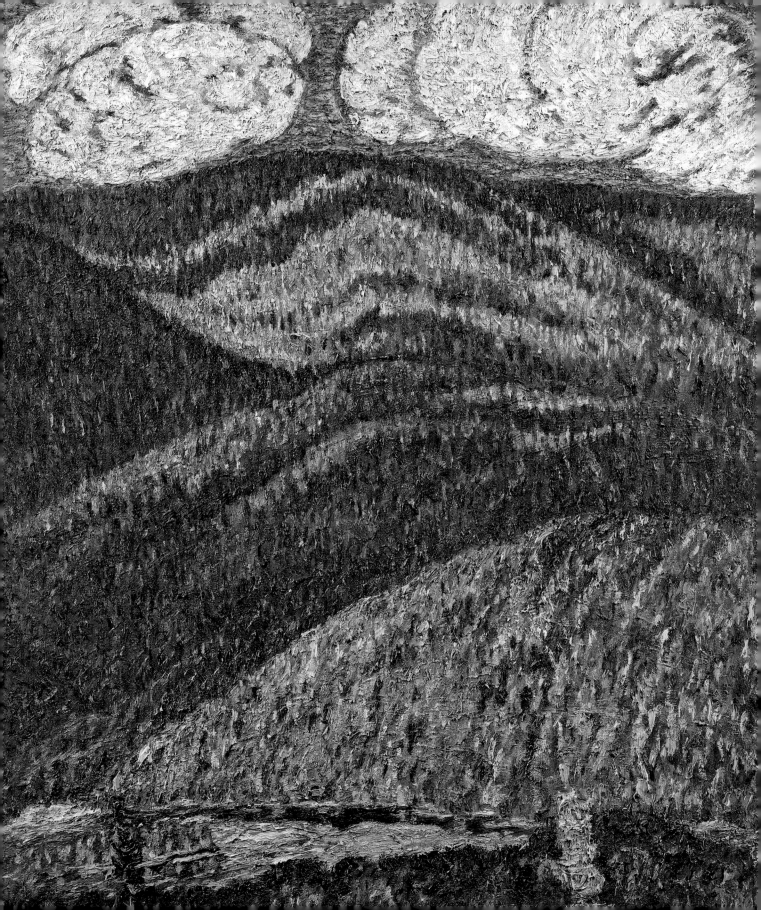

DIRECTORS' FOREWORD

This collaboration between The Metropolitan Museum of Art and the Colby College Museum of Art marks a homecoming of sorts. "Marsden Hartley's Maine" is the first large monographic Marsden Hartley exhibition to appear in a New York museum since 1980, when the Whitney Museum of American Art mounted its seminal retrospective. Owing to The Met's eight-year lease of the Whitney's former home on Madison Avenue, now The Met Breuer, our exhibition quite remarkably appears in the same building that presented that earlier, groundbreaking show. Another homecoming will occur when the exhibition opens later in Maine, an occasion that will bring some of Hartley's most extraordinary works back to the place that inspired them.

Both The Met and the Colby Museum have in their collections significant holdings of Hartley's paintings and works on paper, a fortuitous connection that formed a starting place for this productive partnership. The Met first acquired work by Hartley in 1942, when it purchased *Lobster Fishermen* from the wartime exhibition "Artists For Victory." At the time of that acquisition, only a year before the artist's death, Hartley was enjoying a late-career wave of critical acclaim and hard-earned recognition from museums, galleries, and private collectors. The other Hartley works in The Met's collection were acquired after the painter's death, the majority arriving in 1949 as part of the great Alfred Stieglitz Collection, which Georgia O'Keeffe administered and distributed across six institutions, three of which — The Met, the Philadelphia Museum of Art, and the Art Institute of Chicago — have contributed works from their respective Stieglitz Collections to this exhibition. The Met's trove from this remarkable gift includes Hartley's iconic *Portrait of a German Officer*, painted in 1914, a work that does not figure in the present Maine-centric exhibition. Two additional works now in The Met's collection that are included, *Mount Katahdin, Autumn, No. 2* and *Albert Pinkham Ryder*, came in 1991 as part of the bequest of Edith Abrahamson Lowenthal, a fine collection of American modernism. In light of numerous gifts critical to "Marsden Hartley's Maine," the exhibition offers an opportunity to celebrate the generosity of our supporters over many years.

Collecting and presenting works by Hartley since the early 1960s, soon after its founding in 1959, the Colby Museum has recently benefited from the donations of eleven works by Hartley from the Maine- and New York–based artist Alex Katz and his foundation. A selection of these gifts, including the early works *Maine Landscape* and *Desertion*, and the late seascape *City Point, Vinalhaven*, painted soon after the artist's return to Maine in 1937, have greatly enriched this exhibition, as has *Church at Head Tide, Maine*, another late painting, which came to the museum through the bequest of Maine collector Adelaide Moise.

We commend the exhibition's curators— Randall R. Griffey of the Metropolitan, Donna M. Cassidy of the University of Southern Maine, and Elizabeth Finch of the Colby College Museum of Art—for assembling this beautiful and revelatory selection of works in a spirit of true collaboration. In consultation with Met curatorial colleagues

Sylvia Yount, Lawrence A. Fleischman Curator in Charge, The American Wing; Nadine Orenstein, Drue Heinz Curator in Charge, Department of Drawings and Prints; and John Carpenter, Mary Griggs Burke Curator of Japanese Art, Department of Asian Art, Randy Griffey selected additional works from the Museum's collection by Hartley's key artistic touchstones—among them, Paul Cézanne, Winslow Homer, and Albert Pinkham Ryder—for the presentation at The Met Breuer.

Our museums owe a tremendous debt to the lenders to the exhibition and especially to those, such as the Frederick R. Weisman Art Museum at the University of Minnesota, Minneapolis, and the Bates College Museum of Art, who generously accommodated loan requests for several works. Other institutions, including the Carnegie Museum of Art, the Phillips Collection, the Wadsworth Atheneum Museum of Art, and the Museum of Fine Arts, Boston, have agreed to temporarily part with paintings that represent cornerstones of their modern collections. Similarly, several private collectors have demonstrated their support by lending their treasures to share with our audiences.

We thank the many generous donors who have made this project possible, with a special nod to the Henry Luce Foundation for its overarching support of the show both in New York and Maine.

At The Met, the exhibition also benefited from the important support of the Barrie A. and Deedee Wigmore Foundation, the William Randolph Hearst Foundation, and the Jane and Robert Carroll Fund. Major support for the Maine presentation has also been provided by Bank of America, Betsy Cohen and Edward Cohen/Aretê Foundation, the National Endowment for the Arts, and the Everett P. and Florence H. Turner Exhibition Fund. The publication is made possible by The Andrew W. Mellon Foundation, Charles Butt, and Laura and Robert W. Stone.

In the history of American modernism, Marsden Hartley stands apart for the clarity, force, and distinctiveness of his artistic vision. Like other artists of his generation, he associated places with nationally relevant themes. But Hartley expressed the yearning for home and belonging from the unique perspective of his humble beginnings and with unparalleled poignancy and perseverance. Maine was, as this exhibition and catalogue demonstrate, his essential and most enduring subject.

Thomas P. Campbell
DIRECTOR AND CEO
THE METROPOLITAN MUSEUM OF ART

Sharon Corwin
CAROLYN MUZZY DIRECTOR AND CHIEF CURATOR
COLBY COLLEGE MUSEUM OF ART

ACKNOWLEDGMENTS

This co-organized exhibition began as a lively three-way conversation about the role of memory in the art of the great American modernist Marsden Hartley. The topic of memory, we found, led inexorably to Hartley's place of origin and revealed the principal themes and subjects that defined his career. Throughout this journey of discovery we have been grateful for the extraordinary support of the directors who recognized the significance of this project and have been its devoted advocates: Thomas P. Campbell, Director and Chief Executive Officer, The Metropolitan Museum of Art, and Sharon Corwin, Carolyn Muzzy Director and Chief Curator, Colby College Museum of Art. We also extend heartfelt thanks to our many generous lenders, both private and institutional, without whom this exhibition would not be possible. A complete list of the lenders to the exhibition is provided on page 12.

We are indebted to the dedicated staff at our respective institutions for their many essential contributions that ensured the success of this project. At The Met, Sheena Wagstaff, Leonard A. Lauder Chairman of the Department of Modern and Contemporary Art, was instrumental in bringing the exhibition to fruition at The Met Breuer, as was Pari Stave, senior administrator for the department. Appreciation is also extended to Quincy Houghton, associate director for exhibitions, who followed Jennifer Russell in that capacity; Linda Sylling, former manager for special exhibitions and gallery installations; Martha Deese, senior administrator for exhibitions and international affairs; Aileen Chuk, chief registrar; and Mary Allen, associate registrar. Katy Uravitch, exhibition project manager at The Met Breuer, coordinated the scheduling and logistics. We extend our gratitude to Cynthia Iavarone, collections manager, and to art technicians Tony Askin, Jeff Elliott, Sandie Peters, and Brooks Shaver. Thanks go also to Jason Herrick, senior philanthropy officer; Elizabeth Burke, deputy chief development officer for foundation giving; Evie Chabot, development officer for government and foundation giving; Sarah Higby, former deputy chief development officer for corporate programs; and Jessica Sewell, development officer for corporate programs.

For the catalogue of the exhibition we thank Mark Polizzotti, publisher and editor in chief, and Michael Sittenfeld, senior managing editor. Elizabeth De Mase was responsible for the acquisition of all the images in the book, and Paul Booth for the high quality of the reproductions. We are grateful as well to other members of the Editorial and Publications Department who were indispensable to the completion of this book: Gwen Roginsky, Peter Antony, Anne Rebecca Blood, and Briana Parker. The volume's elegant design is the work of Christopher Kuntze. Jean Wagner edited the notes and references with careful attention to detail. Emily Walter's thoughtful and discerning editing of the catalogue manuscript warrants special recognition.

Dan Kershaw, exhibition design manager, developed the show's elegant installation plan for The Met Breuer, to which Chris Noey, general manager of media production and online features, and Paul Caro contributed, while Anna

Rieger, senior graphic designer, crafted its striking graphic identity. Conservators Isabelle Duvernois, Rachel Mustalish, and Cynthia Moyer ensured that the Metropolitan's works in the exhibition were in top condition for display. Valued partners in the American Wing, particularly Sylvia Yount, Lawrence A. Fleischman Curator in Charge, and Elizabeth Mankin Kornhauser, Alice Pratt Brown Curator of American Paintings and Sculpture, have been steadfast champions of the project. Curatorial colleagues Nadine Orenstein, Drue Heinz Curator in Charge, Department of Drawings and Prints; John Carpenter, Mary Griggs Burke Curator of Japanese Art, Department of Asian Art; and Jeff L. Rosenheim, Curator in Charge, Department of Photographs, are due many thanks. Early in the exhibition's development, collections management associates Devon Zimmerman and Catherine Burns provided key administrative support, duties assumed with expertise by research associate Michele Wijegoonaratna. Karen Williams, assistant museum librarian in the Thomas J. Watson Library, conducted critical research. Patryk Tomaszewski volunteered his time to contribute substantively to exhibition texts.

Hartley paintings given to the Colby Museum by Alex Katz and his foundation were the genesis of this project in Maine. Early in his tenure as Colby College's twentieth president, David A. Greene embraced a collaborative venture with The Met with characteristic enthusiasm. His commitment has been shared by the Colby College Museum of Art's Board of Governors, led by board chair Karen Linde Packman and vice-chair Hilary Barnes Hoopes. Among the museum's staff, Patricia King, associate director; Lauren Lessing, Mirken Director of Academic and Public Programs; Diana Tuite, Katz Curator; Justin McCann, Lunder Curator for Whistler Studies; Anna Fan, assistant for special projects; and Karen Wickman, executive assistant, offered invaluable guidance at every stage of the project.

The design of the Maine presentation of this project benefited from the expert eye of Greg Williams, director of museum operations. Lorraine DeLaney, registrar for exhibitions and loans, oversaw the transport of artworks with admirable care and alacrity. Stew Henderson, senior preparator, deftly served as the exhibition's lead installer. Paige Doore, registrar for collections, made key contributions to the registration and installation team. Margaret Aiken, Linde Family Foundation Coordinator of School and Teacher Programs, and Shalini Le Gall, curator of academic programs, envisioned the project's educational and programmatic offerings working in collaboration with the community-based initiatives of Miriam Valle-Mancilla, assistant for access and outreach; Jordia Benjamin, Mirken Coordinator of Academic and Public Programs; and Francisca Moraga López, Mirken Family Post-baccalaureate Fellow in Museum Studies. Colby interns Leah Bilodeau, Margaret Robe, Francesca Soriano, Neil Sefah, and Briana Williams brought an inspiring spirit of discovery to exhibition-related assignments. In the Colby College office of grants and sponsored programs, William Layton, director, and Seven Grenier, associate director, led advancement initiatives for the Maine presentation in collaboration with Liz Herring Menard, director of museum development. Gerry Boyle, assistant director of communications, and Milton Guillen, photography and video journalist, documented the various places Hartley lived and worked in Maine, while their colleague Kate Carlisle, director of communications, expertly stewarded Maine-based publicity efforts. From its constellation of professional associations, the museum enlisted the expert help of paintings conservator Nina Roth-Wells and the graphic designer Amanda Hughen, who was responsible for the Maine venue's exhibition graphics; Dakota DeVos did essential exhibition research at the Hartley Papers at Yale; and John Farmer provided early editorial guidance.

The study of Hartley's art continues to benefit from the groundbreaking scholarship of Elizabeth McCausland and the subsequent contributions of Barbara Haskell, Gail Levin, Gail Scott, and Jonathan Weinberg. As this project developed, the dialogue it engendered expanded to include new contributors to a growing field. We are especially grateful for the insights of poet Richard Deming, a senior lecturer at Yale University, who considers Hartley's Maine writings and poems in his essay for this catalogue. Met conservators Isabelle Duvernois and Rachel Mustalish were the dream duo we enlisted to write a chapter on Hartley's materials and techniques. Andrew Gelfand, Colby Museum's Anne Lunder Leland Curatorial Fellow, deserves our thanks for the refreshingly original chronology that appears here, as well as for the innumerable research queries he handled with aplomb.

Collective knowledge of Hartley would be far poorer without the sustaining resources of the Smithsonian's Archives of American Art and the Beinecke Rare Book & Manuscript Library at Yale University. The treasures to be found in Maine's archives, historical societies, and libraries have been invaluable to this exhibition's place-specific focus. We are especially thankful for the research assistance of Danielle Fortin and Rick Speer at the Lewiston Public Library, and for the historical expertise of Cathy Stone at the Lovell Historical Society and independent scholar Dan Barker, both of whom also shared their collections of historical photographs. Anne Chamberland, Acadian archives specialist, Acadian Archives, University of Maine at Fort Kent, similarly provided key research support.

In 2014 the Portland Museum of Art hosted a gathering for scholars, offering a unique opportunity for the curatorial team to engage in an in-depth consideration of the exhibition's subject with some of the state's curators and art historians, including Libby Bischof, Ron Crusan, Jessica May, Karen Sherry, Gail Scott, Tanya Sheehan, and Justin Wolff. Bill Low, curator of the Bates College Museum of Art, one of the lenders to the exhibition, deserves special acknowledgment for granting ready access to the Marsden Hartley Memorial Collection and Archives. We also extend hearty collective thanks to Phil Alexandre, Deborah Evans, Robin Jaffee Frank, Maria Friedrich, Tracy Gill, Julie Graham, Erica E. Hirshler, Chris Huntington, Charles Ipcar, Simeon Lagodich, Stephen May, Charlotte McGill, Erin Monroe, Johanna Moore, Stephen Petegorsky, and Arlene Palmer Schwind.

Last but not least, we acknowledge the contemporary artists we encountered during the course of this project who helped us to see Hartley in new ways as we considered the painter from Maine who remains vibrantly present in minds and hearts. These artists, along with the many colleagues mentioned above, joined in an expanded conversation that helped us understand Hartley's origins and his relation to place.

Donna M. Cassidy
UNIVERSITY OF SOUTHERN MAINE

Elizabeth Finch
COLBY COLLEGE MUSEUM OF ART

Randall R. Griffey
THE METROPOLITAN MUSEUM OF ART

LENDERS TO THE EXHIBITION

Addison Gallery of American Art, Phillips
Academy, Andover, Massachusetts

Alexandre Gallery, New York

Allen Memorial Art Museum, Oberlin College,
Ohio

The Art Institute of Chicago

AXA Equitable Life Insurance Company, New York

Baltimore Museum of Art

Bates College Museum of Art, Lewiston, Maine

Brooklyn Museum

The Butler Institute of American Art, Youngstown,
Ohio

Carnegie Museum of Art, Pittsburgh, Pennsylvania

Colby College Museum of Art, Waterville, Maine

Crystal Bridges Museum of American Art,
Bentonville, Arkansas

Currier Museum of Art, Manchester, New
Hampshire

Curtis Galleries, Minneapolis, Minnesota

Detroit Institute of Arts

Farnsworth Art Museum, Rockland, Maine

Fogg Museum, Harvard Art Museums, Cambridge,
Massachusetts

Frederick R. Weisman Art Museum at the
University of Minnesota, Minneapolis

Grey Art Gallery, New York

Hirshhorn Museum and Sculpture Garden,
Smithsonian Institution, Washington, D.C.

Francine and Roger Hurwitz

Pitt and Barbara Hyde

Karen and Kevin Kennedy

Myron Kunin Collection of American Art

Lewiston Public Library

Norma B. Marin

Michael Altman Fine Art, New York

The Metropolitan Museum of Art, New York

Museum of Fine Arts, Boston

The Museum of Modern Art, New York

National Gallery of Art, Washington, D.C.

The Nelson-Atkins Museum of Art, Kansas City,
Missouri

New Orleans Museum of Art

Ogunquit Museum of American Art

Philadelphia Museum of Art

The Phillips Collection, Washington, D.C.

Portland Art Museum

Princeton University Art Museum

Private collections

Saint Louis Art Museum

Sheldon Museum of Art, University of Nebraska,
Lincoln

Ted and Mary Jo Shen

Smith College Museum of Art, Northampton,
Massachusetts

Smithsonian American Art Museum,
Washington, D.C.

Stedelijk Museum, Amsterdam

University of Colorado Art Museum, Boulder

Wadsworth Atheneum Museum of Art, Hartford,
Connecticut

Walker Art Center, Minneapolis, Minnesota

Whitney Museum of American Art, New York

Worcester Art Museum

Maurice and Suzanne Vanderwoude

Jan T. and Marica Vilcek/The Vilcek Foundation

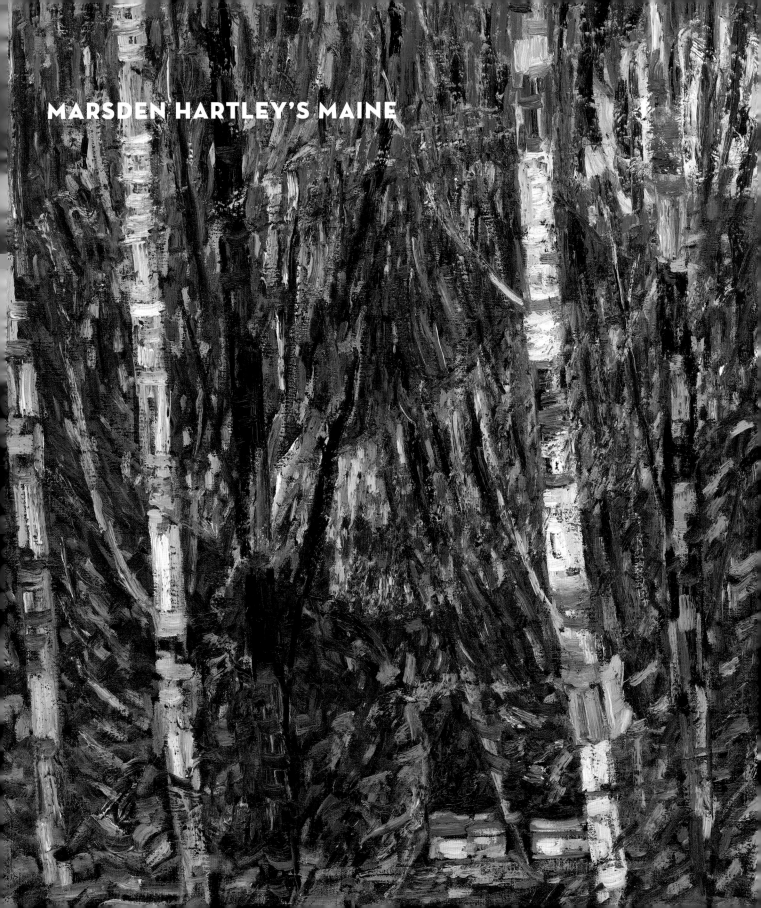

MARSDEN HARTLEY'S MAINE

CHRONOLOGY

Andrew Gelfand

This chronology focuses on Marsden Hartley's relationship to Maine as understood not only through his periods of residency in the state but through his artistic and literary work and personal associations. Together with this central narrative runs a second, contextual history. It includes key dates in the history of Maine, capturing the socioeconomic environment in which Hartley was raised and worked and demonstrating the evolution of the state that bookended his career. Also included are cultural events that occurred during Hartley's quest to be "the painter from Maine," notable dates in the careers of fellow artists working in the state, related exhibitions, and major cultural currents reflected in Hartley's work.

1877
January 4 Born in Lewiston, Maine, as Edmund Hartley to Thomas Hartley and Eliza Jane Harbury, both English immigrants. Thomas works in the city's textile mills, although he later struggles to find permanent work. The family lives in a boardinghouse at 12 Chestnut Street. Edmund is one of seven children and the only son to survive childhood, an older brother having died in 1874 and two younger brothers in infancy. As a child, he enjoys playing in Franklin Pasture and sings in the choir at Trinity Church.

1878
Hudson River School painter Frederic Edwin Church purchases a camp on Lake Millinocket, near Mount Katahdin, which he paints often until his death in 1900.

1882
The Portland Society of Art is founded as an art gallery and school on Congress Street.

The Knights of Labor arrive in Maine, attracting membership from mill workers in Lewiston and signaling the rise of the labor movement in the state.

1883
The Bangor Public Library opens.

1884
Winslow Homer moves from New York City into a former carriage house on Prouts Neck. It will serve as his home and studio until his death in 1910.

1885
March 4 Eliza Hartley dies. With Thomas unable to care for the entire household, the family separates. Edmund's youngest sisters move to Cleveland, Ohio, to live with an older sister. Edmund moves to Auburn, Maine, in the care of another, married sister.

1886
Childe Hassam works in oil and watercolor during his first extended trip to Appledore

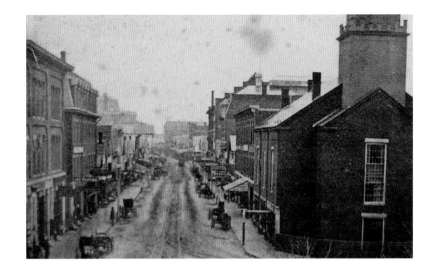

Island in the Gulf of Maine. There he associates with the artistic circle around the poet Celia Thaxter.

1888
Franklin Simmons's statue of Henry Wadsworth Longfellow is dedicated in Portland.

1889
August 20 Thomas Hartley marries his childhood friend Martha Marsden. After he travels to England with Edmund to collect her, the couple settles in Cleveland.

Portland mayor James P. Baxter opens the city's first public library. In his six years as mayor, Baxter will also develop many of the city's park spaces.

1890
March 1 Sarah Farmer, with four businessmen, opens a hotel in Eliot, Maine. Four years later the property, renamed Green Acre, becomes a religious and spiritualist summer colony.

1891
October 28 As part of the nationwide campaign to build Civil War memorials, Portland dedicates the Portland Soldiers and Sailors Monument, also known as *Our Lady of Victories*. The bronze sculpture, by Franklin Simmons, is placed on a granite base designed by the architect Richard Morris Hunt.

The Mosher Press is founded in Portland by Thomas Bird Mosher.

1892
At age fifteen, Hartley leaves school and begins work at a shoe factory in Auburn to help support his family.

March 26 Walt Whitman dies in Camden, New Jersey.

1893
Leaves Auburn to join family in Cleveland, where he works as an office assistant at a marble quarry.

The octagonal Maine State Building is erected at the World's Columbian Exposition in Chicago. Designed by architect Charles Sumner Frost, a native of Lewiston, and built entirely of granite and slate imported from Maine, the building celebrates the state's cultural resources and tourism. After the fair, it is dismantled and reassembled in Poland Spring, where

Lisbon Street, Lewiston, ca. 1890. Lewiston Public Library, Gridley Barrows Collection

The Hartley family residence at 12 Chestnut Street, Lewiston, ca. 1879. (Building demolished in 1991; photograph, late 20th century.) Lewiston Public Library, Gridley Barrows Collection

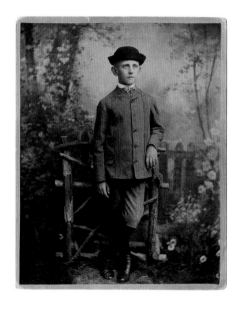

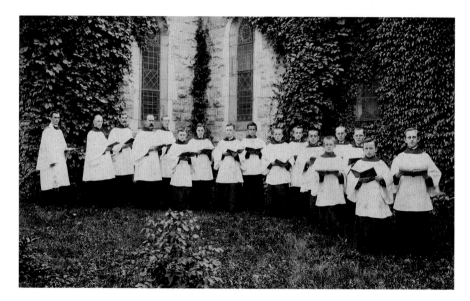

Marsden Hartley, age seven, 1884. Bates College Museum of Art, Lewiston, Marsden Hartley Memorial Collection

Choir at Trinity Church, Lewiston (Hartley at far right), 1891. Bates College Museum of Art, Lewiston, Marsden Hartley Memorial Collection

today it houses an art gallery and serves as a cultural center.

1896

Takes first art lessons with Cleveland-based landscape painter John Semon.

Sarah Orne Jewett publishes her novella *The Country of the Pointed Firs*, set in the fictional fishing village of Dunnet Landing, Maine.

Edwin Arlington Robinson publishes his first collection of poems, *The Torrent and the Night Before*. Throughout his career, Robinson will set many of his poems in the fictional Tilbury Town, modeled after his hometown of Gardiner, Maine.

Ben Brown purchases land in Lovell to create Ben Brown's Camps on Kezar Lake, one of several tourist lodges in the area.

1898

First encounters the work of New England Transcendentalist Ralph Waldo Emerson through a copy of his *Essays*, given to Hartley by Nina Waldeck, his drawing teacher at the Cleveland School of Art.

March 31 The first exhibition of The Ten, a group of American Impressionists, opens at the Durand-Ruel Gallery in New York. Its members include John Henry Twachtman, Childe Hassam, J. Alden Weir, and later, William Merritt Chase.

The first pier at Old Orchard Beach is built as a major recreational and tourist attraction.

Charles Herbert Woodbury begins teaching summer art classes in Ogunquit, offering instruction in painting and drawing from nature.

Marion Larrabee Volk and a friend purchase land in Center Lovell, Maine, later known as Hewnoaks. There, Marion and her husband, Douglas, host artists associated with the Arts and Crafts movement. Marion revives historical weaving techniques and, in collaboration with local spinners and weavers, forms the venture Sabatos Industries.

1899

Anne Walworth, a trustee at the Cleveland School of Art, presents Hartley with an annual stipend of $450 to study art in New York for five years.

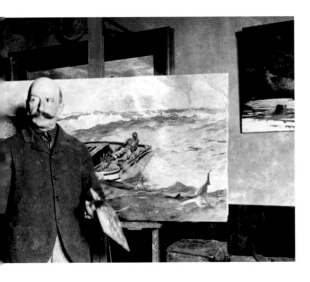

1900

Summer Following a year at William Merritt Chase's New York School of Art, Hartley returns to Lewiston, his father and stepmother having returned as well. He spends time sketching and studying nature, developing a small collection of specimens. Has first contact with Portland painters Charles L. Fox and Curtis Perry through the Lewiston artist Alice Farrar.

The Great Northern Paper Company opens its first mill in Millinocket, Maine.

1901

July After a year at the National Academy of Design, where he will continue his studies for the next three years, Hartley leaves New York for Fox and Perry's small art colony in North Bridgton, Maine, based at an inn owned by Bill Adams. Meets trapper Wesley Adams, brother of the inn's proprietor and a rugged backwoods figure. Wesley Adams's demeanor personifies Maine to Hartley, and he is the subject of Hartley's future (unpublished) essay "Wesley Adams — Maine Trapper."

1902

Summer In Center Lovell, residing in a cooper's shop.

1903

Summer In Center Lovell, residing in a cobbler's cabin at the entrance to Hewnoaks.

The Lewiston Public Library opens, constructed with funds from Andrew Carnegie.

The German art journal *Jugend* publishes a feature with color reproductions of work by Italian Divisionist painter Giovanni Segantini.

1904

Summer In Center Lovell.

American Impressionist Willard Metcalf leaves New York to join his parents in Clark's Cove, Maine. Having spent most of his early career abroad, he begins to adopt the New England landscape as his predominant subject.

1905

November Alfred Stieglitz opens the Little Galleries of the Photo-Secession—commonly known as 291—at 291 Fifth Avenue, New York. Originally dedicated to the promotion of Pictorialist photography, Stieglitz will later shift his interests to American modernism.

Winslow Homer with *The Gulf Stream* in his studio at Prouts Neck, ca. 1900. Bowdoin College Museum of Art, Brunswick, Maine, Gift of the Homer Family

Hewnoaks, home of Douglas and Marion Volk

Marsden Hartley (second from left), writer Helen Campbell, and other residents at Green Acre, 1907

LATE 1905 – EARLY 1906

Touring as an extra with Proctor's Theater Company, Hartley meets Horace Traubel, associate and promoter of Walt Whitman, through Portland publisher Thomas Bird Mosher. In Camden, New Jersey, completes earliest extant painting, *Walt Whitman's House* (fig. 144).

1906

Fall Returns to Lewiston, hoping to teach art.

December 29 Work is featured in the *Lewiston Saturday Journal*, including an early version of *Storm Clouds, Maine* (Walker Arts Center), his first painting seen as employing the stitched brushstroke of Giovanni Segantini.

Adopts his stepmother's name, referring to himself as Edmund Marsden Hartley.

October 22 Paul Cézanne dies in Aix-en-Provence.

1907

Summer and fall At the suggestion of Thomas Mosher, works in maintenance at Green Acre, where he explores comparative religion and Transcendental philosophy. Receives visits from Horace Traubel.

November Work is exhibited in the Boston home of a Green Acre acquaintance, the writer and philanthropist Sara Chapman Thorp Bull.

Summer Painter and theorist Arthur Wesley Dow lectures at Green Acre.

1908

Spring Prominent Boston collector Desmond Fitzgerald purchases a painting by Hartley of a Maine blizzard. Hartley leaves for North Stoneham, Maine, with profits from the sale. Posts his letters from North Lovell.

Presents the painting *Shady Brook* (fig. 22) to the Lewiston Public Library.

Abandons first name and hereafter goes by the name Marsden Hartley.

Paints Impressionist landscapes marked by vivid, expressive color and textured surfaces. Makes a series of self-portrait and figure drawings (figs. 14–18).

1909

April Through his friend the poet Shaemas O'Sheel, meets Alfred Stieglitz.

May 8–18 First exhibition with Stieglitz at 291, "Exhibition of Paintings in Oil by Mr. Marsden Hartley of Maine." The installation includes *The Silence of High Noon—Midsummer* and *Song of Winter No. 6* (figs. 28, 31). After seeing the show, gallery owner N. E. Montross agrees to sponsor Hartley for two years, his stipend determined by the cost of living in Maine. Montross also

introduces him to the work of Albert Pinkham Ryder, whom Hartley meets later that year.

Summer and fall Looking to Ryder, Hartley begins the Dark Landscapes series in New York (figs. 13, 39), continuing work after returning to North Stoneham in November.

Artist Carl Sprinchorn makes his first visit to Maine, staying in Tenants Harbor.

1910

March 9–21 Work is included with that of Arthur Dove, John Marin, and Edward Steichen, among others, in the 291 exhibition "Young American Painters," securing his association with the Stieglitz circle.

Summer and fall In North Stoneham, painting intensely colored landscapes. Begins relationship with John Wilson, a sailor home on leave.

Stieglitz associate Clarence H. White opens a summer school for photography at the new Seguinland Hotel near Georgetown. Teachers include Max Weber and Gertrude Käsebier.

1911

Summer In North Stoneham, creates a series of still lifes based on reproductions of paintings by Cézanne. Visits John Wilson in Norway, Maine, for two weeks in June.

Fall Upon returning to New York, first encounters the work of Cézanne and other European artists at the home of Henry Osborne and Louisine Havemeyer.

March 1-25 Alfred Stieglitz presents the first exhibition of Cézanne in the United States at 291. Edward Steichen, based in Paris, organizes the show, drawing on the collection of the Galerie Bernheim-Jeune.

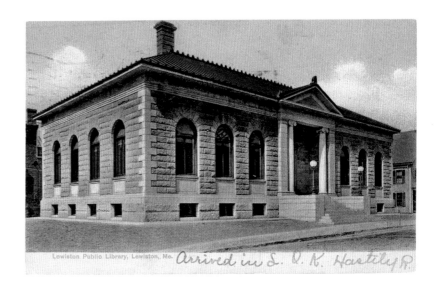

Postcard of the Lewiston Public Library, ca. 1907

Announcement for Hartley's Lewiston art class, 1906. Horace Traubel and Anne Montgomerie Traubel Papers, Library of Congress, Washington, D.C.

Cabin, known as "the hut," in North Stoneham believed to be Hartley's periodic residence between 1908 and 1911. Courtesy Dan Barker

The Hartley family, ca. 1910. Marsden Hartley Collection, Yale Collection of American Literature, Beinecke Rare Book & Manuscript Library, Yale University, New Haven

The Portland Society of Art expands with the addition of the L. D. M. Sweat Memorial Galleries.

Hamilton Easter Field and Robert Laurent open the Summer School of Graphic Arts in Perkins Cove, Ogunquit, a more modernist-leaning alternative to the program offered by Charles Herbert Woodbury.

1912

February 7–26 Second solo show at 291, "Exhibition of Recent Paintings and Drawings by Marsden Hartley."

Spring Before leaving for Paris, Hartley visits Lewiston, where he sees his father for the last time.

Leon Leonwood Bean founds his mail-order business, L. L. Bean, in Freeport, Maine. At the outset, the company sells only waterproof boots.

1913

February 17-March 15 With works by more than three hundred American and European artists, the International Exhibition of Modern Art, known as the Armory Show, is held in New York. It introduces modernist painting and sculpture to the American public on a scale previously unmatched. Two paintings and six drawings by Hartley are included.

1914

August 4 Thomas Hartley dies.

Summer John Marin makes his first visit to Maine, staying in West Point and studying etching under printmaker Ernest Haskell.

Summer Edward Hopper makes his first trip to Maine, staying in Ogunquit. In the fall he shows the work he completed at the Montross Gallery in New York.

Paper manufacturing surpasses textile production as the largest industry in Maine.

1915

January–February The Daniel Gallery in New York exhibits Hartley's Dark Landscapes series and still-life paintings of 1911.

May Stepmother Martha Marsden dies.

September–October While in Germany, Hartley arranges for the exhibition of forty-five Maine landscape drawings, all made in 1908, at the Galerie Schames in Frankfurt and the Münchener Graphik-Verlag in Berlin.

January 28 Germany sinks the American merchant ship *William P. Frye* (made in Bath, Maine) on its way to England with a cargo of wheat.

With funds from Stieglitz, John Marin purchases a small island near Small Point Harbor, Maine, where he works over the next two decades.

1916

Summer While spending the summer in Provincetown, Massachusetts, meets fellow Maine painter Carl Sprinchorn, who becomes a lifelong friend. In July, visits family in Auburn for a week.

The U.S. Congress passes the Shipping Act in an attempt to promote marine trading slowed by the war in Europe, leading to a brief resurgence of the Maine shipbuilding industry.

1917

January 22–February 7 Third and final solo exhibition at 291, "Marsden Hartley's Recent Work, Together with Examples of His Evolution." The show includes abstract paintings made in Provincetown the previous summer as well as earlier works.

Summer Returns to Lewiston in June, spending time with Maine poet Wallace Gould. He soon moves south to Ogunquit, where he resides at Hamilton Easter Field's Summer School of Graphic Arts. There he employs German folk art techniques to produce reverse paintings on glass, including *Three Flowers in a Vase* and *Still Life* (figs. 62, 64).

Fall Resides in Hamilton Easter Field's Brooklyn Heights apartment.

Wallace Gould dedicates his poetry volume *Children of the Sun* to Hartley: "Who, with me, has

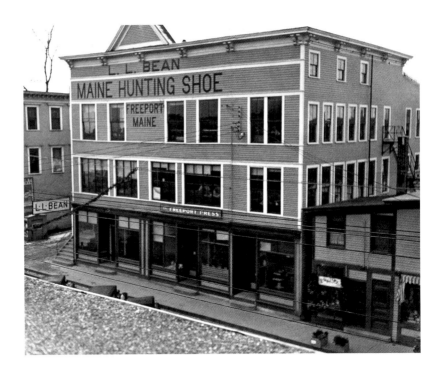

First L. L. Bean store, opened in 1912 (photograph, 1920s)

survived all the ninth waves and who will leave me only at some ebbing of tide which he shall choose or with which he shall naturally drift out, I present these children, for he is godfather."

April 6 The United States declares war on Germany. More than thirty-five thousand Maine citizens serve in the armed forces.

July 1 Facing financial uncertainty, Stieglitz closes 291.

1918

May Visits Wallace Gould in Maine.

Summer Hamilton Easter Field brings the painter Yasuo Kuniyoshi to Ogunquit.

November 11 The Armistice of Compiègne marks the end of World War I and the German surrender.

The University of Maine removes the dean of the Law School, William E. Walz, for alleged German sentiments.

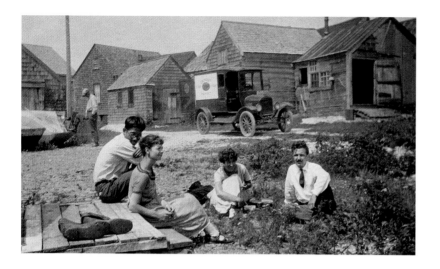

Yasuo Kuniyoshi and his wife, Katherine Schmidt, with artists Betty and Niles Spencer in Ogunquit, ca. 1923. Dorothy Varian Papers, Archives of American Art

1919

July Publishes article on Gould, "The Poet of Maine," in *The Little Review*.

Horace Traubel dies, having published three of the eventual nine volumes of *With Walt Whitman in Camden*. Drawing on Traubel's close friendship with Whitman, they are an account of the poet's life and philosophy in his last years.

Charles Herbert Woodbury publishes his *Painting and the Personal Equation*, disseminating the teachings of his Ogunquit course.

Lafayette National Park, renamed Acadia in 1929, is established as the first national park east of the Mississippi River.

1920

January 2–21 Exhibits glass paintings at the Daniel Gallery.

Spring Georgia O'Keeffe takes the first of several trips to York Beach, Maine. Stieglitz remains in New York.

1921

May 10–17 Stieglitz organizes a show and an auction of Hartley's work at the Anderson Galleries in New York to raise money for the painter to live in Europe. It includes 117 works dating from 1908 to 1919.

Boni & Liveright publishes Hartley's *Adventures in the Arts: Informal Chapters on Painters, Vaudeville, and Poets*, a collection of essays that includes chapters on Whitman and Cézanne, Albert Pinkham Ryder, and Winslow Homer.

1922

August Critic Paul Rosenfeld publishes a laudatory article on Hartley in *Vanity Fair*: "That which Cezanne declared to Renoir it had taken him ten (or was it twenty?) years to discover, the difference existing between the arts of painting and sculpture, this Maine boy, with his inborn fineness of feeling, seems from the first of his career to have well sensed."

In response to the influx of immigrants from Central and Eastern Europe, Maine native Kenneth L. Roberts publishes *Why Europe Leaves Home*, a collection of essays urging extensive legal restrictions on immigration.

Following the death of Hamilton Easter Field, the Summer School of Graphic Arts temporarily closes.

1923

French sculptor Gaston Lachaise and his wife, Isabel, purchase a home near Georgetown. Marguerite and William Zorach acquire a home in nearby Robinhood Cove.

1924

Summer While in Paris, creates two Maine landscapes from memory, both titled *Paysage* (figs. 54, 55), a thematic continuation of his New Mexico Recollections completed in Berlin the previous year.

Paul Rosenfeld publishes *Port of New York: Essays on Fourteen American Moderns*. In his essay on Hartley, Rosenfeld underscores the central importance of Maine in Hartley's work and predicts that the artist will return to the state.

The Ku Klux Klan reaches the zenith of its anti-Catholic and xenophobic activities in Maine, helping to elect Owen Brewster as governor.

In an effort to preserve the racial homogeneity of the American people, President Calvin Coolidge signs into law the Immigration Act of 1924, curtailing immigration from Central and Eastern Europe and Africa, and banning the immigration of Arabs and Asians.

The American Wing of the Metropolitan Museum of Art opens.

1925

January 19–February 19 The Maine *Paysages* are included in a group show of American artists at the Galerie Briant-Robert in Paris.

1926

Summer Edward Hopper returns to Maine after a decade-long absence, staying in Rockland.

1928

August In Georgetown, spends two weeks with Gaston and Isabel Lachaise and Paul and Rebecca Strand.

Fall In Paris, begins a series extending into the next year of shell paintings inspired by shells he collected on his last trip to Maine.

Fall Writes the catalogue introduction to Marin's exhibition at Stieglitz's Intimate Gallery in New York. The show includes watercolor landscapes of Maine.

1929

March 19-April 7 Paul Strand exhibits recent photographs of Georgetown and Center Lovell at Stieglitz's Intimate Gallery. The catalogue introduction is written by Gaston Lachaise.

October The stock market crashes, precipitating the Great Depression.

November 8 The Museum of Modern Art opens in New York.

1930

September At Stieglitz's new gallery, An American Place, exhibits landscapes made the previous summer in New Hampshire. The work receives positive critical attention. Critics view the paintings as Hartley's return to his New England origins.

March 10-November 2 The Metropolitan Museum of Art exhibits all 1,967 objects bequeathed the year before by Henry Osborne and Louisine Havemeyer.

May 6-June 4 Alfred H. Barr Jr. organizes an exhibition of work by Thomas Eakins, Winslow Homer, and Albert Pinkham Ryder at the Museum of Modern Art.

1931

Former Governor Percival P. Baxter donates to the state of Maine 6,000 acres of land around Mount Katahdin, purchased from the Great Northern Paper Company. The land will eventually become Baxter State Park.

1932

April 26–May 15 In her Downtown Gallery in New York, Edith Halpert exhibits Hartley's paintings of Dogtown Common in Gloucester, Massachusetts, in the show "Pictures of New England by a New Englander." Hartley includes his poem "Return of the Native" in the catalogue's foreword. It is also published in the magazine *Contact*.

1933

Fall After reading Gertrude Stein's *Autobiography of Alice B. Toklas* in Germany, begins writing the autobiographical "Somehow a Past." Hartley continues to work on the manuscript throughout the remainder of his life.

October 30 The Museum of Modern Art opens a retrospective of Edward Hopper that includes recent works depicting Rockland, Portland, and Cape Elizabeth, Maine.

John Marin spends his first summer on Cape Split in Addison, Maine. He maintains his summer residence there until his death in 1953.

1934

Reflecting on his earliest experiences at 291, Hartley contributes an essay, "291—and the Brass Bowl," to *America and Alfred Stieglitz: A Collective Portrait*, a volume celebrating the photographer and gallery owner.

December 24 Regionalist painter Thomas Hart Benton becomes the first artist featured on the cover of *Time* magazine.

The U.S. Department of the Treasury opens the Section of Painting and Sculpture (later the Section of Fine Arts), commissioning murals and sculpture for post offices and other federal buildings. Works produced focus on local history and help to create a climate of productivity and hope during the Great Depression.

1935

January 4 On his fifty-eighth birthday Hartley destroys dozens of early works in storage to reduce costs. Among them may have been many early Maine works.

As part of President Franklin Delano Roosevelt's New Deal, the Civilian Conservation Corps begins work on the Maine section of the Appalachian Trail. When completed in 1937 the trail connects Springer Mountain in Georgia to Mount Katahdin.

The Index of American Design, set up under the sponsorship of the Federal Art Project, commissions artists to record and document American art practices, to discover what is "American" in the decorative arts.

Robert Laurent reopens Hamilton Easter Field's school as the Ogunquit Summer School of Painting and Sculpture.

1936

Writes catalogue essay for John Marin's retrospective at the Museum of Modern Art, organized by Alfred Stieglitz, the first significant retrospective of a Stieglitz circle artist. Hartley remarks on Marin's status as a non-native artist working in Maine, challenging critical identification of Marin with the state.

Franklin Delano Roosevelt is elected president for a second term. Maine is one of only two states (the other being Vermont) to vote for Republican nominee Alfred Mossman (Alf) Landon.

The slogan "Vacationland," an acknowledgment of Maine's significant tourism industry, first appears on state license plates.

The Winslow Homer centennial is marked with exhibitions in New York at the Whitney Museum of American Art, the Macbeth Gallery, and Knoedler & Co., as well as at the painter's Prouts Neck home and studio.

Carl Sprinchorn returns to Maine for his first extended stay since 1922, settling in Patten. He soon meets Caleb Warren Scribner, the chief game warden of Mount Katahdin.

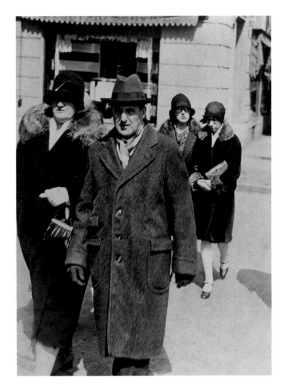

1937

April 20–May 17 Hartley exhibits final group of Dogtown paintings as well as new work from Nova Scotia at An American Place, his last show with Stieglitz. While no works in the exhibition depict Maine, he writes "On the Subject of Nativeness— A Tribute to Maine" for the catalogue, reflecting on noted Maine artists, poets, and writers.

June Hartley's return to Maine is announced in the *Lewiston Saturday Journal*. After visiting family in Auburn, works in Georgetown for the summer, staying near Isabel Lachaise. Takes first trip to Vinalhaven, on Fox Island.

October 27–November 27 Although he no longer represents Hartley, Stieglitz includes him in the retrospective "Beginnings and Landmarks: '291,' 1905–1917" at An American Place.

December Moves to Portland.

Publishes the essay "The Six Greatest New England Painters" in *Yankee* magazine and begins writing the essay "This Country of Maine."

The Federal Writers' Project of the Works Progress Administration publishes the popular travel guide *Maine: A Guide "Down East,"* acknowledging the rise of automobile tourism in the state.

The violent Lewiston-Auburn shoe workers' strike results in a loss to workers, demonstrating the state's reluctance to embrace New Deal reforms.

Thomas Hart Benton publishes the autobiographical *An Artist in America*.

Poet Robert P. T. Coffin publishes *Kennebec: Cradle of Americans*, a historical account of the state.

Hudson D. Walker, 1934. Courtesy of the University of Minnesota Archives—Twin Cities

Hartley teaching at the Bangor Society of Art, *Bangor Commercial Daily*, 1939. Marsden Hartley Collection, Yale Collection of American Literature, Beinecke Rare Book & Manuscript Library, Yale University, New Haven

Well-Known Artist Instructs Class Here

—Staff Photographer

Marsden Hartley, popular American artist, is shown with Miss Georgia Worster, superintendent of art in the Bangor Public schools, during the Saturday afternoon class which he is conducting at the Bangor Society of Art in the studio on Broad street.

1938

February 28–April 2 First exhibition at the Hudson D. Walker Gallery in New York, presenting Maine paintings and drawings completed in the past year. From the show the Addison Gallery of American Art, in Andover, Massachusetts, purchases *Jotham's Island, Off Indian Point, Georgetown, Maine* (fig. 145).

Summer Paints in Vinalhaven. Creates first "archaic portraits" of Albert Pinkham Ryder and the Mason family, with whom he boarded on the island of Eastern Points, Nova Scotia, in 1935 and 1936.

November Returns to Portland.

Two poems by Hartley are included in *The Triad Anthology of New England Verse*.

September The New England hurricane of 1938 claims hundreds of lives and causes widespread property damage and power outages throughout the region.

1939

March 6–April 8 Second show at the Hudson D. Walker Gallery includes seascapes and landscapes of Vinalhaven and Portland and portraits of Ryder and the Mason family.

May 18–September 4 The painting *Kennebec River, West Georgetown* (fig. 58) is included in the exhibition "Art in New England: Contemporary New England Oil Paintings" at the Institute of Modern Art in Boston.

Spring Visits World's Fair in New York, where *Ghosts of the Forest* (fig. 95) is exhibited in the Contemporary Arts Building.

Summer Stays with John Evans and Claire Spencer at Bagaduce Farm in West Brooksville.

September Moves to Bangor and teaches painting at the Bangor Society of Art.

October Guided by game warden Caleb Warren Scribner, takes eight-day trip to Mount Katahdin, making sketches and oil studies of the mountain. The subject occupies him for the next three years.

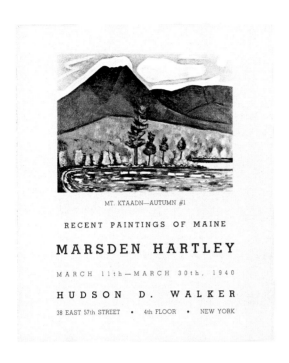

MT. KTAADN—AUTUMN #1

RECENT PAINTINGS OF MAINE

MARSDEN HARTLEY

MARCH 11th—MARCH 30th, 1940

HUDSON D. WALKER

38 EAST 57th STREET • 4th FLOOR • NEW YORK

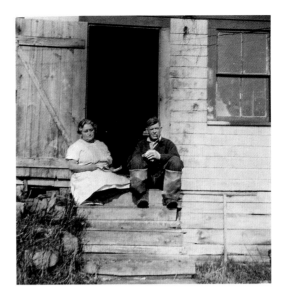

Catalogue cover for Hartley's final exhibition at the Hudson D. Walker Gallery, with *Mount Katahdin, Autumn, No. 1* (fig. 131). Marsden Hartley Collection, Yale Collection of American Literature, Beinecke Rare Book & Manuscript Library, Yale University, New Haven

Katie and Forrest Young, ca. 1941. Marsden Hartley Collection, Yale Collection of American Literature, Beinecke Rare Book & Manuscript Library, Yale University, New Haven

December Exhibits recent paintings at Symphony Hall in Boston. The show travels to six other American venues, including the Palace of the Legion of Honor in San Francisco.

The Saint Louis Museum of Art acquires the Georgetown landscape *Smelt Brook Falls* (fig. 90).

April 17–May 6 Maine painter Waldo Peirce exhibits at the Midtown Galleries in New York.

Magic Realist painter Ivan Albright arrives in Maine for the first of three consecutive summers that he will spend there. The following summer he resides in Corea, a fishing village near Mount Desert Island.

Carl Sandburg publishes the four-volume *Abraham Lincoln: The War Years*, the second half of his mythologizing biography of the president.

The centenary of Cézanne's birth is celebrated with exhibitions and publications in New York, London, and Paris.

1940

January Wins prize at the Pennsylvania Academy of the Fine Arts for the painting *End of the Hurricane* (Wichita Art Museum).

March 11–30 Third and final exhibition at the Hudson D. Walker Gallery. The show includes *Birds of the Bagaduce*; *Madawaska—Acadian Light-Heavy*; *Knotting Rope*; *Mount Katahdin, Autumn, No. 1*; and *Mount Katahdin, Autumn, No. 2* (figs. 57, 118, 124, 131, 132), as well as "archaic portraits" of Abraham Lincoln and John Donne. Walker closes the gallery later in the year.

August Moves to Corea, lodging with Forrest and Katie Young. Uses upper story of the town's abandoned Baptist church as a studio.

Falmouth Publishing House issues Hartley's second volume of poetry, *Androscoggin*.

Finishes the poem "Cleophas and His Own," an elegiac tribute to the Mason family, which he began in 1935.

Works include Maine landscapes and paintings of bathers and lobstermen.

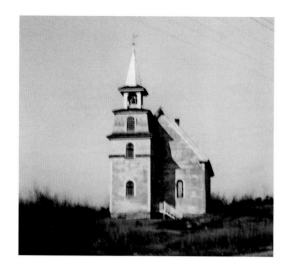

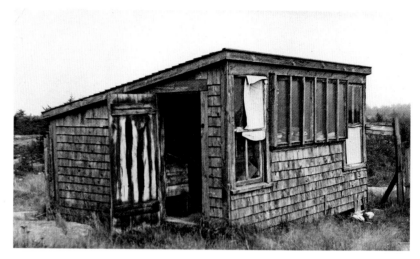

The abandoned Baptist church in Corea, which served as Hartley's studio, ca. 1940. Bates College Museum of Art, Lewiston

Exterior view of Hartley's last studio, Corea, 1943. Bates College Museum of Art, Lewiston

1941

January Returns to Bangor. Delivers a lecture, "The Meaning of Painting," at the University of Maine, Orono.

August Arrives in Corea and stays with the Young family, using their chicken coop as a studio.

October 24–November 24 Exhibits at the Cincinnati Art Museum with Stuart Davis. Visits show and spends Christmas with family in Cleveland.

The Worcester Art Museum purchases *The Wave* (fig. 101).

Hudson Walker purchases twenty-three paintings from Hartley for his personal collection, which he later bequeaths to the Frederick R. Weisman Art Museum at the University of Minnesota, Minneapolis.

Leon Tebbetts, founder of the Falmouth Publishing House, publishes Hartley's third and final volume of poetry, *Sea Burial*.

The United States enters World War II. Ninety-three thousand men and women from Maine serve in the armed forces.

Following the death of founder Charles Herbert Woodbury, the Ogunquit Summer School of Drawing and Painting closes.

1942

January Delivers talk at the Cincinnati Art Museum: "Is Art Necessary — What Is Its Social Significance?"

March Returns to New York for an exhibition at the Macbeth Gallery.

July Returns to Corea.

August Signs contract with famed French art dealer Paul Rosenberg, who has recently opened a gallery in New York.

October 12–31 Knoedler & Co. presents a show of Hartley's early drawings.

December Places fourth in the Metropolitan Museum of Art's "Artists for Victory Exhibit." The museum acquires Hartley's submission, *Lobster Fishermen* (fig. 87).

The Whitney Museum of American Art acquires *Granite by the Sea*.

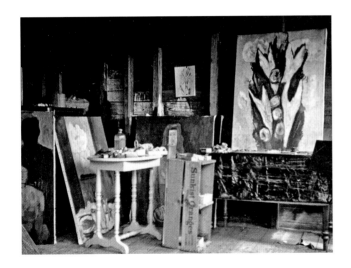 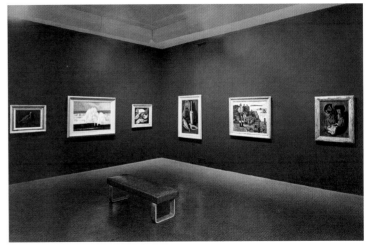

Portland hosts the first public showing of the Walt Disney film *Bambi*. In making the film, animators model characters and scenery after the wildlife of Mount Katahdin and Maine's woodlands.

1943

February 2–27 First and only show at the Paul Rosenberg gallery. Includes *Evening Storm, Schoodic, Maine*; *Evening Storm, Schoodic, Maine, No. 2*; *Young Seadog with Friend Billy*; and *Mount Katahdin, November Afternoon* (figs. 102, 103, 122, 133).

July 20 His health deteriorating, Hartley makes final trip to Corea.

September 1 Forrest and Katie Young take Hartley to a hospital in Ellsworth.

September 2 Hartley dies in the hospital of heart failure. His ashes are scattered over the Androscoggin River, in accordance with his wishes.

The Phillips Collection in Washington, D.C., acquires *Off the Banks at Night* (fig. 85).

With the conclusion of the New Deal, the Treasury Section of Fine Arts ends, having commissioned and installed murals for federal buildings throughout Maine.

1944

October 24 The Museum of Modern Art opens a Hartley retrospective organized by Hudson Walker.

Interior view of Hartley's last studio, 1943. Bates College Museum of Art, Lewiston

Installation view of the Hartley retrospective at the Museum of Modern Art, October 24, 1944– January 14, 1945

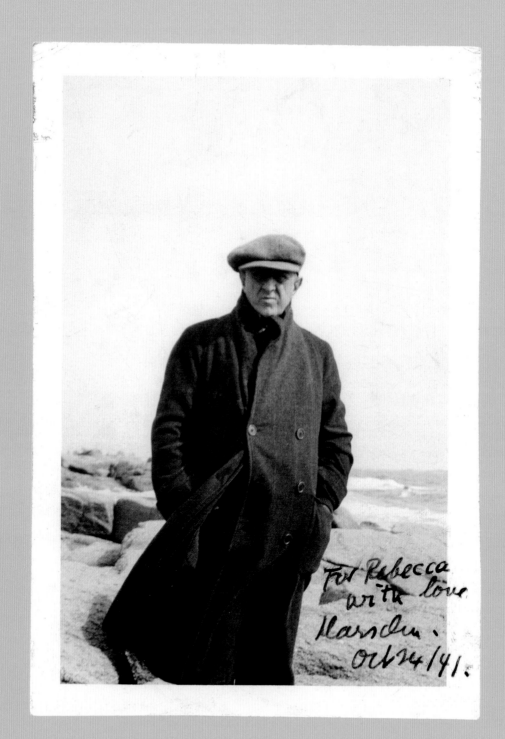

For Rebecca
with love.
Marsden.
Oct 24/41.

INTRODUCTION Marsden Hartley's Maine

Donna M. Cassidy • Elizabeth Finch • Randall R. Griffey

"Marsden Hartley's life made a full circle before its close," wrote Elizabeth McCausland in the opening of her seminal 1952 monograph on the artist.[1] This circle was inscribed around Maine: Hartley was born in the mill city of Lewiston in 1877 and died in the Down East coastal town of Ellsworth in 1943 (fig. 1). At his request, his ashes were scattered over the state's storied Androscoggin River, the waterway after which he had named a collection of poems published three years before his death.[2] Hartley began his professional career in the first decade of the twentieth century by creating lush, dazzling landscapes of his home state's western hills and concluded it by presenting himself (beginning in 1937) as "the painter from Maine" and producing roughly rendered paintings of — and publishing related poetry and prose about — Maine's rugged landscape, coastal terrain, and working-class folk.[3] In the interim, he made only brief visits to the state in 1916 and 1918, with summertime stays in 1917 and 1928. Nevertheless, he felt that Maine was with him both as a point of reference and as a concept throughout his many travels across Europe and North America. Yet Maine, the ur-subject that infused the full spectrum of his oeuvre, has been only selectively addressed by his earliest interpreters and subsequent scholars.

Marsden Hartley's Maine considers the artist's complex, sometimes contradictory, relationship with his native state and how he navigated this relationship through painting. Hartley explored

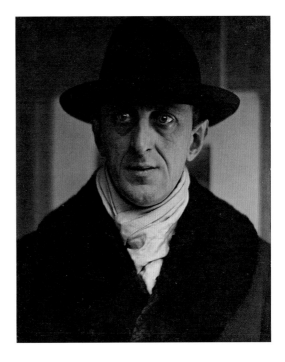

both what was exhilarating and what was desolate in Maine, finding there both light and darkness — the brilliant Post-Impressionist landscapes versus the bleak, deserted Maine works of his early career and the 1924 Paris *Paysages*; the bright, buoyant coastal views versus the mournful landscapes of his late career. It was this perception of Maine as a place of desolation, together with his habitual restlessness, that prevented him from settling there permanently.

Having endured a lonely childhood and stung by the devastating loss of his mother at the age

◀ Marsden Hartley in Maine, 1941. Postcard to Rebecca Strand. New Mexico History Museum, Santa Fe

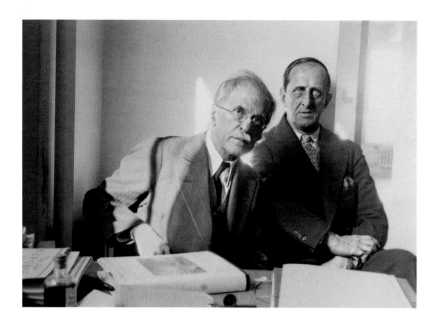

of eight, Hartley sought to distance himself from the New England conservatism of his upbringing, outwardly rejecting his home state as a marker of heritage for many years. Writing from Bermuda in February 1917 to his dealer, photographer and gallery owner Alfred Stieglitz, he chafed at critic Henry McBride's characterization of him as a Yankee in a review of Hartley's Berlin paintings. "This Hartley . . . is a lean, intellectual, disillusioned type," McBride wrote in the New York *Sun*: "'Very American,' as the Berlin newspapers said; so American that it is a fair guess that he is a Yankee."[4] To Stieglitz, Hartley retorted, "I come as near being a man of no land as anyone I know, spiritually speaking."[5] Earlier, in 1913, he had written to Gertrude Stein from Germany: "I am without prescribed culture," adding, "I have grown up out of a strange thicket."[6] The contradiction in these statements — one a proclamation of self as tabula rasa and the other professing a far more complex and fraught relationship to his beginnings — suggests the fluctuating, unsettled nature of Hartley's feelings toward his place of origin. The artist's homosexuality — alluded to in his personal correspondence and conveyed in poignant, coded

terms in some of his greatest works — may have contributed to an ingrained sense of isolation that could be only partially dispelled by chosen friendships and alliances.

Leaving Maine in 1893 to join his family in Cleveland, Ohio, Hartley began his art education in that city. He moved to New York in the fall of 1899 and spent the following summer in Maine, establishing a pattern of living and working between his home state and New York or Boston. In New York in April 1909, Hartley met Stieglitz, who would become not only his dealer but his confidante and counselor throughout much of his career (fig. 2). Stieglitz immediately recognized Hartley's unique voice ("I believed in you & your work . . . I felt a spirit I liked") and the very next month exhibited a selection of the Maine landscapes at his Little Galleries of the Photo-Secession, at 291 Fifth Avenue, known simply as 291.[7] Hartley had another solo show at the gallery in the winter of 1912, and in April he left New York for his first trip to the modernist art capitals of Europe, Paris and Berlin. He returned briefly to New York in late 1913 to exhibit, again at 291, his earliest European works. Back in Germany by the spring of 1914, he remained there until wartime conditions forced him to return to the United States in the winter of 1915.

Hartley continued his travels on this side of the Atlantic, with stints in Provincetown (1916), Bermuda (1916–17), Ogunquit (1917), New Mexico (1918–19), and California (1919), before again settling in New York and playing a brief, rather nominal role in the international Dada movement. In late 1921 he returned to Europe, first to Paris and then to his beloved Germany, where he remained until 1923.

That year Hartley began a series of paintings that revisited his New Mexico landscapes before venturing on to Vienna and Italy. He traveled to New York in 1924 but quickly sailed back to Paris. The following year he moved to Vence, in south-

eastern France. In 1926, 1927, and 1929 he painted in Aix-en-Provence (fig. 3), in an artistic communion with Paul Cézanne, an experience that bore fruit not only in his own paintings of Mont Sainte-Victoire — a site immortalized by the French Post-Impressionist — but also, more subtly and more profoundly, in his later depictions of Maine's Mount Katahdin.

The emotional toll of this peripatetic life began to weigh on Hartley, as he confided to Stieglitz in December 1924, and he began to "feel the need of finding an actual . . . spiritual pied à terre for the earthly as well as the idyllic side of my existence. . . . I want so earnestly a 'place to be.'"[8] External pressures also began to define his personal and professional relationship with his homeland. Chief among these was the belief, prevalent throughout the 1920s and into the 1930s, that the creation of great American art was predicated on an artist's "rootedness" in his or her native culture.[9] It was a trend in step with the rise of isolationist and anti-immigration sentiments during this period. Stieglitz was among the most devoted and active proselytizers of cultural nationalism through the promotion of his second circle of artists, including Hartley, Charles Demuth, Arthur Dove, Georgia O'Keeffe, Paul Strand, and John Marin (fig. 4), a group he christened in the 1925 exhibition "Seven Americans" and subsequently supported through his gallery An American Place, which opened in 1929. However, Hartley's continued distance and perceived disconnectedness from the United States with his travels to Mexico, Germany, and Nova Scotia in the early 1930s contributed to a growing and eventually irreconcilable rift with Stieglitz, although his return to American subjects, and particularly to Maine, was due in large part to the influence of his former mentor.[10]

But the narrative of a triumphant late-life return was only part of the story. Hartley transformed American modernism by approaching his place of origin as a lifelong creative resource.

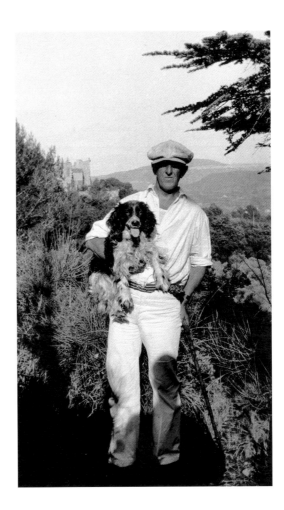

3 | Marsden Hartley and his dog in Aix-en-Provence, ca. 1926. Archives of American Art, Smithsonian Institution, Erle Loran Papers, 1912–99

Fundamentally, the state offered the inspiration of nature as an alluring subject, as it had for many earlier American artists, including Fitz Henry Lane, Frederic Edwin Church, and, most famously, Winslow Homer, who created a vision that was unique among his contemporaries also painting in the state and whose precedent as a painter of Maine Hartley was acutely aware (figs. 5, 6). Hartley's early Maine landscapes of the western hills overlap and contrast with Homer's coastal views, and his later work is in dialogue with that of other artists in Maine, both native-born and transplants, among them John Marin, Edward Hopper, painters in the Ogunquit and Monhegan art colonies, and those who produced the New Deal post office murals.[11]

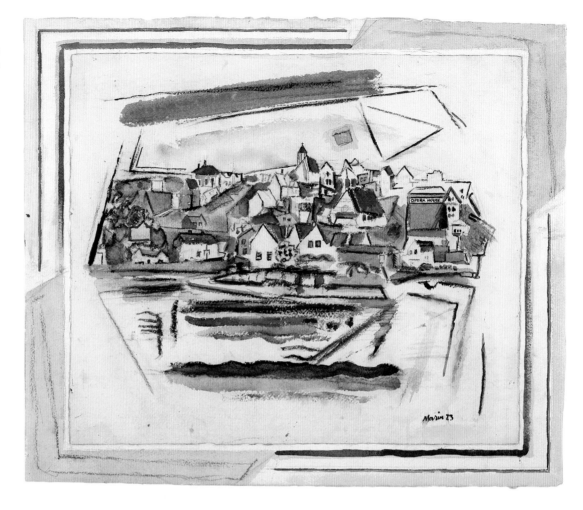

4 | John Marin (1870–1953). *Stonington, Maine*, 1923. Watercolor and charcoal on paper, 21¾ x 26¼ in. (55.2 x 66.7 cm). Colby College Museum of Art, Waterville, Gift of John Marin Jr. and Norma B. Marin

Hartley rendered Maine for reasons and with effects that extended far beyond topographical or physical description. The landscape served as a slate on which he pursued new ideas and theories pertaining to formal elements of color and design. It was a modernist testing ground. In his Maine landscapes of 1908–11, he experimented with abstracting from nature and established compositional devices that would recur throughout his oeuvre. Consider, for example, the many similarities connecting *Carnival of Autumn*, 1908 (see fig. 74), and *Mount Katahdin, Autumn, No. 2*, 1939–40 (see fig. 132). Both present their respective landscape subjects in flattened, hieratic arrangements composed in tiers: lake and foothills, mountain — which

appears well above the composition's center point — and a band of blue sky filled with white clouds. Furthermore, the sublimity of the landscape suggested to Hartley the presence of a higher power, one that he was predisposed to understand through the lens of American Transcendentalism after he discovered Ralph Waldo Emerson's *Essays*.

Maine's dramatic change of seasons led Hartley to make landscapes in series, sustained meditations on the passage of time and the inherent tension between temporality and permanence. His paintings of the tempestuous coastlines are imbued with pain, loss, and alienation, themes that course through his life as they give power to his art. Maine's lumberjacks and loggers appear in both

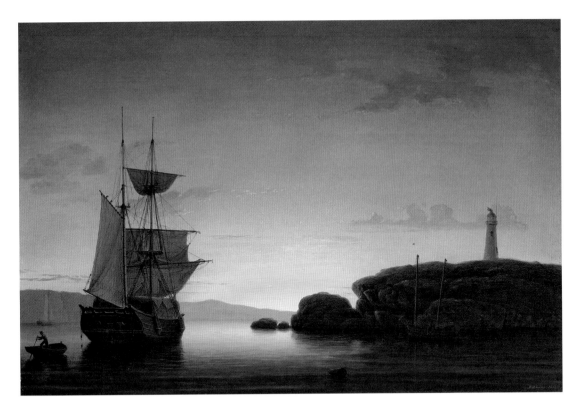

5 | Fitz Henry Lane (1804–1865). *Lighthouse at Camden, Maine*, 1851. Oil on canvas, 23 x 34 in. (58.4 x 86.4 cm). Yale University Art Gallery, New Haven, Gift of the Teresa and H. John Heinz III Foundation

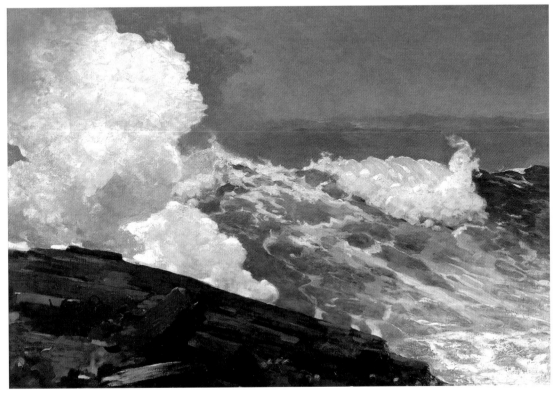

6 | Winslow Homer (1836–1910). *Northeaster*, 1895; reworked by 1901. Oil on canvas, 34½ x 50 in. (87.6 x 127 cm). The Metropolitan Museum of Art, Gift of George A. Hearn, 1910

the early and the late work. He also drew farmers and formidable New England spinsters early in his career, and to this collection of traditional types he added fishermen and hunters when he returned to Maine in his final years. Hartley's protagonists are embodiments of the rugged terrain, stalwart expressions of a rough and precarious existence.

Hartley's Maine includes absences and omissions. He painted the inland mountains and the coast as well as the people of these regions, but his Maine remains untouched by industrialization. Power lines and highways appear nowhere in his paintings. And while he grew up in the industrial city of Lewiston and even worked briefly in a shoe factory, these experiences are never invoked. When he did paint Lewiston, early in his career, it was the poetic Androscoggin River that figured in such works as *River by Moonlight*, a painting no longer extant but mentioned in an article from 1906.[12] Later paintings of woodlots and log drives allude to the lumber industry, with dramatic views of nature touched by workers but no sign of the mills.

Hartley observed Maine as an outsider always returning, as a traveler remembering his birthplace. As the art historian Bruce Robertson has written, "The act of looking was [for Hartley] always mediated by memory."[13] He perceived Maine through the veil of the many places he had lived in or passed through — towns and cities in Europe and across North America; Hartley's Maine was a global place. Other representations of the state, not only by other artists — Homer and Marin — but advertisements for tourists, film, and regionalist literature by, for example, Sarah Orne Jewett, all influenced the way the artist envisioned the land and its people. Hartley worked primarily from the imagination, in a studio, and less directly from nature. During winters in New York, he would rework and complete pictures begun in Maine during the summer and autumn. Distance, selectivity, imagination, and memory — these were the elements that shaped his vision.

The Maine paintings brought Hartley success late in his career. In the 1930s, when artistic identification with place was tantamount to cultural significance, Hartley understood Maine to be essential in gaining recognition as a great American artist, recognition he achieved just before his death. Until this shift in his fortunes, he endured what were at best uneven reviews for much of his nearly forty-year career. His seemingly unfocused engagement with Post-Impressionism, Cubism, Expressionism, Symbolism, and various realist idioms struck many critics and others in the know as evidence of a painter grasping for direction, not a painter with a unique vision and in command of his own artistic voice. Thus Hartley was for most of his life forced to eke out a hand-to-mouth existence, even with the help he received from a few devoted supporters and dealers, most notably Alfred Stieglitz.

The course of Hartley's career began to change in 1937, when he declared himself "the painter from Maine," and during the last five or so years of his life his reputation grew among critics and lay audiences alike. His work earned critical praise, received awards, and entered prominent private and public collections, including those of Duncan Phillips and the Metropolitan Museum of Art.[14] Such was Hartley's stature and self-confidence in late 1942 that he could write to his niece and confidante Norma Berger, "I have a high position as a painter — as high as anyone. . . . When I am no longer here my name will register forever in the history of American art."[15]

As Hartley predicted, his name does register prominently in art history, but not for the reasons he might have imagined in 1942. For much of the late twentieth century, his reputation rested not on his late work or his early experimental landscapes of Maine, but rather on the abstract paintings he made in Berlin between 1913 and 1915, when he was in the mix of European avant-garde artists, not least among them Picasso and Kandinsky. *Portrait*

of a German Officer (fig. 7), a composition that draws in equal measure from Synthetic Cubism and Expressionism, became a mainstay in textbooks on modern art and exemplified the abstract work through which Hartley came to be known by museumgoers and students of art history. In 2014 the Nationalgalerie, Berlin, mounted an exhibition of Hartley's German Officer paintings to mark the centennial of their creation, a testament to their continued acclaim.

Until recent years, critical and scholarly praise of Hartley's German period frequently came at the expense of his other work, including the early Maine landscapes that had launched his career and the Maine paintings that had bolstered his reputation in the 1930s and 1940s. This bias is particularly pronounced in William Innes Homer's 1977 study of the Stieglitz circle in the early twentieth century. "At the time of the closing of 291 [in 1917]," Homer wrote,

Hartley's art lacked the definite direction it had shown in Germany in 1913–1915. In retrospect, these seem to be the most important years of his career. He had succeeded in keeping pace with the most advanced developments in European painting and aesthetics, yet he also listened to the inner voice of his own creative impulse and was not ashamed of his American roots. . . . When Hartley was forced to abandon the congenial creative ambiance of Berlin, however, his style faltered . . . [his] most important period was over.[16]

Hartley registered prominently, if briefly, in modern art history as an important member of the American avant-garde, but his work outside this specific context was thought to be less worthy of serious consideration and effectively disappeared into near obscurity. Karen Wilkin identified this imbalance when, in 1988, she observed, "Marsden Hartley is one of our best painters, but not long ago he could have been described as an enigmatic presence in the history of this country's art. Not that he was unrecognized. Quite the contrary, but he was known for a fraction of his work."[17]

7 | *Portrait of a German Officer*, 1914. Oil on canvas, 68¼ x 41⅜ in. (173.4 x 105.1 cm). The Metropolitan Museum of Art, Alfred Stieglitz Collection, 1949

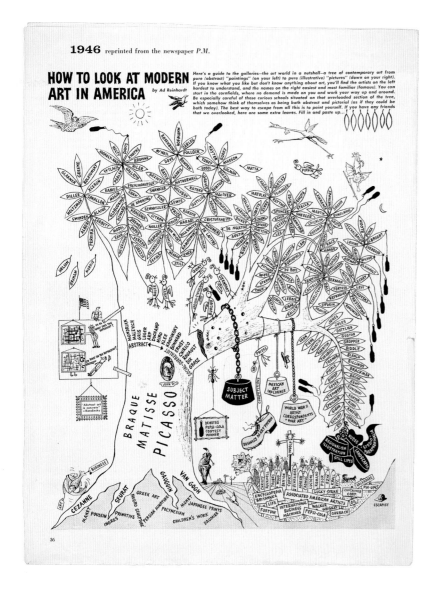

latter connoting representational painting with recognizable subject matter and narrative, which the critic associated with spurious capitalism and a myopic, even potentially dangerous, cultural nationalism.[18] Among other wide-ranging effects, Greenbergian formalism drained American Scene painting and Regionalism of the 1930s of cultural value. Because Hartley's late Maine work related to these two movements, the leaf bearing his name in Ad Reinhardt's arboreal genealogy of modern art of 1946 (fig. 8), a mere three years after Hartley's death, appears on a branch breaking under the weight of "subject matter."

While Hartley's Maine work suffered for decades under the regime of postwar formalist art criticism, a few contrarian critics, particularly those writing in popular (nonspecialist) contexts, advocated for its aesthetic and cultural merit. Among the most vocal supporters of this part of Hartley's career was Robert M. Coates, reviewer for *The New Yorker*, who, cutting remarkably against the dominant grain of contemporary art criticism, asserted in 1960:

It wasn't until Hartley settled on Maine as his particular province that he reached his true stature. I don't know what it is about Maine — dour, rugged, remote, its people cantankerous and its climate barbarous — that not only attracts the artist but incites him on to the fullest development of his powers.[19]

The great sea change in Hartley studies can be traced to the 1980 retrospective curated by Barbara Haskell of the Whitney Museum of American Art, a project that prompted its many visitors to consider more seriously dimensions of the painter's career beyond his renowned German period.[20] Coinciding with the new postmodern academic critiques of master narratives of modernism, including Greenberg's formalist paradigm, the Whitney retrospective laid the foundation for the more expansive study of Hartley's career that has followed. It was concurrent with a rediscovery of his work as a writer, with publications of his poetry

8 | Ad Reinhardt (1913–1967). "How to Look at Modern Art in America," from *PM*, June 2, 1946. Ad Reinhardt Papers, 1927–1968, Archives of American Art, Smithsonian Institution, Washington, D.C.

Wider understanding of Hartley's complex career has been predicated on and symptomatic of the weakening influence of the formalist critical paradigm that held sway throughout much of the mid- and late twentieth century, one that underpinned Homer's 1977 assessment. Most famously articulated and promoted by the Marxist critic Clement Greenberg, this ideology favored abstraction and compositional flatness over all representational idioms. For Greenberg a work of art was either "avant-garde" or "kitsch," the

and essays — the groundbreaking work of Gail R. Scott.[21] Scott also organized the 1982 exhibition "Marsden Hartley: Visionary of Maine," which considered Hartley's paintings and drawings from the perspective of his poetry.[22]

Since the 1980 Whitney show and this more recent scholarship, Hartley studies have flourished, with abundant publications and exhibitions addressing new and far-ranging aspects of his life and career, including his sexuality, race and ethnicity in his work, and his travels beyond the early German period. These diverse perspectives were brought to bear on the most recent Hartley retrospective, curated by Elizabeth Mankin Kornhauser for the Wadsworth Atheneum Museum of Art in 2003–4. The exhibition traveled to two additional venues and was accompanied by a large, multi-author catalogue (unprecedented for Hartley), an index of Hartley's even loftier art-historical stature in the twenty-first century.[23]

Marsden Hartley's Maine joins these reevaluations by examining Maine as place and the place of Maine in Hartley's art, recovering the significance that his home state had in the artist's own lifetime. It examines the range of Hartley's work in his native region — from the innovative early paintings of Maine's western hills, works that established his formal strategies and ideas about nature, to the distinctive glass paintings done in Ogunquit and the representations of Maine from abroad, to the final paintings of the coast, Mount Katahdin, and the local inhabitants of the land. As the exhibition demonstrates, the artist had a unique vision of the place he called home. For Hartley, Maine was a lifelong source of inspiration integrally linked to his personal history, his wider cultural milieu, and his desire to create a new regional expression of American modernism.

BECOMING "AN AMERICAN INDIVIDUALIST"

The Early Work of Marsden Hartley

Elizabeth Finch

*It is naturally up to every artist to refrain from fashionable eclecticism and strike out for the valleys and the mountains of his own private originations — and when that is done we shall have something.** — Marsden Hartley

In the winter of 1906, a reporter knocked at the door of Edmund Marsden Hartley's studio on Lisbon Street in downtown Lewiston, Maine. The article that subsequently appeared in the local paper offered the first account of the "student and painter of nature" who would later gain recognition for his bold, forcefully wrought contributions to American modernism.[1] But at that moment, the story to be told concerned a young artist with newly acquired cosmopolitan credentials and a wide range of interests and enthusiasms. While landscape was this painter's principal subject, in his studio were oil sketches after paintings by the French Symbolist Pierre Puvis de Chavannes, a selection of Japanese prints, and a portfolio of botanical and entomological studies. None of these artworks survived Hartley's itinerant life, nor did a "bright water color sketch" whose subject, the journalist noted, was Boston's Revere Beach, a favorite site among New England artists drawn to scenes of modern leisure. By the early twentieth century, the once controversial stylistic hallmarks of French Impressionism — sketchiness to the point of unfinish, heightened color, forms defined by light effects rather than line — had been so thoroughly assimilated by these American artists that they could be reduced to a pithy prescription for compositional integrity. "A dot of color here, another there," Hartley noted while surveying his studio in the company of his visitor, "harmonizes and completes the whole."

9 | Marsden Hartley, ca. 1912. Arnold Rönnebeck Papers and Louise Emerson Rönnebeck Papers, Archives of American Art, Smithsonian Institution, Washington, D.C.

* Marsden Hartley, "The Education of an American Artist," unpublished manuscript, late 1930s. Marsden Hartley Collection, Yale Collection of American Literature, Beinecke Rare Book & Manuscript Library, Yale University, New Haven.

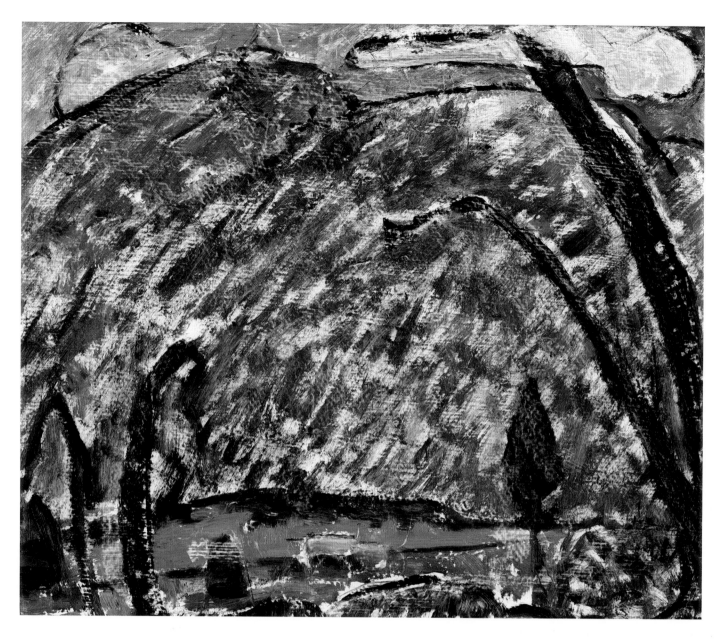

10 | *Landscape No. 14,*
1909. Oil on academy
board, 16½ x 18⅜ in.
(41.9 x 46.7 cm). The
Frederick R. Weisman Art
Museum at the University
of Minnesota, Minneapolis,
Bequest of Hudson D.
Walker from the Ione
and Hudson D. Walker
Collection

Yet this artist who had mastered the language of Impressionism was also, the reporter observed, "a temperamentalist in painting with a tendency to the dramatic in nature." It was this aspect of Hartley's artistic persona that was gaining presence and clarity in 1906. Roughly two years later, he wrote to his friend and mentor the publisher Horace Traubel with the news that the Boston-based artist and critic Philip Hale had detected "a *fine insanity*" in his work stemming from "a strong insistence upon the personal interpretation of the subjects chosen."[2] By the spring of 1911, with his first trip to Europe more than a year away, he proclaimed himself "an American individualist to be heard from."[3]

Hartley was correct in his prediction, but the significance of the period of artistic exploration initiated by what he later described as his

"original" return to Maine has been largely over-shadowed by the accomplishments that followed.[4] Positive critical reception of Hartley's late Maine paintings, dating from 1938 to 1942, through which he successfully promoted a renewed creative allegiance to his home state, partly explains this disparity. In comparison, the extant early Maine works, far fewer in number and confined to the period 1906 to 1911, have been discounted as derivative or, more charitably, as a phase Hartley "worked his way through" on the way to the full expression of his artistic destiny.[5] For the critic Clement Greenberg, the artist's formative years were little more than a "fling at the high palette of the later impressionists and of the fauves."[6] This view of Hartley aligns with the stark distinction commonly made between the artist's pre-Europe works and his German abstractions.[7] Yet the painter who described himself in 1913, when he was living in Berlin, as "by nature a visionary" was, in actuality, only a small distance — communicated through a shift in rhetoric rather than intention — from the aspirant profiled in 1906.[8] There is evidence of this connection in a photograph of the artist with a Japanese print, taken not long after his arrival in Europe, which echoes the arrangement of his Lewiston studio (fig. 9).

This continuity exists in Hartley's work as well. Compare, for example, the pronounced primitiv-ism of *Landscape No. 14*, 1909 (fig. 10), a Maine subject, with *Painting No. 1*, 1913 (fig. 11), in which the American artist responded to the work of the Russian-born Vasily Kandinsky through his mem-ory of Maine's western mountains. Between 1913 and 1915, during his first stay in Germany, Hartley came closest to severing his imagery from things in the world — the defining, if elusive, criterion of abstraction. Integral to this break was a series of landscape-derived proto-abstractions, specifically the "native" landscape that defined his early work. Moreover, it was also in the context of Maine, and through the subjects Hartley explored there,

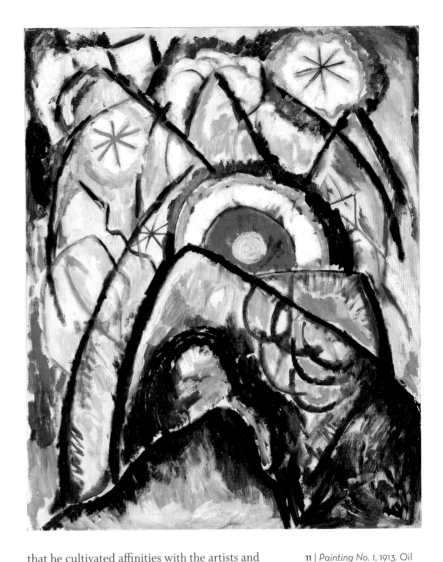

11 | *Painting No. 1*, 1913. Oil on canvas, 39¾ x 31⅞ in. (101 x 81 cm). Sheldon Museum of Art, University of Nebraska—Lincoln

that he cultivated affinities with the artists and writers who were essential to his paired pursuits of authenticity and originality. Hartley became an American individualist through interpretation and expressions of artistic kinship based in the specific-ities of place.

Finding Maine

Traveling by train through the countryside toward Lewiston in May 1900, Hartley was "nearly wild," as he recounted in a letter to his friend Richard Tweedy, "to get out and paint . . . the tender spring colors."[9] It was a desire at once apt and common-place, especially for artists during the period of

SCENERY ON THE MAINE CENTRAL RAILROAD'S MOUNTAIN DIVISION.

12 | White Mountains montage, ca. 1890, from George H. Haynes, *The State of Maine in 1893* (1893)

Impressionism. Indeed, retreating to a rural setting to paint, whether at an artist's colony or as a student at a seasonal art school, was standard practice among American artists at the turn of the century. Hartley, who had recently completed a year of study at William Merritt Chase's New York School of Art, would have known of the older artist's summer school at Shinnecock Hills on Long Island. He may also have been familiar with the colony associated with John Henry Twachtman and his circle at Holley House in Cos Cob, Connecticut, and with the instruction offered by Arthur Wesley Dow in Ipswich, Massachusetts.

New England drew the greatest number of artists, and the coast of Maine became a preferred destination, especially after 1884, when Winslow Homer began to live and work year-round at Prouts Neck. Throughout the 1890s, Childe Hassam, the Impressionist painter of New England, was periodically in residence on the Isles of Shoals in the Gulf of Maine. In 1898, Charles Herbert Woodbury established the Summer School of Drawing and Painting in Ogunquit, and farther north, also around the turn of the century, the Georgetown area became a haven for the photographer

F. Holland Day. About a decade after Woodbury arrived in Ogunquit, Hamilton Easter Field and Robert Laurent would choose the same coastal town for their Summer School of Graphic Arts, where Hartley would stay in 1917.

Parallel to these developments was the burgeoning industry of marketing both coastal and inland Maine as "Vacationland."[10] Before he left Lewiston for Cleveland in 1893, Hartley would have seen advertisements beckoning summer visitors to resorts on Maine's Sebago Lake and in the White Mountains along the state's border with New Hampshire. A promotional montage produced by the Maine Central Railroad's Mountain Division (fig. 12) shows an arrangement of scenic landscapes reminiscent of Hudson River School paintings, amended by illustrations of the train that conveniently offered connections, through Portland, to Boston and New York.

It was logical and strategic, therefore, that Hartley chose Lewiston over Cleveland as his summertime residence after his first year in New York. It was also financially pragmatic. By 1900, Hartley's father and stepmother had returned to Lewiston, and he stayed with them that summer. Yet having arrived back home, Hartley was hard-pressed to find landscape subjects within walking distance of the city, which offered "little convenience . . . for conveyance," as he ruefully observed.[11] Instead, he returned to collecting and drawing butterflies and flowers, pastimes of his childhood.

Hartley also discovered the local library, which had established its first free reading room during the years he was away. It was here that he spent his afternoons exploring a wide range of subjects, from entomology and natural history to philosophy and religion.[12] That summer and into the early fall, before Hartley returned to his studies in New York, extensive reading complemented his "researches" in nature.[13] Both activities were aspects of the same passion for discovery that inspired the artist

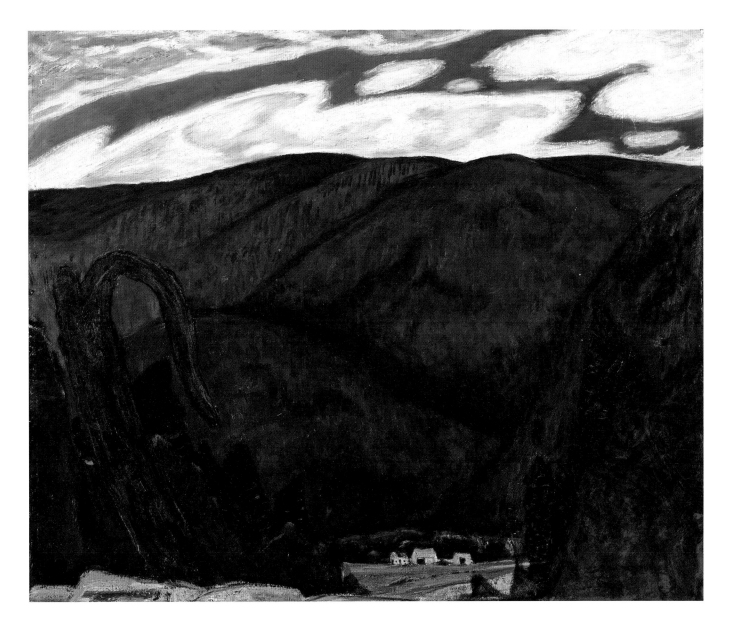

to compare his first encounter with Ralph Waldo Emerson's *Essays* to a religious conversion and to embrace the poetry of Walt Whitman with similar fervor a few years later. Hartley's pursuit of formal artistic training was, in comparison, a kind of background noise. There was nothing this emerging artist desired to learn, his actions seemed to say, that he could not teach himself.

In 1901, seeking to return again to Maine, Hartley secured an invitation to an art commune in North Bridgton, roughly fifty miles west of Lewiston. Hearing of the mountain and lake views in the Lovell region, another fifteen miles west, he headed there for the summer of 1902. It was this remote Maine, looking toward the White Mountains and a world away from Lewiston's thunderous mills, that Hartley claimed as his own. He vividly described the area in his letters, and it appears in his prose and poetry decades after he had moved on to other locales. "The moon is

13 | *The Dark Mountain*, 1909. Oil on commercially prepared paperboard (academy board), 19¼ x 23¼ in. (48.9 x 59.1 cm). The Art Institute of Chicago, Alfred Stieglitz Collection

14 | *Self-Portrait*, ca. 1908. Charcoal on paper, 11⅞ x 8⅞ in. (30.2 x 22.5 cm). The Frederick R. Weisman Art Museum at the University of Minnesota, Minneapolis, Bequest of Hudson D. Walker from the Ione and Hudson D. Walker Collection

15 | *Self-Portrait as a Draftsman*, 1908. Lithographic crayon on paper, 12 x 9 in. (30.5 x 22.9 cm). Allen Memorial Art Museum, Oberlin, Gift of the Oberlin Class of 1945

16 | *Old Man in a Rocking Chair*, 1908. Graphite on paper mounted on paperboard, 12 x 9 in. (30.5 x 22.9 cm). The Frederick R. Weisman Art Museum at the University of Minnesota, Minneapolis, Bequest of Hudson D. Walker from the Ione and Hudson D. Walker Collection

17 | *Old Maid Crocheting*, 1908. Graphite on paper, 12 x 9 in. (30.5 x 22.9 cm). Colby College Museum of Art, Waterville, Museum Purchase from the Mellon Art Purchase Fund and the A. A. D'Amico Art Collection Fund

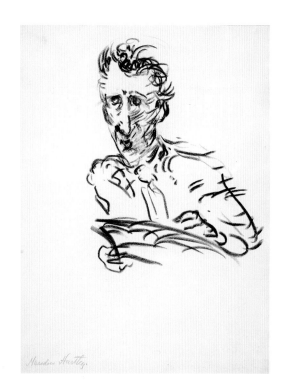

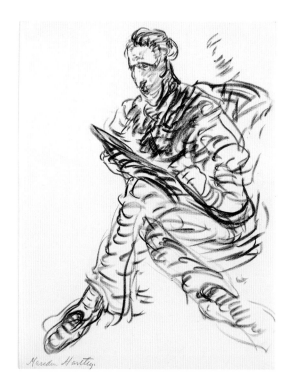

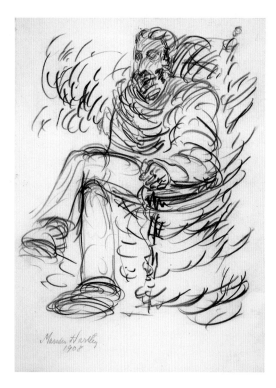

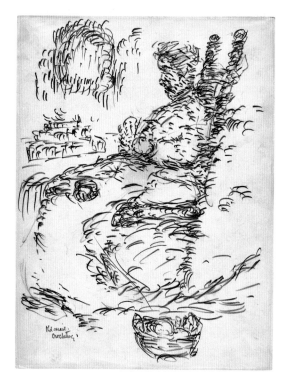

18 | *Chopping Wood*, 1908. Graphite on paper, 12 x 9 in. (30.5 x 22.9 cm). Bates College Museum of Art, Lewiston, Marsden Hartley Memorial Collection, Gift of Chris Huntington and Charlotte McGill

that collection, but the United States as "a teeming nation of nations" that constituted "essentially the greatest poem."[19] Hartley, by contrast, immersed himself in one site that symbolized rural New England, rooting his artistic ambition in a region that offered an idealized alternative to his urban existence.[20]

Long walks generated later memories of Lovell's Kezar Lake and the nearby mountains that would be realized in Hartley's repertoire of landscape subjects. The artist interacted with the local residents — farmers, innkeepers, "old maids," loggers, trappers — some of whom were the subjects of his early figure drawings from 1908, done at the same time and in the same kinetic style as his first self-portraits (figs. 14–18). This association with people so seemingly removed from modern life complemented his stay in a seasonal community taken with the homespun aesthetic of the Arts and Crafts movement. Hewnoaks, the newly rusticated home of the artist Douglas Volk and his wife, Marion Larrabee Volk, served as the local headquarters of resurrected handicrafts, especially weaving and wood carving.[21]

During his second summer in Lovell, Hartley lived in a building at the entrance to the Hewnoaks compound, a choice that suggests a desire to connect with Douglas Volk, whom he mentions in a letter in 1901.[22] Hartley would have been familiar with Volk's paintings, in which romanticized figures — typically a boy or young woman — pose against wooded backgrounds. *The Young Pioneer*, a full-length portrait of the Volks' son Gerome wearing a rustic costume and holding a canoe paddle (fig. 19), won first prize at the 1899 Colonial Exhibition in Boston. The critic Charles Caffin described Volk as a practitioner of "exalted symbolism," a phrase that could equally apply to Hartley's rapturous mountainscapes of 1908 and 1909.[23]

But it was Marion Volk and the local women she enlisted to weave rugs who arguably had a greater impact on Hartley. The Volks were

shining so perfectly bright," he wrote to his friend Marguerite Karfiol in 1904, "and the mountains stand out in somber grayness."[14] Hartley waited until 1909, when he was living in New York, to paint his recollection of these nocturnal encounters (fig. 13). "It took me four years to develop a sense of how to go about painting those hills," he later wrote in his autobiography, "Somehow a Past."[15]

Hartley's process was one of looking, rumination, and distillation: "I have done nothing much since arriving here but rest and gather myself."[16] For what purpose did he pause and regroup? To "gather up," as he observed, "the ravellings, ready to start upon the weaving of the true and strong fibre by which we live."[17] By 1904, Hartley was writing poems and reading Whitman's poetry. His conflation of internal and external gathering suggests an individual sensitized to the exchange between self and other that runs through *Leaves of Grass*.[18] Whitman's subject was "not merely a nation," as the poet wrote in the 1855 preface to

uncompromising in their search for and attention to authenticity. "No pretence is made of making the rug more than a result of local possibilities," remarked the anonymous contributor to a hand-printed booklet published at Hewnoaks, "but within these limits care and sincerity are the key notes of the whole thing."[24] Yet this expression of localness was capacious. As a participant in the "Indian craze" that swept across the United States in the early 1900s, Marion Volk appropriated patterns she found in Native American art to design her rugs and made a point of distinguishing her weaving process from that of the hooked rugs of New England (fig. 20).[25] She was "a twentieth century weaver at an eighteenth century loom," to borrow a phrase that appeared in a magazine feature on Hewnoaks, and her aesthetic choices were in step with the interest in primitivism then emerging in Europe.[26]

The Native American imagery that appeared a few years later in Hartley's German abstractions demonstrates that Hartley, too, sought to identify with an exoticized other.[27] His Maine drawings were in keeping with this mission, and he used them as overtures of sorts during his first trip to Europe. "I am very glad you like the drawings of the American farmer," he wrote to the German Expressionist painter Franz Marc. "He was a very interesting fellow — charming nature — kind, gentle — and always thinking deeply upon all sorts of subjects."[28] Late in life Hartley wrote a similarly admiring remembrance of Wesley Adams, a Maine trapper who "owned nothing at all but his dirty cabin and his own thinking bones" and was "essentially poetical as so many rough types are."[29] Maine "folk," their labor, and their countryside served for Hartley as an originating source, to be envisioned and reinvisioned in his work for years to come.[30]

Hartley mentions Hewnoaks in his autobiography, noting that Marion Volk wove "applied Indian designs" and the Volk family was "all for the restoration of the New England folk arts." But "nothing much," he concluded, "came of this."[31] Indeed, by the 1930s, Hewnoaks had faded into obscurity; the colony's rug-making enterprise had been abandoned years earlier. The brief life of Marion Volk's venture and the commonly held bias toward the superiority of the fine over the applied arts may account for Hartley's failure to acknowledge the importance of Lovell's vibrant folk art to his early

work. This failure contrasts markedly with his declared allegiance to the writers Emerson and Whitman, and to the artists Giovanni Segantini and Albert Pinkham Ryder. But there is more to the picture. Hartley came to understand his artistic mission as in opposition to that of such figures as Douglas Volk, whose romanticizing paintings may have exemplified the "simpering sentiment" that, "no matter how genuine," he sought to avoid.[32]

The figures with whom Hartley publicly identified served as both foils and surrogates, while the full range of his connections constituted a richer and more complex reality. The investigation of this reality sheds light on the transition in America from Impressionism to the regionally inflected modernism that would distinguish the artists associated with Alfred Stieglitz and his circle. In the first decade of his practice, Hartley's identification

21 | *Robin Hood Cove, Georgetown, Maine,* 1938. Oil on commercially prepared paperboard (academy board), 21¾ x 25⅞ in. (55.2 x 65.7 cm). Whitney Museum of American Art, New York, 50th Anniversary Gift of Ione Walker in memory of her husband, Hudson D. Walker

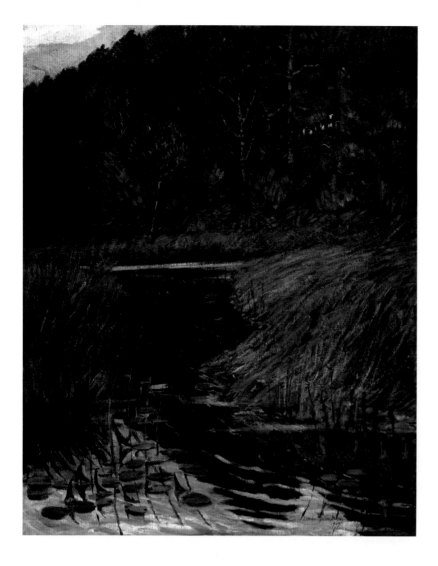

and delivered a lecture, presumably on the "space art" of painting outlined in his influential book *Composition* (1899). The mix of Transcendentalism, art, and world religions that Hartley found at this retreat on the Piscataqua River may have informed the expressive direction of his practice, but Boston was where he established the connections that would eventually lead him back to New York. In 1906, while maintaining a studio in Lewiston, Hartley painted Maine's Speckled Mountain from his memory of it in an oncoming storm. This is likely the work that he refers to in a letter as "the most professional picture I have yet accomplished," adding that he was "talking [through it] to the world . . . not to Lewiston."[34] Yet it was in Lewiston that Hartley first established the personal communion with nature that he later expressed through his identification with rural Maine.

When he reflected on his early life, Hartley frequently mentioned Lewiston's Franklin Pasture, his favorite childhood haunt, noting its topography — wooded, hilly, and with a stream.[35] Throughout his career he would explore various combinations of these elements, often with the water motif (be it a brook, lake, or waterfall) in the foreground (fig. 21; and see fig. 90).[36] *Shady Brook* (fig. 22), one of the artist's earliest works, painted in 1907, exemplifies this configuration. Already by this date Hartley was interested in a compositional scheme in which a monumental form — here, the suggestion of a hill or wooded rise — replaces the horizon line, reducing the sense of depth, flattening imagery to the picture plane, and emphasizing the overall constructedness of the painted scene. The focused tenor of this arrangement suggests an evolution of the sustained looking skills that the artist honed through his exploration of botany and entomology. Moreover, among other sources, including scenic postcards, the composition recalls the pitched perspective common to the Pictorialist photography prevalent at that moment, especially the landscape and farming subjects of Rudolf Eickemeyer, whose

with Lovell and its people mingled with the insights he gained in other places — most notably Boston and New York — and from the world of printed matter. What he deemed of value he applied to "the problems of painting," as he came to succinctly describe his charge.[33]

Exporting "The Great Intangible"

Hartley lived away from Lovell between late 1904 and the spring of 1908, taking occasional jobs, including a stint maintaining tents at Green Acre, a spiritualist center in Eliot, Maine, in the summer of 1907. Arthur Wesley Dow visited that season

nostalgia-saturated book *The Old Farm* appeared in 1901 (fig. 23).

Hartley gave *Shady Brook* to the Lewiston Public Library, which opened in 1903 in an impressive granite building paid for by Andrew Carnegie (see page 19, top). The artist's 1906 studio was around the corner, and his gift honored its establishment and, by extension, its predecessor, the modest reading room that had been his refuge a few years before. His gesture also suggests a stealth emulation of Pierre Puvis de Chavannes, whose program of murals at the Boston Public Library he copied sometime after its completion in 1896.[37] Three of Puvis's panels address the subject of poetry, and one of them, *Pastoral Poetry* (fig. 24), includes a landscape with a watery foreground akin to that in *Shady Brook*. If Hartley intended the comparison, he would have understood his painting to be starkly divergent from Puvis's in its palpable lack of human presence. The Maine landscape that he called up from memory, ancient and depopulated, creates an unlikely alliance between the waning years of Impressionism and rural New England's fading glory.

In Boston, where Hartley relocated in the fall of 1907, he sought out the artist and fellow Maine native Charles Hovey Pepper, as well as Philip Hale and Charles and Maurice Prendergast, artists associated with progressive tendencies in art. Through Desmond Fitzgerald, a collector of French Impressionism who had seen one of Hartley's paintings in Boston at the Rowland Gallery, he was introduced to Dodge MacKnight, a painter of brilliantly colored landscapes and winter scenes of Cape Cod, Massachusetts. Fitzgerald bought one of Hartley's winterscapes, which the artist described in a letter to Horace Traubel as a "Maine blizzard."[38] The sale is mentioned several times in Hartley's correspondence and, much later, in his autobiography. The prominent Bostonian, Hartley

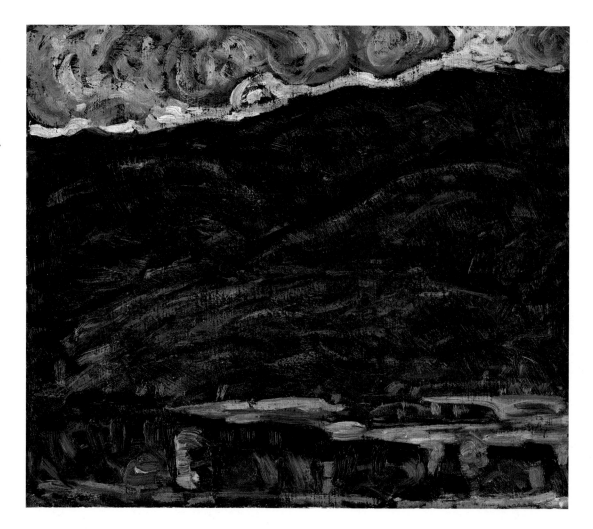

remarked to Traubel, owned "the finest collection of modern pictures in New England." Fitzgerald saw in Hartley's work "a new note in art." He also encouraged the artist to "get away to the mountains and paint freely."[39]

So advised, and with his path newly legitimized, Hartley settled in North Stoneham, within walking distance from North Lovell, in May of 1908 for what would be his longest stay in the region. By December he could triumphantly claim a studio "strewn with mountains in autumn glow — mountains in blizzard etc. etc."[40] Living in western Maine heightened the physical presence of Hartley's evocations, from the distinctive patterning of the mountains by passing clouds to the recognizable shape of Kezar Lake's Birch Island visible in *Autumn Color* (fig. 25) and *Carnival of Autumn* (see fig. 74).

By February or March 1909 Hartley was back in Boston, where he enlisted Maurice Prendergast to write a letter introducing him to William Glackens. In a draft of this correspondence, Prendergast described the young painter as having the gift of transporting nature. "This gentleman Mr. Hartley," he observed, had brought a "piece of the mountains back with him."[41] Viewers of the early landscapes perceived Hartley both as a conduit and an interpreter; he himself described his paintings, using the language of transcendence, as "little visions of the great intangible."[42] The intent gaze of

27 | *Landscape No. 25*, ca. 1908–9. Oil on commercially prepared paperboard (academy board), 12 x 12 in. (30.5 x 30.5 cm). The Metropolitan Museum of Art, Alfred Stieglitz Collection, 1949

28 | *The Silence of High Noon—Midsummer*, ca. 1907–8. Oil on canvas, 30½ x 30½ in. (77.5 x 77.5 cm). Collection of Jan T. and Marica Vilcek, Promised Gift to the Vilcek Foundation

the amateur botanist had been replaced by that of an artist-seer in pursuit of the hidden order of nature. *Winter Chaos, Blizzard* (fig. 26), a work of unbridled dynamism, returns to the subject of the painting that Hartley had sold to Fitzgerald.

The subdued mood that distinguishes *Shady Brook* became, in 1908 and later, one among many in a wide chromatic spectrum. Although not systematically applied, the addition of numbers to titles, as in *Landscape No. 25* (fig. 27), underscored

the serial nature of his practice, linking the works while ensuring their distinction from one another. In *The Silence of High Noon — Midsummer* (fig. 28) non-naturalistic color — found, for instance, in the touches of red paint that outline the clouds — co-exists with the comparatively illusionistic rendering of the dramatic shadows cast on the mountain at midday, animating the whole into a united, pulsing vision of a landscape at the height of summer. The seasons of summer, fall, and winter would

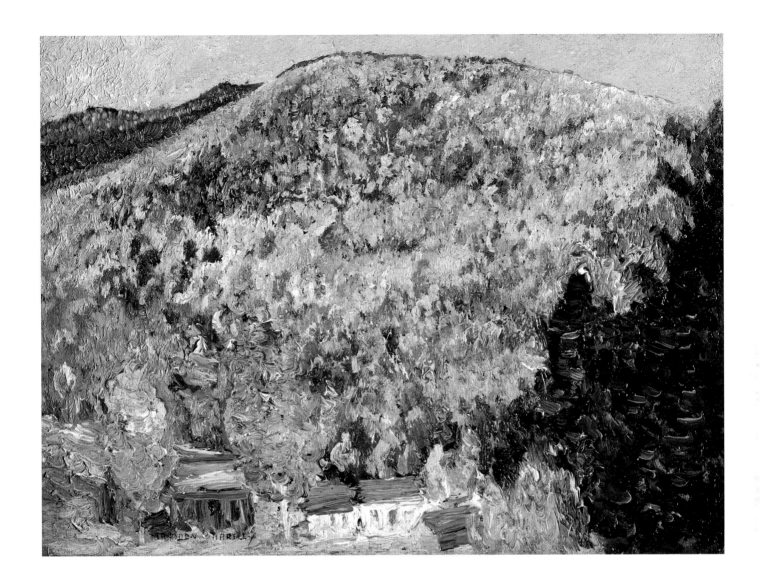

become Hartley's abiding subjects, as did evening (figs. 29, 30). Hartley's Maine was either at the peak of its powers or in glorious decline.

The grouping of seasonal themes into "songs" signaled their association with Whitman's "Song of Myself." Another painting from this period, *Proud Music of the Storm*, also derives from Whitman.[43] This coding of self in terms of nature (and Whitman) reverberates in the paint facture. Shades of blue tinged with pink predominate in the Songs of Winter series, and the subtle variation of loosely applied paint denotes both subject matter and the

suggestion of distance or proximity. In number six from this series, for example (fig. 31), the rounded mountain is constructed of diagonal brushstrokes, while the band of evergreens and the strip of snow filling the shallow foreground are a flurry of vertical and horizontal strokes.

Blue shadows cast by the clouds similarly suggest oncoming winter in *Hall of the Mountain King* (fig. 32), while the profusion of reds and oranges in the lower register of this majestic painting denotes an autumnal scene. Like Hartley's Songs, this painting evokes music, taking its title

29 | *Summer*, 1908. Oil on academy board, 9 x 11⅞ in. (22.9 x 30.2 cm). The Frederick R. Weisman Art Museum at the University of Minnesota, Minneapolis, Bequest of Hudson D. Walker from the Ione and Hudson D. Walker Collection

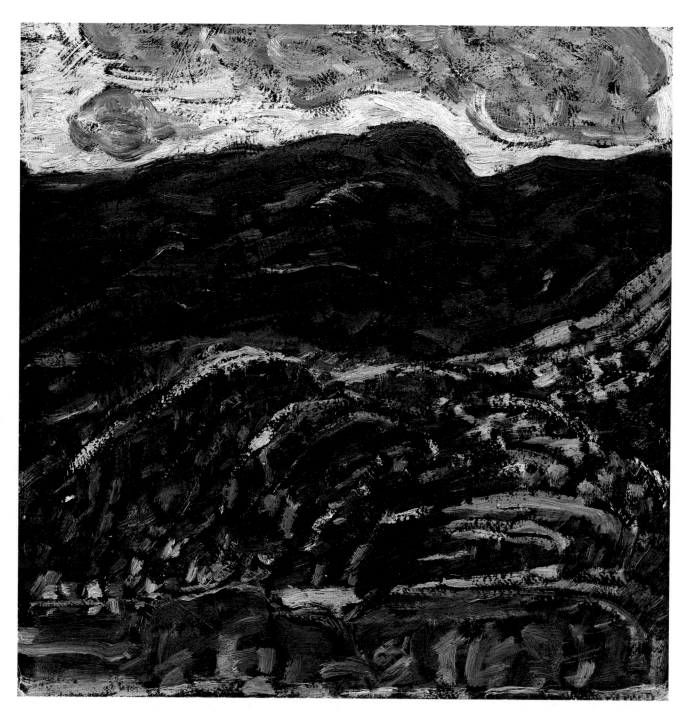

30 | *Kezar Lake, Autumn
Evening*, ca. 1910. Oil on
commercially prepared
paperboard (academy board),
12 x 12 in. (30.5 x 30.5 cm).
Harvard Art Museums,
Fogg Museum, Cambridge,
Bequest of Lee Simonson

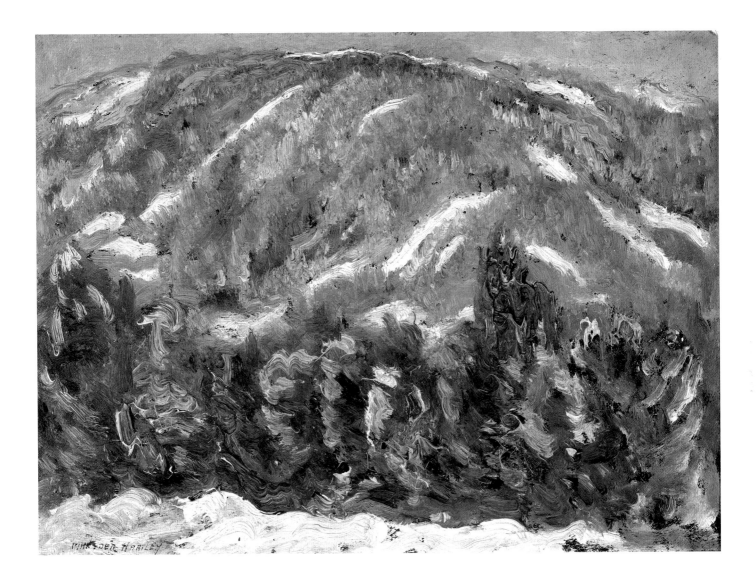

from Edvard Grieg's "In the Hall of the Mountain King," an orchestral piece composed for Henrik Ibsen's 1876 play *Peer Gynt*. In a letter to Traubel, Hartley noted that an acquaintance had compared his paintings to the music of Grieg. It was "something to live up to," he added, and may have prompted his consideration of the Norwegian composer's work as a theme.[44] Such connections appealed to the autodidact. Indeed, a few years later he remarked to Stieglitz that the "mere title" of Kandinsky's book *Concerning the Spiritual in Art* (1912) "opened up the sensation for me — and

from this I proceeded."[45] Similarly, the Fauvist turn of Hartley's work around 1909, and most forcefully in 1910, in such works as *Untitled (Maine Landscape)* (fig. 33), brought about his emergence as a self-declared "imaginative colorist," responding to paintings he had seen or heard about by Henri Matisse and by such Americans as Dodge MacKnight and Alfred Maurer.[46]

Through his channeling of an "old" Maine landscape and its association with music and selfhood, Hartley brought new life to a vanguard movement suffering from its own success. "Impressionism

31 | *Song of Winter No. 6*, ca. 1908–9. Oil on board, 8⅞ x 11⅞ in. (22.5 x 30.2 cm). Farnsworth Art Museum, Rockland, Maine

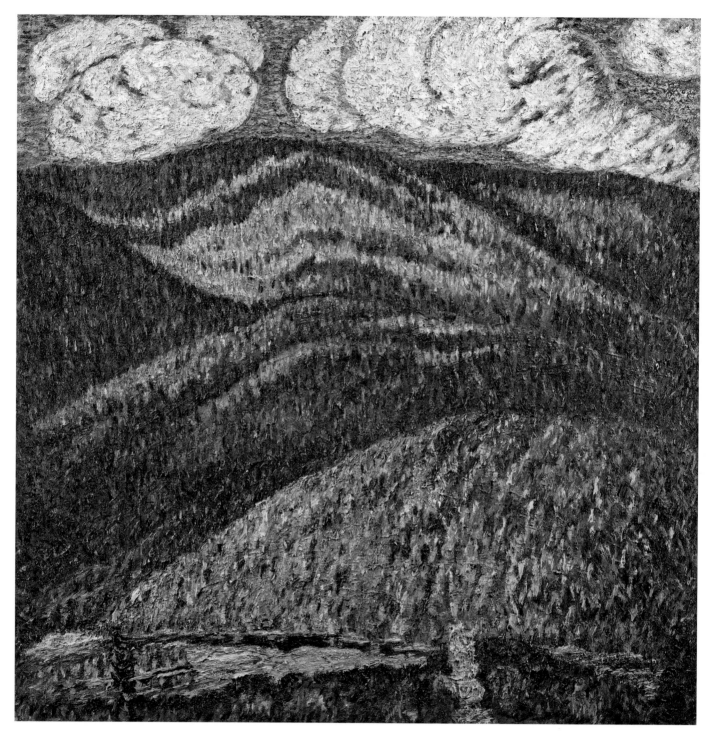

32 | *Hall of the Mountain King*, ca. 1908–9. Oil on canvas, 30 x 30 in. (76.2 x 76.2 cm). Crystal Bridges Museum of American Art, Bentonville, Arkansas

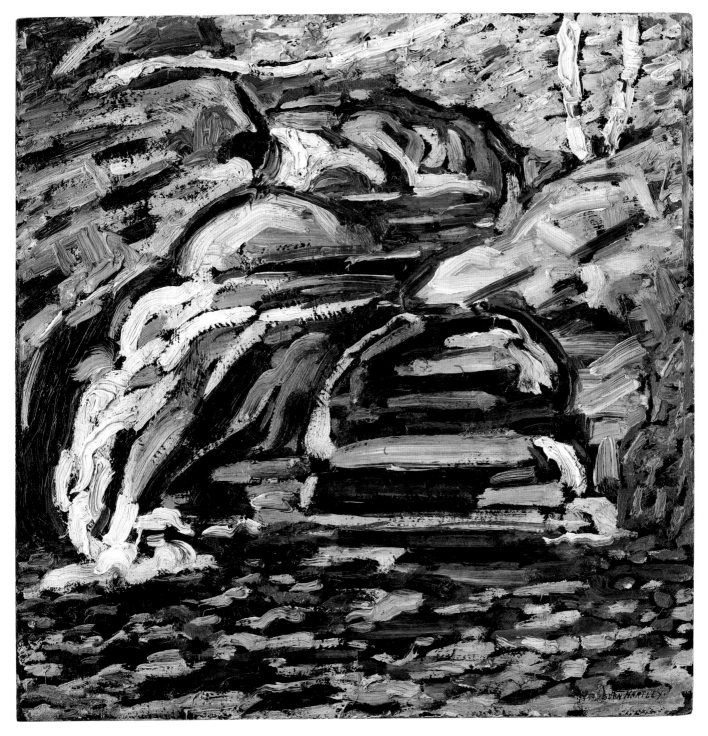

33 | *Untitled (Maine Landscape)*, 1910. Oil on board, 12⅛ x 12 in. (30.8 x 30.5 cm). Collection of Jan T. and Marica Vilcek, Promised Gift to the Vilcek Foundation

is no new thing," wrote the disenchanted critic
Charles de Kay in 1904, "and we have seen var-
ious brands in the United States."[47] Places, on
the other hand, offered proof of "sincerity," a
word that figured significantly in one of Hartley's
earliest published reflections on landscape.[48]
Hartley would likely have known of the American
Impressionist Willard Metcalf's paintings of Maine,
which garnered considerable critical attention in
the early 1900s. Indeed, he adopted the square
format that Metcalf preferred. But a comparison
with Metcalf's *The White Veil No. 1* (fig. 34), a work
contemporaneous with Hartley's early snowscapes,
exemplifies the striking difference between the
two artists' responses to the same region. Metcalf's
supporters praised his "judicious" paintings, which
conveyed "the simple sentiment and charm of the
American countryside."[49] By contrast, the quixotic
permutations of Impressionism, which Hartley
began to pursue in earnest about 1907, moved
between two extremes: full-throated exuberance
and irredeemable loss. The latter came to fruition
in the second half of 1909, although it was subtly
present in the artist's first winter blizzards and
autumn nocturnes. For Stieglitz, Hartley's art pos-
sessed "a spirit" that led him to give the unknown

artist a show, even after he had decided the season
was over.[50] Hartley's variation on the reigning
style — which by 1910 would acquire the ungainly
name Post-Impressionism — was an ideal fit for the
gallery that led the way to American modernism.

Hartley's Segantini

Hartley's first exhibition at Stieglitz's gallery, 291,
was held in May 1909. A review in *Camera Work*
by the poet and critic Sadakichi Hartmann noted
the "temperamental, self-taught manner" of the
thirty-three paintings shown, all of which, he
observed, had been created "up there in Maine
amidst the scenery of his fancy."[51] Yet it was the
presence of what the critic identified as "the
famous Segantini 'stitch'" — a reference to the
Italian painter Giovanni Segantini — that became
synonymous with Hartley's debut. Segantini took
up Divisionism in 1891 and led the Italian branch
of that movement until his death in 1899 at the age
of forty-one. Hartley learned of Segantini through
the magazine *Jugend,* which dedicated its January
1903 issue to him, illustrating several paintings
in color, including *Plowing* (fig. 35). We know this
source from Hartley's later writings, in which he
explicitly acknowledges Segantini's influence,

observing that Segantini had not only "invented a new type of impressionistic brush," but "taught me all I know about the mountain."[52] Hartley even wrote an (unpublished) account of Segantini's life. Notably, it parallels his own biography in several ways, from their humble beginnings and the early deaths of their mothers to their mutual identification with mountains.[53]

While Segantini was undoubtedly important to Hartley, his significance has been both overstated (by the artist and others) and misunderstood. It was from the vantage point of a chosen Maine landscape that Hartley recognized Segantini. Moreover, it was the idea of the painted stitch, rather than its duplication, that was of interest to the American artist. Segantini's brushstrokes, legible even in the imperfect print register of the *Jugend* illustrations, often mimic the actual texture of the thing represented, as seen, for example, in the foreground of *Plowing*, where repeated linear applications of paint evoke individual blades of grass with uncanny fidelity. The jagged profiles of the Alps, starkly defined by the sharp light characteristic of a high-altitude landscape, consist of swirling patterns that create hyper-realistic rock striations.

Hartley aptly described Segantini's paintings as "peculiarly 'life-like.'"[54] His illusionism is distinct from the transporting interpretation of nature that defines Hartley's early artistic production. The difference between the two artists' work is also revealed in the way they depicted themselves in nature. Several photographs of Segantini document his intrepid approach to plein air painting in the Alps. In one such image he poses before an early version of *Plowing* in the company of his wife, Bice Bugatti (fig. 36). By contrast, Hartley presents himself elegantly presiding over, but not looking at, a view of the Androscoggin River (fig. 37). The river, which he knew so intimately, thus became a backdrop not unlike the kind he stood before as a child in a photographer's studio (see page 16, left).

Hartley's stitched brushstroke, in comparison with Segantini's — seen to brilliant effect in the lush impasto of *The Silence of High Noon — Midsummer*, *Hall of the Mountain King*, and *Carnival of Autumn* (see figs. 28, 32, 74) — more resembles the dense texture of a rug. It was a connection made by Hartley himself. In a letter to his niece Norma Berger, he noted the origin in nature of patterns found in woven materials, such as tapestries and rugs, and extended this association

36 | Bice Bugatti and Giovanni Segantini with the first version of *Plowing*, 1888–89. Bündner Kunstmuseum, Chur

37 | Marsden Hartley on the banks of the Androscoggin River, Lewiston, ca. 1910. Bates College Museum of Art, Lewiston, Marsden Hartley Memorial Collection

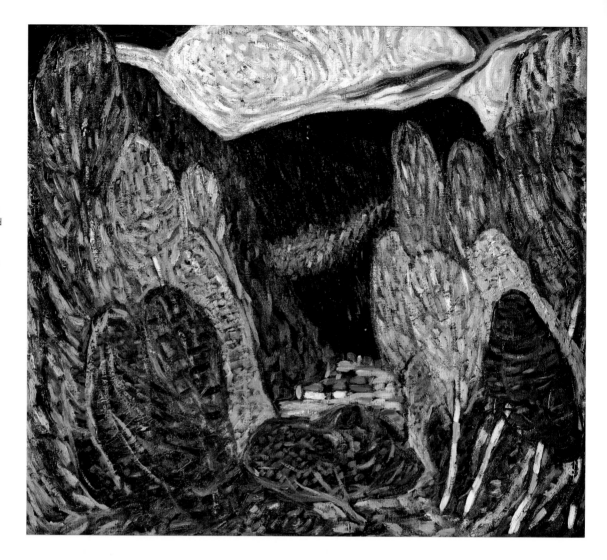

38 | *Landscape No. 36,*
1908–9. Oil on canvas,
30⅛ x 34 in. (76.5 x
86.4 cm) The Frederick R.
Weisman Art Museum
at the University of
Minnesota, Minneapolis,
Bequest of Hudson D.
Walker from the Ione
and Hudson D. Walker
Collection

39 | *The Dark Mountain
No. 1,* 1909. Oil on commer-
cially prepared paperboard
(academy board), 14 x
12⅛ in. (35.6 x 30.8 cm).
The Metropolitan Museum
of Art, Alfred Stieglitz
Collection, 1949

to paintings. "One sees the sources of nature," he observed, "[in] these created things as well as in pictures."[55] In other letters to his niece, his close and lifelong confidante, he mentions lace and embroidery, enclosing fragments of these materials, just as he did leaves and flowers, in the envelopes he posted from North Lovell. "Just some little bits of lovliness [*sic*] for you dear Norma — good to look at though not of much practical service to you."[56] These deeply personal notations, as well as the artist's encounter with the rustic aesthetic of Hewnoaks and his own desire to "gather up the

ravellings," signal a defining affinity with the handmade and the rough-hewn.

Once implemented, Hartley's stitched brushstroke quickly loosened and grew in expressivity. The primitive, even child-like, quality of the strokes is seen in a work such as *Landscape No. 36* (fig. 38), a painting closely allied in intention with the overt awkwardness of *The Dark Mountain No. 1* (fig. 39), with its mix of layered colors, thinly applied. The repetition of the stitched brushstroke, paired with the mountain motifs that Hartley returned to in series, generated new pathways to

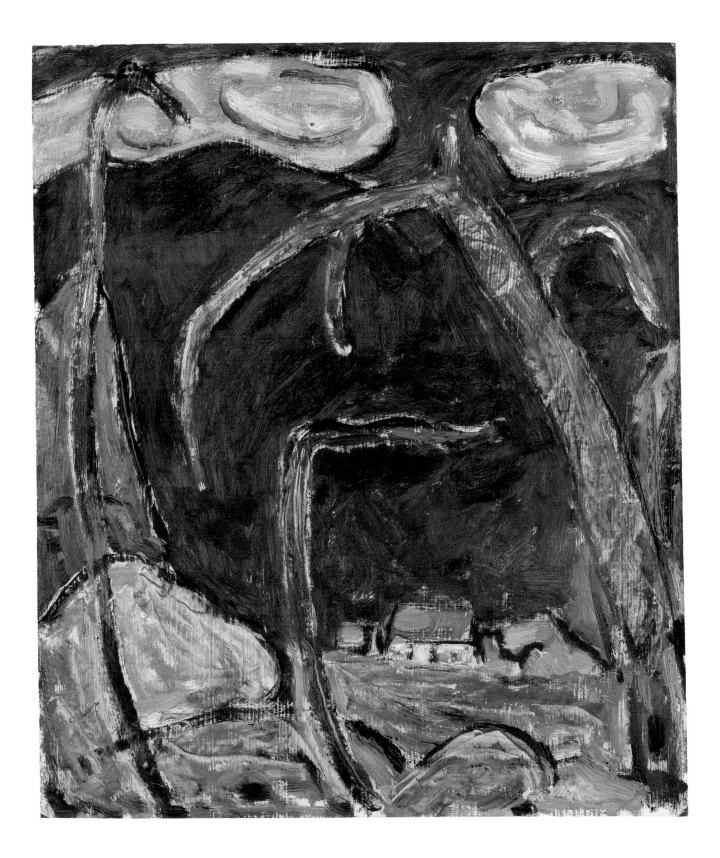

40 | *Maine Woods*, 1908.
Oil on canvas, 29½ x
29½ in. (74.9 x 74.9 cm).
National Gallery of Art,
Washington, D.C., Gift of
Bernard Brookman

FACING PAGE
41 | *Maine Landscape*,
1908. Oil on commercially
prepared paperboard
(academy board), 12¼ x
12⅜ in. (31.1 x 31.4 cm).
Colby College Museum of
Art, Waterville, Gift of the
Alex Katz Foundation

42 | *Sawing Wood*, ca. 1908.
Graphite on paper, 12⅛ x
9 in. (30.8 x 22.9 cm).
Whitney Museum of Ameri-
can Art, New York, Gift of
Mr. and Mrs. Walter Fillin

43 | *Woodcutters*, 1908.
Graphite on paper, 12 x
9 in. (30.5 x 22.9 cm). Bates
College Museum of Art,
Lewiston, Marsden Hartley
Memorial Collection, Gift
of Chris Huntington and
Charlotte McGill

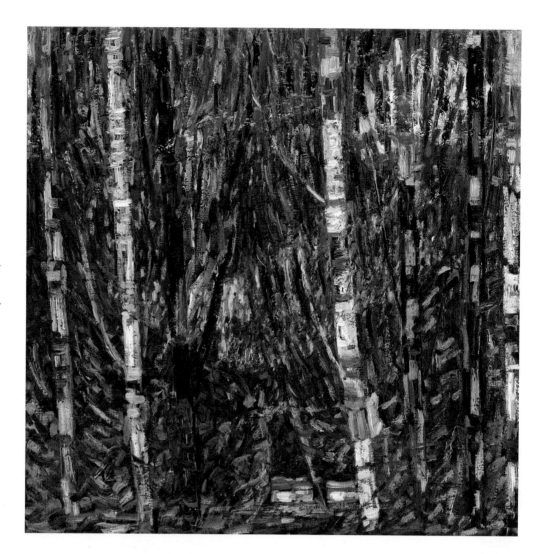

abstraction. In *Maine Woods* (fig. 40), allover
patterning, acute cropping, and an emphasis on
aligned marks result in a flame-like screen befitting
the autumnal subject. In a closely related work,
Maine Landscape (fig. 41), the established composi-
tional scheme — trees flanking a mountain — is
taken to an experimental, abstracted extreme.
Figure drawings made about the same time, such
as *Sawing Wood* and *Woodcutters* (figs. 42, 43),
similarly take up the stitched mark to suggest form
as magnetic synergy.

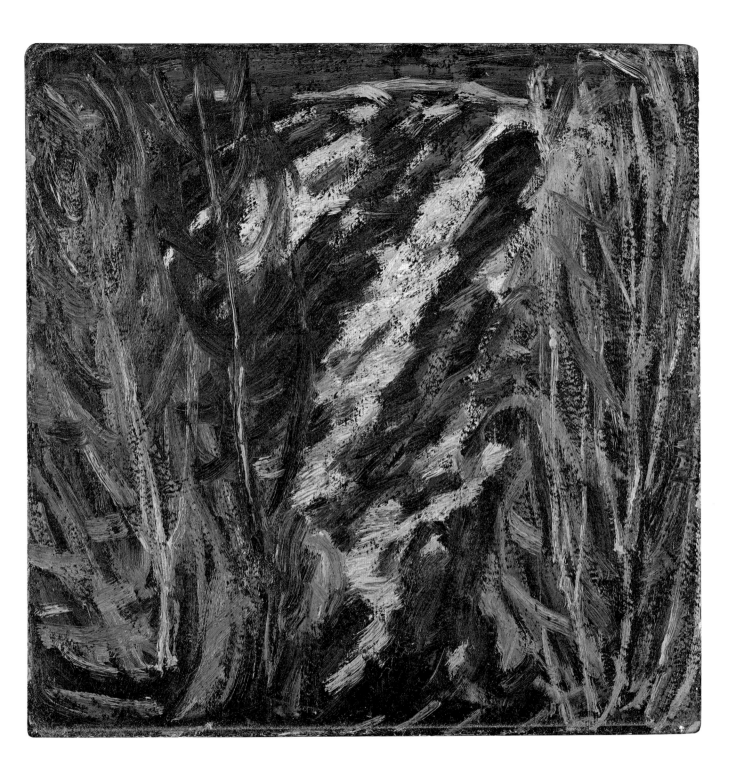

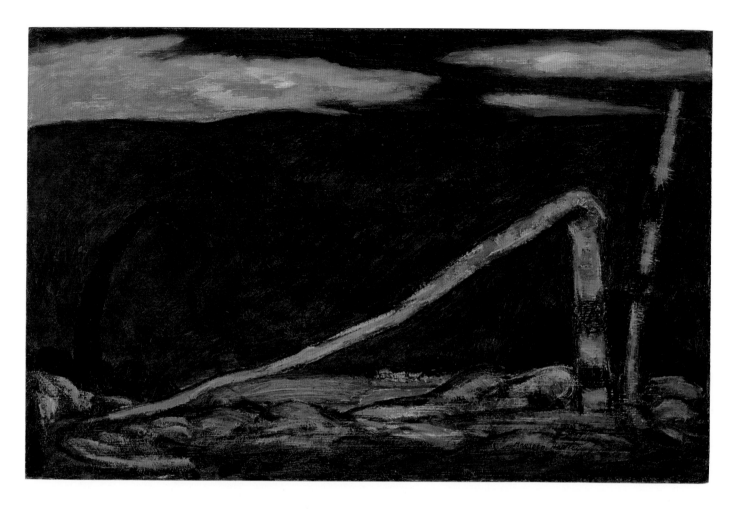

44 | *Desertion*, 1910. Oil on commercially prepared paperboard (academy board), 14¼ x 22⅛ in. (36.2 x 56.2 cm). Colby College Museum of Art, Waterville, Gift of the Alex Katz Foundation

Sourcing "The Field of Imagination"

In the fall of 1910, Hartley sent a photo postcard of Lovell to his niece, noting in the margin that the site was "a mile from my little home." As if working from a memory of his paintings of looming mountains, he added, "I live very near the big mountain in the distance — it is not as far away as it looks here."[57] By the first decade of the twentieth century, Lovell was an emerging tourist destination prized, in large part, for its remoteness. Like other travelers, Hartley took the train to Fryeburg and caught, as he later recalled with bemusement, "a real Buffalo Bill coach and four . . . everything went by this one stage, one trip a day."[58]

This aspect of Lovell's allure was comparable to that of the nearby White Mountains, where inaccessibility and the fortifying perils experienced by early settlers remained part of that region's abiding mythos well after the railroad reached Crawford Notch in 1875. Hartley may have known of Thomas Cole's 1839 painting of that site (National Gallery of Art, Washington), in which a man on horseback approaches what is presumably his home and waiting family, while a stagecoach heads toward the notch in the distance. The house depicted had belonged to Samuel Willey, whose tragic fate had been a source of fascination since 1826, when the entire Willey family perished while fleeing a landslide that left their home untouched. Similar, if less foreboding, representations of houses in the shadow of mountains appeared frequently in popular sources, including Thomas

Sedgwick Steele's *Canoe and Camera: A Two Hundred Mile Tour through the Maine Forests* (1880), which featured an illustration of Hunt's Farm, where both Henry David Thoreau and Frederic Edwin Church had been sheltered en route to Katahdin.

The symbolic evocation of shelter embodied by such structures in remote locations echoed the actual presence of abandoned homesteads and farms at the turn of the century. This was especially true in areas such as Lovell, where lack of access to rail transport forced farms to consolidate or to fail. Indeed, deserted farms were as common as the broken trunks of birch trees, which are more vulnerable to the region's fierce winter storms than its ubiquitous white pines. Modest dwellings — farmhouses and cabins (or "camps") — can be found in a few of Hartley's paintings prior to his first exhibition at 291 (see fig. 29), but they begin to proliferate (often in compositions that feature broken trees; fig. 44) after he encountered the work of Albert Pinkham Ryder in May or June 1909.

The New England painter had an ardent following among Hartley's New York colleagues. Coincidentally, one of Ryder's acolytes, Kenneth Hayes Miller, was a friend of Hartley's from art school. Hartley's introduction to Ryder came through the art dealer N. E. Montross in 1909, and Ryder's name appears in Sadakichi Hartmann's review of Hartley's first exhibition at 291. Both artists were working from the imagination, which Ryder famously observed was "better than nature."[59] Hartley, we can assume, would have readily agreed, as did a later admirer, Jackson Pollock, who claimed that Ryder was the only "American master" who interested him.[60] Hartley's late homage to Ryder in his autobiography ascribes to one of his paintings, *Moonlight Marine* (see fig. 82), the auratic power that converted him "to the field of imagination into which I was born."[61] This ingenious phrasing makes clear what he wanted

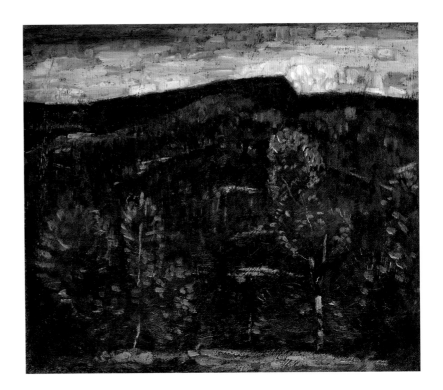

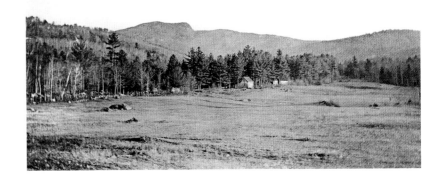

his readers to understand: that the primacy of the imagination in his work preceded his discovery of the kindred artist by many years.

Hartley's connection to Ryder strengthened his embrace of the imagination and ideas over lived experience. "These days I work almost wholly from the imagination," he wrote to his niece in 1910, "making pictures entirely from this point

45 | *Late Fall, Maine,* ca. 1908. Oil on wood, 12 x 14 in. (30.5 x 35.6 cm). Colby College Museum of Art, Waterville, Gift of the Alex Katz Foundation

46 | Field with Wesley Adams's cabin, North Stoneham, Maine. Courtesy Dan Barker

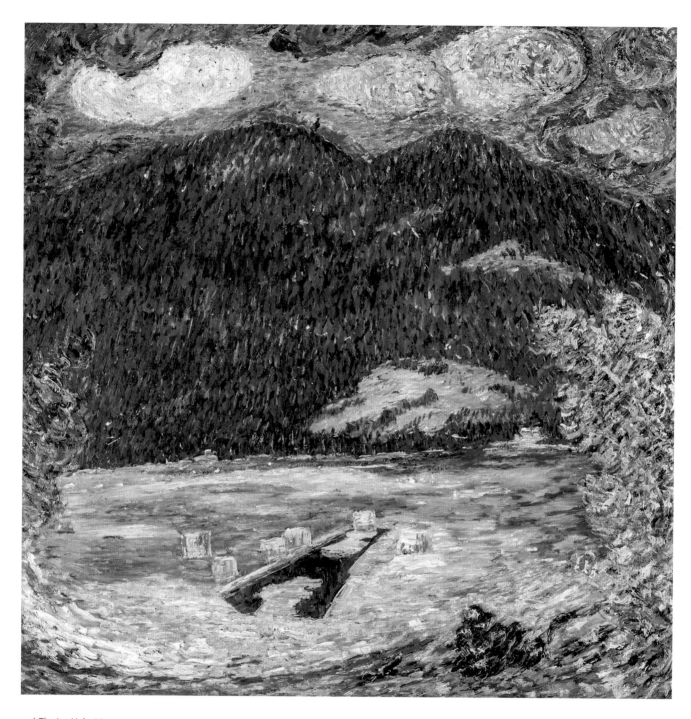

47 | *The Ice Hole, Maine,*
1908–9. Oil on canvas, 34 x
34 in. (86.4 x 86.4 cm). New
Orleans Museum of Art,
Museum Purchase through
the Ella West Freeman
Foundation Matching Fund

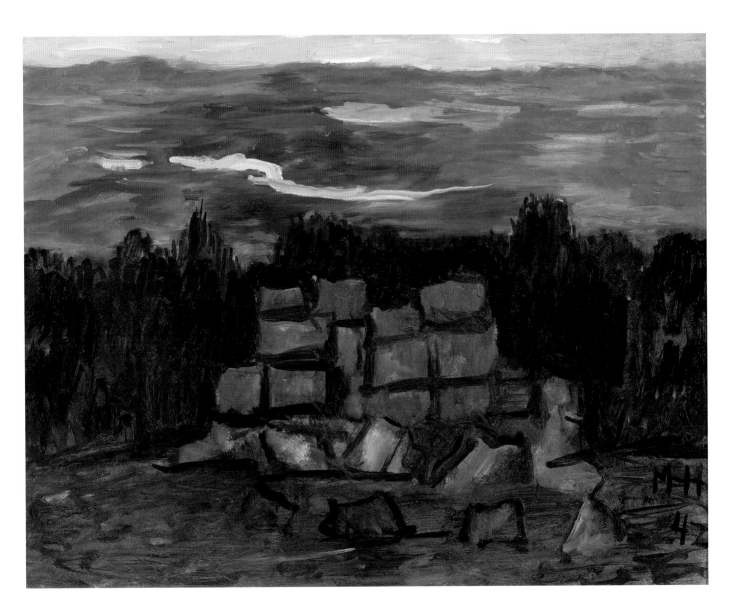

48 | *Sundown by the Ruins,*
1942. Oil on composition
board, 22 x 28 in. (55.9 x
71.1 cm). Whitney Museum
of American Art, New York,
Gift of Charles Simon

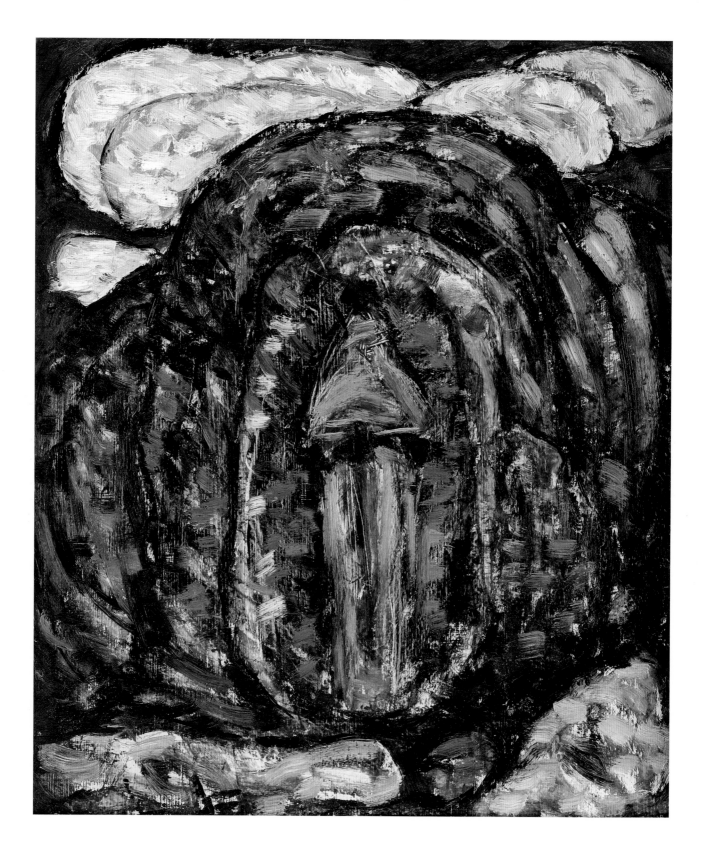

of view using the mountains only as backgrounds for ideas."[62] The artist's biographer, Townsend Ludington, believed that Hartley did not "begin to develop a style that could express what he felt" until he discovered Ryder.[63] But in fact there is a strong element of expressive continuity between Hartley's Post-Impressionist works and the Dark Landscapes series he began in the summer of 1909. See, for example, the image of Miles Notch, repeated in *Kezar Lake, Autumn Evening, Late Fall, Maine,* and *The Dark Mountain No. 2* (figs. 30, 45, 56), a recollection of the mountain that rose above the rustic house of Wesley Adams, a site that Hartley visited frequently and could remember in vivid detail years later (fig. 46).[64]

In Hartley's telling, Lovell was a locus of yearning — an ancient mountain and an empty field at twilight (see fig. 59), a site of ice-harvesting (the industry that epitomized effortful New England) (fig. 47), where the nature of Thomas Cole was recalled, depopulated, through memory. Hartley's deserted houses and farms are the inland relatives of Ryder's storm-tossed boats, the creations of an individualist who responded to the European avant-garde and to his fellow American artists from "the valleys and the mountains of his own private originations."[65] The expressive association of darkness and decay persisted in Hartley's work. A year before his death, he painted one of his strangest and most ominous paintings, *Sundown by the Ruins* (fig. 48), in which a blood-red sky radiates over a cluster of like forms — haphazardly stacked granite blocks or a pile of timeworn lobster traps.

In his autobiography Hartley recalled William Sloane Kennedy, a Transcendentalist writer who pursued "a Thorean [*sic*] life" in a rustic cabin not unlike those that appear in Hartley's early paintings, suggesting that he admired and perhaps aspired to this way of life.[66] His restlessness, however, was a formidable force, establishing a pattern of leave-taking and homecoming that continued throughout his career. Kennedy's modest house

was on the western side of Kezar Lake, facing Lovell, in the shadow of the mountains that had drawn Hartley to the area. It was a place to be remembered, imagined, and revisited from afar, and it mingled with his recollections of abandoned farmsteads, symbols of collective loss that he incorporated into his landscapes. As an artist as well, Hartley lived as an observer, always at a conscious remove, connecting at a distance. In *Landscape No. 20* (fig. 49), dating from his "original" return to Maine, the hybrid form — part figure, part mountain — that rises up at the center of the composition prompted the art historian Elizabeth McCausland to add the subtitle *Resurrection*.[67] But rather than resurrection, it seems more to

49 | *Landscape No. 20 (Resurrection),* 1909. Oil on academy board, 14 x 12 in. (35.6 x 30.5 cm). Collection of Maurice and Suzanne Vanderwoude, Courtesy Alexandre Gallery, New York

50 | *Albert Pinkham Ryder,* 1938. Oil on commercially prepared paperboard (academy board), 28 x 22 in. (71.1 x 55.9 cm). The Metropolitan Museum of Art, Edith and Milton Lowenthal Collection, Bequest of Edith Abrahamson Lowenthal, 1991

express a kind of latency, feeling suppressed, emotion checked.

Hartley's allegiance to Segantini and Ryder deepened with the years, particularly as he pondered his legacy. A profound humanity pervades his late portrait of Ryder (fig. 50). A memory painting, it is drawn from Hartley's sighting of the artist on a night, several decades earlier, when they were both out on solitary walks.[68] All three painters — Ryder, Segantini, and Hartley — made still lifes of dead birds (figs. 51–53). Hartley's regal *Black Duck No. 2*, in particular, suggests an elegiac self-portrait, underscored by the beaky profile. Hartley knew of Ryder's *Dead Bird* and possibly made the connection between his own late still lifes and the stark simplicity of Segantini's *White Goose*.[69] But of this association with his chosen kin we can't be certain. He was, to the end, a Maine-made painter, an American individualist.

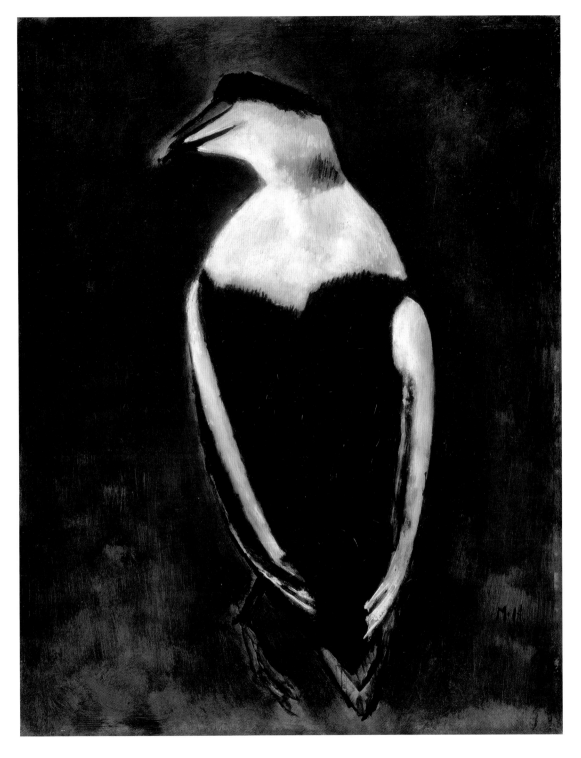

53 | *Black Duck No. 2,* 1940–41. Oil on masonite, 28¼ x 22 in. (71.8 x 55.9 cm). Museum of Fine Arts, Boston, The Hayden Collection, Charles Henry Hayden Fund

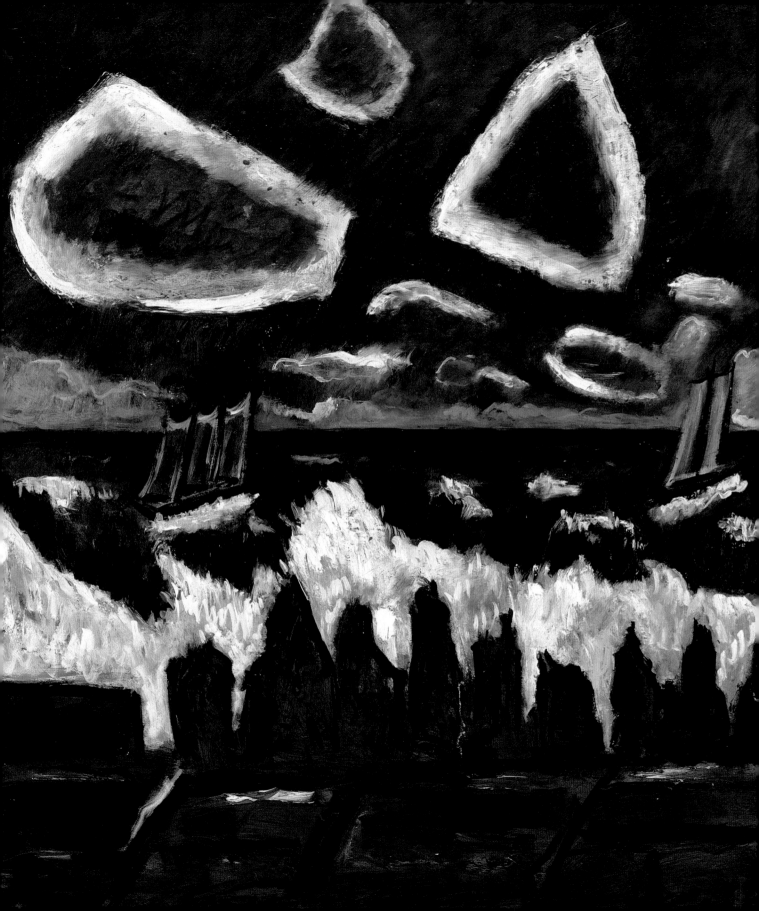

THE LOCAL AS COSMOPOLITAN
Marsden Hartley's Transnational Maine

Donna M. Cassidy

*If there are no pictures of Maine in this present exhibition, it is due entirely to forward circumstance and never in any sense to lack of interest, my own education having begun in my native hills, going with me — these hills wherever I went, looking never more wonderful than they did to me in Paris, Berlin, or Provence.** — Marsden Hartley, 1937

The Maine hills not only traveled with Marsden Hartley but even made an appearance in Paris in 1924–25. Hartley had George Biddle's Paris studio all to himself for three weeks during the summer of 1924 and produced six canvases — one large still life and five landscapes — for an exhibition of American artists at the Galerie Briant-Robert.[1] The landscapes included two of Maine, both titled *Paysage* (figs. 54, 55). When in 1923 Albert Boni had raised the possibility of publishing a portfolio of Hartley's work, Hartley requested from his patron Alfred Stieglitz photographs of his earlier paintings, among which were landscapes of New Mexico and Maine.[2] These photographs inspired a series of memory paintings of two important locales in Hartley's oeuvre — the New Mexico Recollections, done in Berlin in 1923, and the Maine landscapes done in Paris the following year. Another source undoubtedly led to Hartley's turn to his native state at this time. In early 1924, when Hartley was back in New York, the critic Paul Rosenfeld published his book *Port of New York: Essays on Fourteen American Moderns*, which advanced the idea of an authentic national culture and identified the American characteristics of

the artists and writers in the Stieglitz circle. The volume includes an essay on Hartley in which Rosenfeld asserts that one day "Hartley will have to go back to Maine. For it seems that flight from Maine is in part flight from his deep feelings. . . . There is the particular landscape among which his decisive experiences were gotten. . . . It is to this soil . . . that he must return."[3] Hartley made this return in his two *Paysages*.

While the title suggests a French mise-en-scène, the place painted on the large canvases is an imaginary one that Hartley described as "rearrangements of the Maine landscapes of former years."[4] The otherwise bleak and barren nature scenes — typical of the 1909 Maine landscapes inspired by Albert Pinkham Ryder, such as *The Dark Mountain No. 2* (fig. 56) — are enlivened by swirling clouds and undulating mountain ridges outlined in heavy black. In the Weisman *Paysage* the artist's initials appear on a rock at lower right, marking Hartley's presence and signifying that he was one with the landscape here, as he had been in those early

* Marsden Hartley, "On the Subject of Nativeness — A Tribute to Maine," in *Marsden Hartley: Exhibition of Recent Paintings, 1936* (New York: An American Place, 1937): 4.

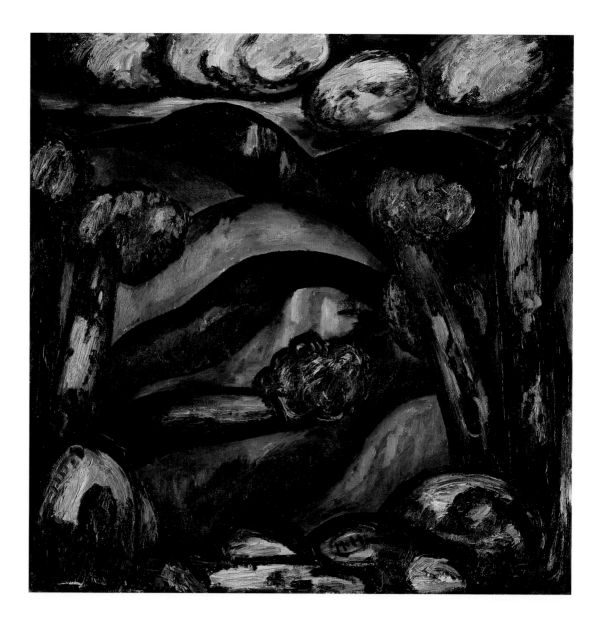

works.[5] The *Paysages* draw from the 1923 New Mexico Recollections as well, creating an imaginative geography of remembered locales.

At the 1925 Briant-Robert exhibition, Hartley's Maine appears not as an isolated provincial region but as part of a cosmopolitan art scene, as it had when the artist exhibited forty-five early Maine landscape drawings in September 1915 at the Galerie Schames in Frankfurt and in October at the Münchener Graphik-Verlag in Berlin.[6] A statement

of Hartley's Americanness, the *Paysage* paintings also embody a transnational modernism, produced, as they were, at the confluence of three locales: Maine with suggestions of New Mexico and painted in Paris. While art historians have typically regarded Hartley's rootedness and rootlessness as oppositional, the *Paysages* merge Europe and the United States, the expatriate and the American.[7]

Hartley himself identified affinities between European landscapes and those of his natal region

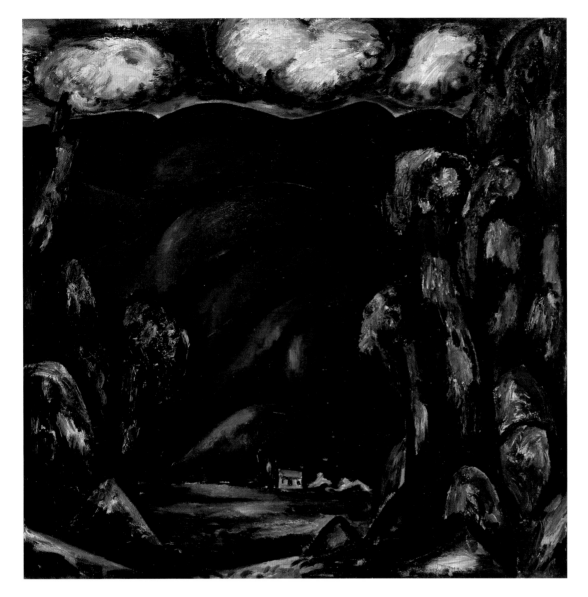

when, in 1929, from Aix-en-Provence, he wrote to his friend and fellow artist Rebecca Strand: "The curious thing about all this being over here is — that it has nothing to do with living in Europe — there are days, weeks, even months when I'm not even conscious of it — I live in spaces that are so integral to my nature as to make geography seem trivial — whole days when I see nothing or feel nothing but New England."[8] Hartley's Maine represents this trivialization of geography,

this blurring of geographic boundaries. Hartley painted Maine not only when he was in his native state but when he was in New York and when he was abroad, frequently invoking it in Provence, Germany, and Nova Scotia, particularly in response to the call — by critics and by Stieglitz himself — for Stieglitz circle artists to be rooted in America. He took these places with him back to Maine as well. What we see in Hartley's Maine is an art that despite its local, regional, or provincial subject was

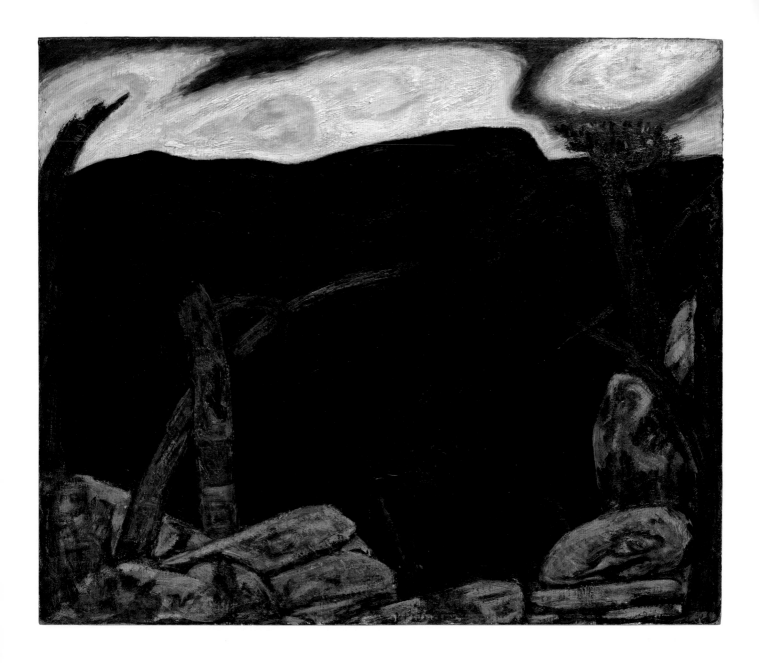

56 | *The Dark Mountain No. 2*, 1909. Oil on commercially prepared paperboard (academy board) mounted to slatted wood board, 20 x 24 in. (50.8 x 61 cm). The Metropolitan Museum of Art, Alfred Stieglitz Collection, 1949

formed by the travel routes that defined his career. The local had become cosmopolitan.

Hartley's Maine: A Global Locale

Early twentieth-century artists from Winslow Homer to John Marin imagined Maine as provincial, a place where people worked in a traditional economy — on the land and at sea — in a culture

seemingly undefiled by modernization. This vision of Maine, advanced also by the tourist industry, appealed to summer visitors in search of contact with nature and escape from urban congestion. Hartley's paintings, writings, and letters similarly present Maine as an antimodern haven, and Hartley himself often expressed his desire to leave behind what he described as the provincial

people of his native state and get back to the city. Yet Maine in fact had commerce with the wider world.

Lewiston, Hartley's birthplace and early childhood home, was the destination of thousands of immigrants who went there in the late nineteenth century to work in the textile mills. In Hartley's day Lewiston was a city of distinct ethnic and class divisions: English Hill overlooking the Androscoggin River housed English immigrant mill workers; Gaspatch, to the south, was settled by Irish workers; and farther south was Little Canada, home to the French Canadians, the largest minority in the city.[9] Through the narrator of his 1935 poem "Cleophas and His Own," Hartley writes of his longing to travel to Nova Scotia, having had a "sense of Canada all [his] life, being born in Maine."[10]

The places where Hartley lived and that he painted in Maine were not circumscribed by local culture. In the summer of 1907 he worked at Green Acre, a retreat in the town of Eliot founded by Sarah Farmer, who grew up in a family of Transcendentalists. Green Acre started out as an inn in a growing summer resort area, but by 1892 it had developed into a site for religious and philosophical study. In 1893 Farmer had visited Chicago after the closing of the Parliament of Religions at the Columbian Exposition. There she met Vivekananda, who had represented Hinduism at the Parliament, and Dharmapala, a Buddhist revivalist from Ceylon, and she invited them to speak at Green Acre. From this point on, the retreat became a center for the study of comparative religions. Known internationally, it attracted speakers from around the world.[11] Farmer envisioned a school at Green Acre that would be global in its reach. It would include Christians and Jews, as well as "representatives of the great faiths of Persia, Turkey, India, China, Japan," and Europe.[12]

Hartley painted in other cosmopolitan communities in Maine — Ogunquit in 1917, Georgetown

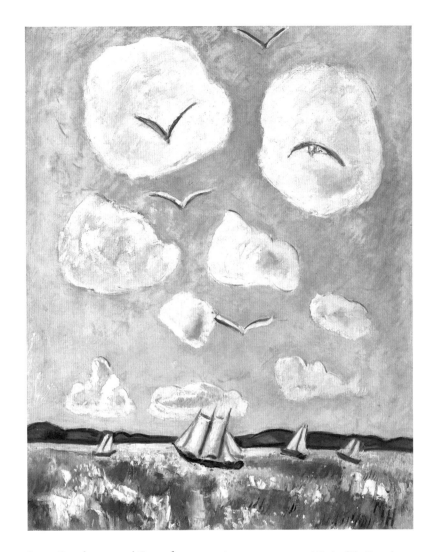

in 1928 and 1937, and Corea from 1940 to 1943. The summer residents of the Ogunquit art colony included modernists who had studied in Europe; co-founder Robert Laurent likened Ogunquit to Concarneau, Brittany. Georgetown became a magnet for New York modernists with transatlantic backgrounds such as Gaston and Isabel Lachaise and Marguerite and William Zorach, along with their guests Paul and Rebecca Strand, John Marin, Paul Rosenfeld, and Jean Toomer.[13] Even the isolated fishing village of Corea had something of an urbane dimension. Boarding with the lobster fisherman Forrest Young and his family, Hartley reported: "Mrs. Young is an ex-Austro Hungarian

57 | *Birds of the Bagaduce*, 1939. Oil on board, 28 x 22 in. (71.1 x 55.9 cm). The Butler Institute of American Art, Youngstown, Ohio

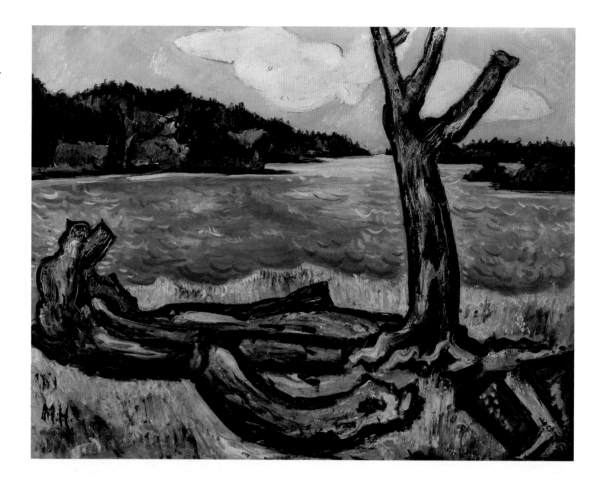

58 | *Kennebec River, West Georgetown*, 1939. Oil on board, 22 x 28 in. (55.9 x 71.1 cm). Private collection, New York

. . . we talk often of Europe."[14] He wrote about Corea's isolation and distinctiveness compared with other Maine tourist areas, but noted too its artistic vitality:

[John] Marin is just up the coast around another bay. . . . Then there is Richard Blackmur up at the next cove, you must have read his brilliant writing of a critical nature in the Hound and the Horn . . . then there is Phillip [*sic*] Horton who is a neighbor of the Blackmurs' — the boy who wrote the book about Hart Crane, and he too has an appointment this year for Harvard. . . . So this end of the coast seems to be the intellectual end.[15]

Hartley's Maine also made reference to the state's role in global commerce during the eighteenth and nineteenth centuries. Mentioned in Hartley's essay "This Country of Maine," Robert P. Tristram Coffin's *Kennebec: Cradle of Americans* (1937), a history of Maine's Kennebec River Valley,

characterized the river's importance: "It was a fishing station for many a European nation in the sixteenth century. . . . The first settlements of the English in the New World were at its mouth. The first ship built in the Western Hemisphere by Englishmen was built here."[16] *Birds of the Bagaduce* and *Kennebec River, West Georgetown* (figs. 57, 58) depict major rivers in the state — the Bagaduce, which empties into Penobscot Bay, gateway to the Atlantic, and the Kennebec, which represents Maine's early transatlantic history. Both paintings evoke the great shipbuilding and shipping trade of Maine's past — the schooners skimming along the Bagaduce and the stark, bare trees along the Kennebec as signs of the forest resources that figured in Maine's international economy. These rivers took Mainers to the ocean and to the far

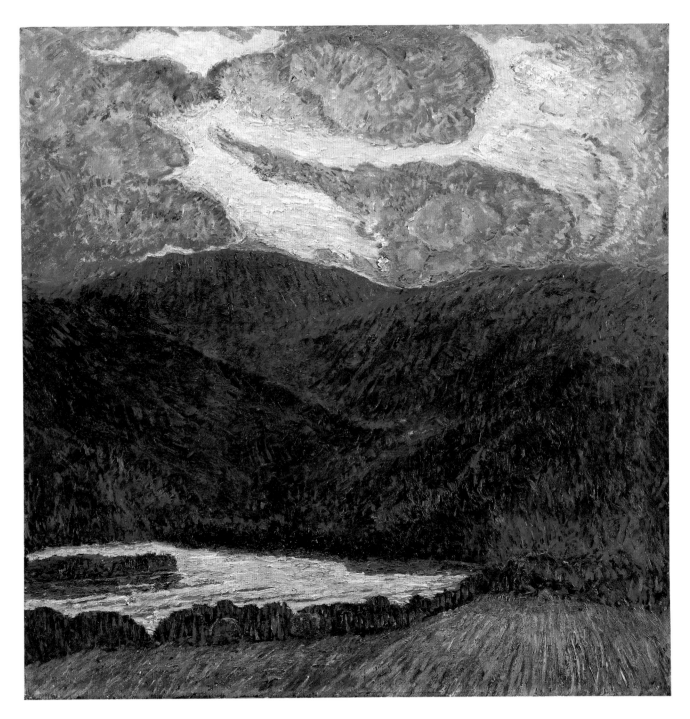

59 | *An Evening
Mountainscape*, 1909.
Oil on canvas, 30¼ x
30¼ in. (76.8 x 76.8 cm).
Myron Kunin Collection
of American Art

60 | Giovanni Segantini (1858–1899). *Death in the Alps*, 1896–99. Oil on canvas, 74⅞ x 126¾ in. (190 x 322 cm). Segantini Museum, St. Moritz, Collection of the Gottfried Keller Foundation

reaches of the globe — a journey outward to a cosmopolitan world, one that Hartley himself embarked on in the early years of his career.

Maine and International Modernism

Influenced by European modernism, Hartley regarded Maine from the start with an international eye. His 1906 Lewiston studio was decorated with Japanese prints, including one by Hiroshige,[17] and the German art journal *Jugend* introduced him to a fresh, modern approach — paintings and prints in the Japanese style but also landscapes by the Italian Divisionist Giovanni Segantini, with their bright colors, elongated and intertwined "stitch" strokes, and imaginative cloud formations. *An Evening Mountainscape* (fig. 59), a view of the western Maine mountains, is rendered with the long, thin brushstrokes and intense colors typical of Segantini, while the swirling impasto clouds recall those in Segantini's *Death in the Alps* (fig. 60), a work reproduced in color in the 1903 issue of *Jugend*, which Hartley knew.

Hartley's brushwork became thicker and denser in other 1908–9 Maine landscapes, the mountain forms crowding the foreground, as in *Carnival of Autumn* (see fig. 74). The colors intensified too, as Hartley saw more Impressionist and Post-Impressionist art in Boston — the paintings of Maurice Prendergast with their tapestry-like strokes and the collection of Desmond Fitzgerald, which included the work of Claude Monet, Camille Pissarro, Alfred Sisley, and the American Impressionists, especially that of Dodge Mac-Knight, a watercolorist known for his dazzling hues.[18] In these first mature works, Hartley viewed the Maine landscape through the lens of international modernism, rendering what he saw before him not by description but through expressive distortion. He moreover imagined the western mountains of Maine as comparable to the north — the snowscapes of Segantini and mountain colors equivalent to the music of Edvard Grieg (see pages 57, 59). He was already envisioning Maine in a transatlantic context.

International modernism shaped Hartley's Maine in other ways. In 1912 he made his way to Paris, where he moved in avant-garde circles. Becoming part of a German coterie — including the artist Arnold Rönnebeck and his cousin Karl von Freyburg — and introduced to the work of Vasily Kandinsky, leader of the Blaue Reiter group, he decided to settle in Germany, where he lived from 1913 to 1915, with occasional trips to Paris and New York. There Hartley established direct contact with the Blaue Reiter artists. In Munich in January 1913 he met Kandinsky and his artist companion Gabriele Münter, both of whom were interested in the traditional folk art of Bavaria and Bohemia, in particular, *hinterglasmalerei* (reverse painting on glass). Alexei Jawlensky, another Blaue Reiter painter, had introduced his colleagues to the glass paintings — more than a thousand — in the collection of the Murnau brewer Johann Krötz. Münter learned the technique from one of the last glass painters in the area, Heinrich Rambold, copied traditional votive scenes, and invented her own religious and landscape subjects (fig. 61). Like the Blaue Reiter artists, Hartley collected *hinter-glasmalerei*, writing to Stieglitz that he would bring back to New York six Bavarian glass paintings that he bought in Munich.[19]

In Germany, Hartley had considered taking up glass painting himself but felt that his work would be too derivative of Kandinsky.[20] He was less inhibited when he stayed at the Ogunquit art colony in the summer and early autumn of 1917. The painter, critic, and collector Hamilton Easter Field, who had founded the Summer School of Graphic Arts, offered Hartley a room by the sea, most likely one of the fishing shacks in Perkins Cove that Field and his co-founder, the sculptor Robert Laurent, had converted into studios. The Ogunquit colonists, like the Blaue Reiter painters, were interested in the lessons traditional folk art had to teach the modern artist. Field decorated the fishing shacks with inexpensive local antique furniture, decoys,

61 | Gabriele Münter (1877–1962). *Bavarian Landscape with Farmhouse*, 1910. Oil on glass, 5⅝ x 8⅜ in. (14.2 x 21.2 cm). Städtische Galerie im Lenbachhaus, Munich

62 | *Three Flowers in a Vase*, 1917. Oil and metal leaf on glass, 13⅛ x 7⅝ in. (33.3 x 19.4 cm). Private collection

63 | Artist unknown. *Unidentified Baby [Dover Baby]*, ca. 1840. Oil on canvas, 26 x 21 in. (66 x 53.3 cm). The Abby Aldrich Rockefeller Folk Art Museum, The Colonial Williamsburg Foundation

64 | *Still Life*, 1917. Oil on glass mounted on board, 16½ x 16 in. (41.9 x 40.6 cm). Private collection

65 | Artist unknown. *Still Life – Flowers and Fruit in White and Pink Bowl*, 1840–60. Oil and metal leaf on glass, 15⅞ x 20 in. (40.3 x 50.8 cm). The Metropolitan Museum of Art, Gift of Edgar William and Bernice Chrysler Garbisch, 1964

weather vanes, hooked rugs, folk portraits, and reverse glass paintings, objects that Laurent and others at Ogunquit picked up on their rambles around the immediate area and in their old Fords to more remote parts of Maine.[21]

Having studied Laurent's collection of early American reverse paintings on glass and with the memory of Bavarian *hinterglasmalerei*, Hartley decided to undertake this difficult medium, exhibiting ten glass paintings at Ogunquit.[22] He undoubtedly followed the traditional technique, drawing his design on the reverse of the glass, starting with the highlights and then painting in the broader areas, adding metal leaf and then firing the glass in a kiln to produce a mirror-like surface.[23] A continuation of the still lifes that Hartley had made in Provincetown in 1916 and in Bermuda early in 1917, *Three Flowers in a Vase* (fig. 62) presents a symmetrically placed decorative white ceramic vase holding three polychrome flowers on a flattened white table against a dark blue ground. The black outlining of the forms and infilling of intense color hint at the Blaue Reiter glass painting style at the same time that the composition draws from the two-dimensional rendering of space and forms of the folk portraits collected in the Ogunquit colony (fig. 63). This same

66 | *Summer, Sea, Window, Red Curtain*, 1942. Oil on masonite, 40⅛ x 30½ in. (101.9 x 77.5 cm). Addison Gallery of American Art, Phillips Academy, Andover, Museum Purchase

67 | *Still Life (Ear of Corn)*, 1917. Oil on glass mounted on board, 20 x 7½ in. (50.8 x 19.1 cm). Collection of Norma B. Marin

68 | *Berlin Series No. 1*, 1913. Oil on canvas board, 18 x 15 in. (45.7 x 38.1 cm). Collection of Jan T. and Marica Vilcek, Promised Gift to the Vilcek Foundation

69 | *Indian Fantasy*, 1914. Oil on canvas, 46¾ x 39⅜ in. (118.7 x 100 cm). North Carolina Museum of Art, Raleigh, Purchased with funds from the State of North Carolina

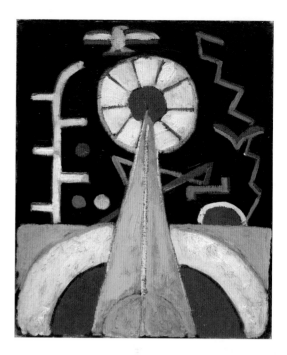

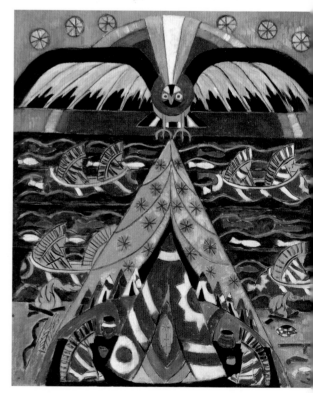

flat symmetry, stylized flower and plant forms, and simple arrangement of objects distinguish another of Hartley's glass paintings, *Still Life* (fig. 64), a work that recalls American reverse painting on glass, which typically includes fruits and flowers on a dark ground with metal leaf (fig. 65). While these paintings do not represent Maine per se, they do suggest Hartley's evocation of Maine art for visual reference and his practice of working in the manner of native artists. This imagery moreover would shape Hartley's later Maine works, the white decorated vase with flowers reappearing in *Summer, Sea, Window, Red Curtain* (fig. 66).

Hartley's Ogunquit glass paintings Americanized European sources. *Still Life (Ear of Corn)* (fig. 67) represents a native iconography. The compositional symmetry and the placement of organic and geometric shapes against a plain dark ground in this and Hartley's other glassworks recall his earlier Berlin abstractions — *Berlin Series No. 1*, for example (fig. 68). Moreover, the symmetry and corncob bring to mind the Native American art Hartley had studied at the Ethnographic Museum of the Trocadéro in Paris and the Museum für Völkerkunde in Berlin, as well as the paintings this art inspired, such as *Indian Fantasy*, which shows at center in a mandorla a Hopi symbol for corn (fig. 69).[24] Thus, Hartley's glass paintings were created at the crossroads of his artistic travels and the cultures that he encountered — American reverse painting on glass, Bavarian *hinterglasmalerei*, Native American art in France and Germany, and his own Berlin abstractions.

Modernist Geography: The Merging of Places

In his classic *Exile's Return: A Literary Odyssey of the 1920s* (1934), Malcolm Cowley argues that young American writers who came of age after World War I — most famously, F. Scott Fitzgerald and Ernest Hemingway — experienced a rootlessness, having been uprooted in spirit by school and college and then uprooted physically by the war,

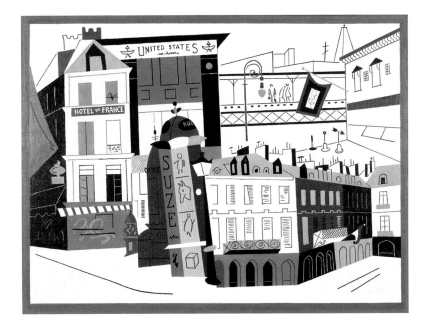

carrying them into "strange countries" and leaving them "finally in the metropolis of the uprooted."[25] These "transatlantic types," as a result, championed a theory of art which holds that "the creative artist is absolutely independent of all localities, nations or classes."[26] While Cowley emphasizes this rootlessness, he also points out that the native land, or home, remained a significant presence for American expatriates: "We saw the America they wished us to see and admired it through their distant eyes. . . . We had come three thousand miles in search of Europe and had found America."[27] This idea of discovering America from Europe was essential to the postwar expatriate experience not only for writers but for artists as well.

In 1928 the painter Stuart Davis crossed the Atlantic to spend a year in Paris, later writing of this time: "There was so much of the past and of the immediate present, brought together on one plane. . . . There was no feeling of being isolated from America."[28] Painted after this trip, *New York–Paris, No. 2* (fig. 70) blends past and present, Europe and America, Paris and New York in a single canvas. Pairing French icons with American emblems at a time when the

70 | Stuart Davis (1892–1964). *New York–Paris, No. 2*, 1931. Oil on canvas, 30¼ x 40¼ in. (76.8 x 102.2 cm). Portland Museum of Art, Hamilton Easter Field Art Foundation Collection, Gift of Barn Gallery Associates, Inc., Ogunquit, Maine

cross-Atlantic circulation of people and ideas was increasing, this hybrid place thus embodied a modern sensibility: the collapse of space and time experienced through travel and tourism.

Hartley as well wrote of the merging of seemingly disparate places. While he was in Berlin, Paris, and southern France in the 1920s, not only were America and home foremost in his mind but so too was the project of creating an American art. On Hartley's request from Berlin in 1923, Stieglitz sent him Henry James's biography of his brother William and their father, *Notes of a Son and Brother* (1914), as Hartley longed "for strictly American readings" "to nourish [his] American moods."[29] The book was an appropriate one for Hartley, the New Englander in Europe, telling as it does the story of the well-known expatriate family, their education in Europe, and their return to New England in 1860. James writes of the detachment that he and his family felt in both Europe and New England, of "being in New England without being of it."[30] Henry James Sr. had been associated with the Concord School of Philosophy and the Transcendentalists — Emerson and Thoreau — yet the family felt alienated from New Englanders in Newport, where they lived, because unlike their neighbors their concerns were not with commerce or business. In Newport, James remained *au courant* with Europe, keeping copies of the French magazine *Revue des Deux Mondes* for his reading and creating what he called an "alternative sphere of habitation."[31]

Hartley too created an alternative space for himself. When he was in Paris in 1929, he "Americanized" his apartment on the Boulevard Jourdain by arranging on his mantelpiece shells that he had collected during a 1928 summer visit to Georgetown. These he placed next to a photograph of himself as a child with his mother, father, and sister, most likely one of the family mementos his sister gave him when he visited her in Maine that summer.[32] He described this room to Rebecca

Strand: "It really is amusing and I am sure there exists nowhere in all Europe so American a touch as I have given it — with your superb quilt . . . a lot of handsome sea shells which I now am painting — the vases that you know & several that I have acquired of the same genre . . . the photo of the Lachaise house I took while I was [in Maine]."[33] With their nostalgic properties, the shells kept Hartley "rooted" in America while he was on the other side of the Atlantic, attached to Maine and to his friends the Strands and the Lachaises, with whom he had spent the previous summer.[34]

Shells (fig. 71) is from the series of fifteen paintings Hartley made in his Paris apartment of the shells collected in Georgetown, although they do not seem to be native to Maine but rather fanciful creations or exotic finds from tourist shops. Displayed in imaginative groupings — brown, yellow, and orange shells and a white and pink almost flesh-like form — the objects, deeply shadowed and painted with the long regular Cézannesque brushstrokes Hartley was using at this time, seem to float on the blue ground. The painting may even be a kind of self-portrait: to Rebecca Strand, in January 1929, he compared himself to "an empty shell in a foreign beach washed up by some irrelevant tide — up there [in Maine]."[35] It is, moreover, the predecessor of the many late still lifes that Hartley painted in Maine — the ethereal *White Sea Horse*, the bold *Lobster on Black Background* (figs. 72, 73) — which served as signs of place.

The modernist collapse of place and time defined Hartley's experience of southern France as well. From 1925 to 1929, when he lived first in Vence and then in Aix-en-Provence — Cézanne's native town — Maine was very much in his mind. "My life [in Aix]," he wrote to Stieglitz, "is really as a more sublimated degree a reversion to the days of Maine — living in a little home alone — dragging the water I need from a well 60 metres away."[36] And indeed, the Provence work exhibits a kinship with the earlier Maine landscapes, the brilliant

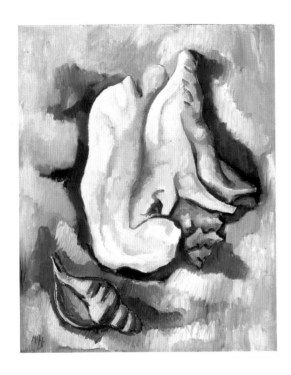

71 | *Shells*, 1928. Oil on canvas 24 x 19½ in. (61 x 49.5 cm). Private collection

72 | *White Sea Horse*, 1942. Oil on hardboard (masonite), 28 x 22 in. (71.1 x 55.9 cm). Collection of Jan T. and Marica Vilcek, Promised Gift to the Vilcek Foundation

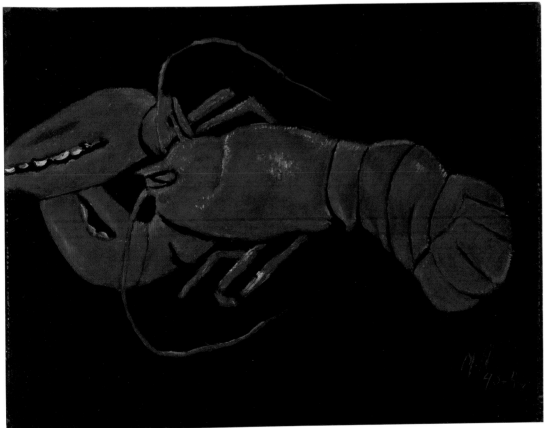

73 | *Lobster on Black Background*, 1940–41. Oil on hardboard (masonite), 22 x 28 in. (55.9 x 71.1 cm). Smithsonian American Art Museum, Washington, D.C., Gift of Mr. Henry P. McIlhenny

74 | *Carnival of Autumn,*
1908. Oil on canvas,
30⅛ x 30⅛ in. (76.5 x
76.5 cm). Museum of Fine
Arts, Boston, The Hayden
Collection, Charles Henry
Hayden Fund

colors of the 1908–11 Post-Impressionist paintings
(fig. 74) revived in his paintings of Mont Sainte-
Victoire (see fig. 107). Hartley noted his change
of mood when he moved from Vence to Aix and
the attendant change in his work: "You will find a
new burst of life in it," he wrote to Stieglitz in 1927,
"a kind of bringing up that first Maine period to
the surface."[37] And to the sculptor John Storrs: "It
all seems like a union of all those qualities I have
admired in America — Maine & N[ew] M[exico]
with something all its own."[38] Still in Aix in 1929,
he wrote to Stieglitz:

I have never once stepped off my own soil — No matter
where my eyes or my mind may have been my feet have
never left the soil that was the first to be called home to
them. You don't transpose a New Englander — he can't
escape himself ever — he can only widen his width — and
that's what I've done — I never felt more New England in
my life than I do sitting in this two by four kitchen this
minute and that's the joy I have in being what I am.[39]

Such feelings form a picture of the artist paint-
ing and living somewhere between Maine and
Provence, past and present.

That Hartley invoked Maine as a comparison to
Provence at this time was due not only to the visual
connections he made but to the discourse current
in the New York art world. Critic Henry McBride
and Stieglitz himself dismissed Hartley's French
landscapes, which were on view at Stieglitz's
Intimate Gallery in January 1929, at a time when
being an American artist meant both living in the
United States and painting America. Not surpris-
ingly, Hartley insisted on his Americanness even
as he painted Mont Sainte-Victoire: "[Southern
France] is not France — it is not Europe — it is
not even Provence. . . . I never feel or have felt
so downright New England as I do this very
minute."[40] Thoughts of home, of Maine and New
England, also filled his letters, the memory of
Maine fresh from his recent visit there.

Articles promoting the 1929 exhibition pre-
sented Hartley's southern French landscapes as
closely affiliated with his American paintings.
Lee Simonson's foreword in the exhibition cata-
logue posited a powerful bond between Aix and
Maine: "It is a particular satisfaction to me that
Marsden, after deserting Speckled Mountain and
Baldface in Maine, has found Mont St. Victoire
near Marseilles." In Simonson's opinion, Hartley's
career between the Maine landscapes and those
of southern France took a detour of sorts. While
noting that some of the Aix paintings were clearly
homages to Cézanne, he attributed their brilliant
colors first and foremost to Hartley's own Maine
views (see above and fig. 59).[41] Hartley's paint-
ings of Mont Sainte-Victoire would in turn shape
his late visions of Mount Katahdin, in both their
heightened color and their emphasis on the stony
ridge of the mountain.

Maine merged with other places on Hartley's
transatlantic journeys. From April 1933 to February
1934 he lived in Germany, first in Hamburg during

the spring and summer and then in a chalet, Haus Schober, in Garmisch-Partenkirchen in the Bavarian Alps. Hartley felt at home in the north, claiming that he was "beginning to breathe [his] own airs again here in Germany for atmospherically and geographically speaking it is much the same latitude as that in which I was born, and the racial life of the place here is so much second nature to me."[42] He thought of the countryside outside Hamburg as similar to Maine with its "deep dark pine woods," the red Norway pines that were also the trees of his native state.[43] In Garmisch-Partenkirchen too he found affinities with Maine: "The rest of nature below the highest Alps is so like my own N[ew] E[ngland] [i.e., Maine] I can hardly believe it . . . — lovely long rows of cord wood stacked up for winter — herds of Jersey cows — sheep — goats — and all that — ox-carts jogging along and the handsome young and old peasants driving them."[44] The mountain snow transported him back to his Maine childhood: "I even ate some snow a few days ago just to revive memories of Maine way back — and the very taste of it sent me flying back to my boyhood up there."[45]

Settling in an area surrounded by the Wetterstein Range, including the country's tallest peak, the Zugspitze, Hartley returned to his identity as a mountain artist by painting the Alps, as in *Garmisch-Partenkirchen* (fig. 75). In this dark-toned work, jagged, rocky mountains fill and press against the vertical picture plane, dwarfing two farmhouses in the foreground and conveying the experience of being in a Bavarian village surrounded by towering peaks. The high horizon, impastoed clouds, minuscule buildings, and blacks and browns recall Hartley's early dark Maine landscapes (see fig. 56). That Hartley was thinking of these works at this time was likely due to his revived interest in Segantini, who had influenced his first landscapes and was very much in Hartley's mind after he'd seen the Italian painter's work at the Hamburg Kunsthalle and the Munich

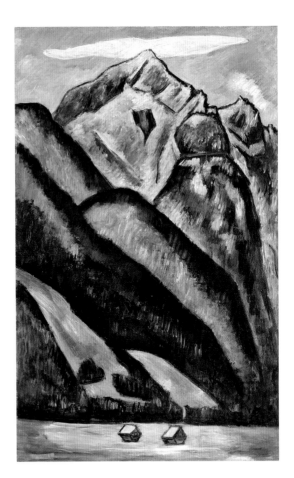

75 | *Garmisch-Partenkirchen*, 1933. Oil on board, 29¼ x 18¼ in. (74.3 x 46.4 cm). Sheldon Museum of Art, University of Nebraska—Lincoln, Bequest of Bertha Schaefer

Pinakothek.[46] In late 1933 Hartley also began writing his autobiography, "Somehow a Past," which included a section titled "The Return to New England."

Hartley's Alpine landscapes not only reach back to his early Maine landscapes but look forward to the late Katahdin paintings of his final years. Painting the Alps was for Hartley "a grand preparation for recovering the 'eye' for the native scene . . . it is exactly alike here."[47] While in Garmisch-Partenkirchen, he sent for tourist literature on Katahdin. He wanted to paint the mountain but feared it would be too expensive to lodge there and even that he might never get a "good look at my own Maine."[48] He did, however, manage a short excursion after his return to the state in 1937. Guided by a game warden, Caleb Warren Scribner,

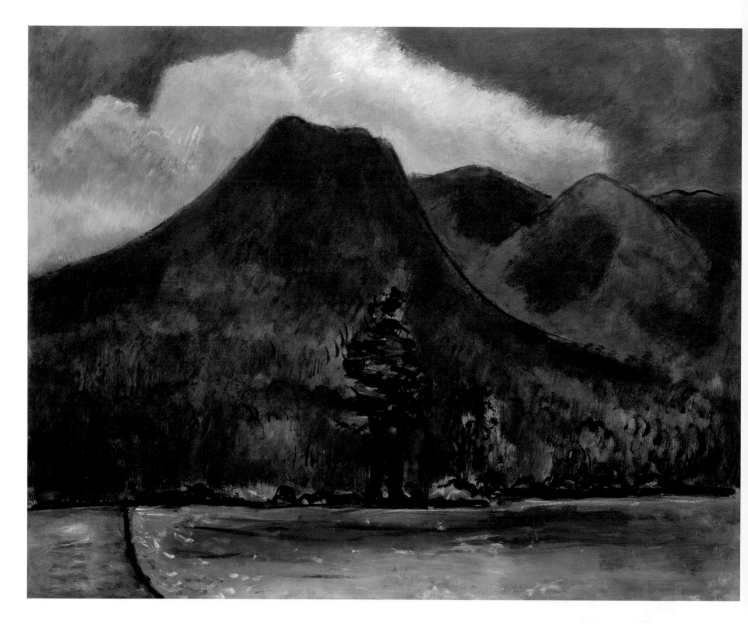

76 | *Mount Katahdin,* 1941.
Oil on masonite, 22 x 28 in.
(55.9 x 71.1 cm). Private
collection

he took an eight-day trip to Katahdin in October 1939, driving eighty miles from Bangor, trekking nearly four miles in a cold rain, and subsisting on jellied venison and venison steak. Hartley stayed at a hunters' camp, Cobbs Camp (see fig. 126), in a log cabin overlooking Katahdin Lake, and he made a series of drawings and oil sketches that were to serve as the basis of the paintings he would work on for the next three years. While Hartley's Katahdin is absent the dominant blacks and grays

of his Alpine scenes and their vertical compression, the Bavarian mountains find echo in the late Katahdin views. As in the Alpine landscapes, the mountain looms large, dominating the picture's surface and the foreground ledge of natural scenery, although it appears flatter, more distant, and iconic (fig. 76). Katahdin stretches horizontally across the canvas, with a tree providing a sense of scale, like the trees and farmhouses in the Alpine works.

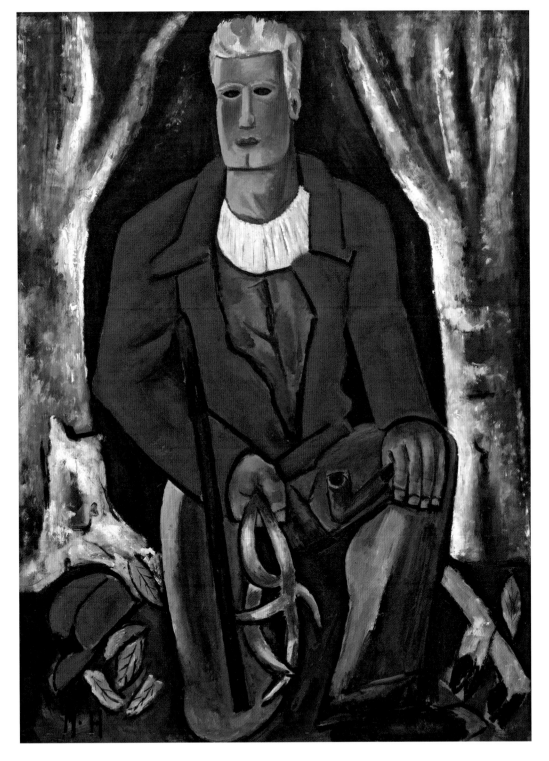

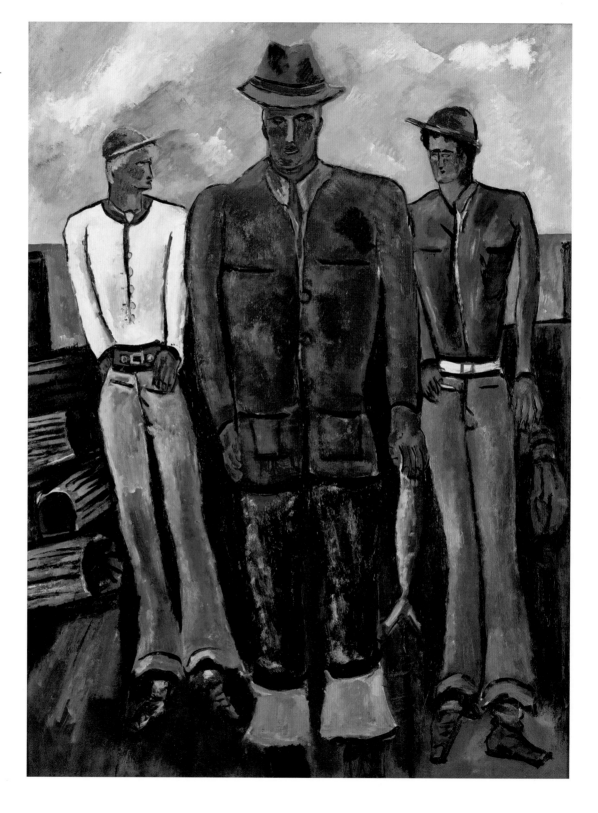

78 | *Down East Young Blades*, ca. 1940. Oil on masonite-type hardboard, 40 x 30 in. (101.6 x 76.2 cm). Wadsworth Atheneum Museum of Art, Hartford, Connecticut, The Douglas Tracy Smith and Dorothy Potter Smith Fund, The Evelyn Bonar Storrs Trust Fund, The Krieble Family Fund for American Art, and The Dorothy Clark Archibald and Thomas L. Archibald Fund

Hartley saw the people of Germany and Maine being as similar as their landscapes, writing to the dealer Edith Halpert in July 1933: "The Hamburg type itself is a finer type of German — staid conservatism and quite like my own New England in its outer behavior."[49] Furthermore, his encounters with traditional folk culture — visiting the Altonaer Volksmuseum in Hamburg, seeing Bavarian peasants dressed in traditional attire, attending the Bauerntheater in Partenkirchen — gave him a new appreciation of the folk culture of his native state. His figure paintings include hybrid types that were both of Germany and of Maine. Evoking the warrior theme common to the German mountain films that Hartley admired (such as *Doomed Battalion*, 1932),[50] *Young Hunter Hearing Call to Arms* (fig. 77) presents a hunter, his blond hair and blue eyes emphatically German as are his smocked shirt and vest, which derive from nineteenth-century German folk attire.[51] Yet for all these Germanic characteristics, this hunter wears the red hunting cap that places him in Maine. In *Down East Young Blades* (figs. 78, 79) the central figure straddles nation and region: he wears an Alpine hat and Bavarian boiled-wool jacket along with typical Maine fishing attire, blue jeans and boots. The figure also resembles Luis Trenker, the German director and actor famous for his work in mountain films, as pictured in a postcard that Hartley owned (fig. 80).

This transnationalism, this merging of places and people, is also evident in Hartley's representations of Nova Scotia and Maine. In his 1937 Hartley show at An American Place, Stieglitz exhibited the artist's recent paintings of Dogtown Common in Gloucester, Massachusetts, together with a series of Nova Scotia still lifes and landscapes — two versions of *Off the Banks, Nova Scotia*, and three of *Church on the Moors, Nova Scotia*. What is curious about this exhibition, in which Hartley declares himself "the painter from Maine" in the accompanying catalogue, is that Maine is conspicuous by its absence — curious until one notes that, for Hartley, Gloucester and Nova Scotia were just like Maine. In the same essay, titled "On the Subject of Nativeness — A Tribute to Maine," he writes: "The subject matter of the pictures in

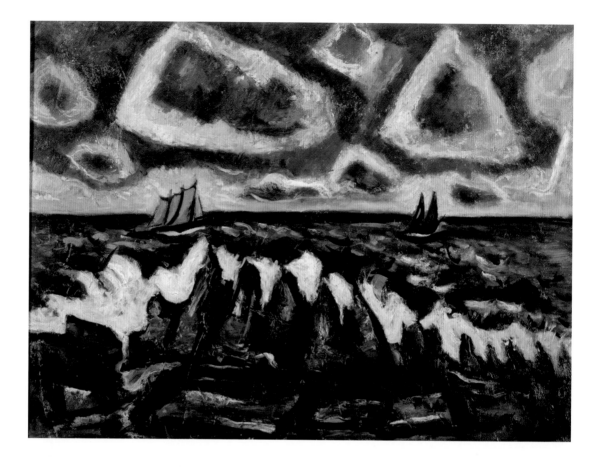

81 | *Northern Seascape, Off the Banks*, 1936–37. Oil on paperboard, 18 x 24 in. (45.7 x 61 cm). Milwaukee Art Museum, Max E. Friedman–Elinore Weinhold Friedman Bequest

this present exhibition is derived from my own native country — New England — and the country beyond to the north, geologically much the same thing . . . and the people that inhabit it, fine types of hard boned sturdy beings, have the direct simplicity of these unique and original places, this country being of course Nova Scotia. . . . Maine is likewise a strong, simple, stately and perhaps brutal country."[52] The Nova Scotia subjects at the American Place gallery were those that would occupy Hartley in the late Maine paintings: braided ropes and shells; mackerel, lobsters, and other sea life; the powerful North Atlantic; landscapes with churches and ruins.

In September 1935 Hartley traveled from Bermuda to Nova Scotia to meet up with the Canadian writer Frank Davison, whom he had known since 1922 when they were both in Berlin, though by the

time he arrived Davison had left. Hartley stayed nonetheless, first in Lunenberg, then in the nearby fishing village of Blue Rocks, and until December on Eastern Points Island, with the Mason family. Hartley returned the following summer and stayed, again with the Masons, through the fall.[53] A tragedy in the family provided a powerful inspiration for Hartley's art. In September 1936 Hartley received news that the two young Mason sons, Donny and Alty, along with their cousin Allen had drowned in a storm while returning in their punt to Eastern Points after a night drinking on the mainland. To Stieglitz he wrote about the "catastrophe," which "left a hollow in every heart that no time can heal": "I loved these two men devoutly and they were so devoted to me. . . . And it is hard to say which is more difficult to endure the first tragic & conscious condition — or the

countless little nothings of the day to remind us of the terrible and irreplaceable loss everywhere one looks."[54]

Several small seascapes constitute Hartley's immediate response to this event and provide the basis for his larger memorial, *Northern Seascape, Off the Banks* (fig. 81).[55] In a letter to his friend Adelaide Kuntz, he describes the "teeth of a gale" that took the lives of the Mason boys and the "silent agony" of the family after their death; these forms and emotions fill the painting.[56] On the rocky coast in the foreground sharp, spiky boulders stand ready to destroy vessels and impale mariners,

while dark, thickly painted clouds oppress the horizon. Hartley evokes the ocean's power by pitting two minute schooners, emblems of Donny and Alty, against the watery expanse — conjuring the Romantic icon of the storm-tossed boat in a vast, dangerous, and indifferent sea, as in Ryder's *Moonlight Marine* (fig. 82), the first Ryder painting to be seen by Hartley, in 1909, and one that he invoked here decades later.

Northern Seascape, Off the Banks had direct ties to Hartley's Maine. When it was shown at An American Place in 1937, it was titled *Off the Banks, Nova Scotia*. But after the exhibition, in which

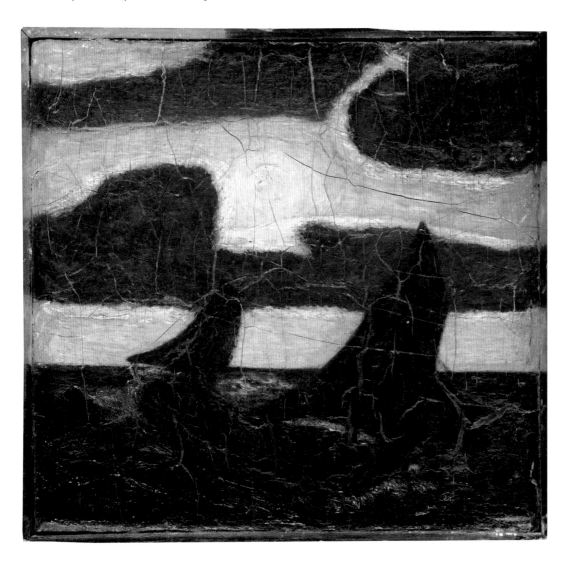

82 | Albert Pinkham Ryder (1847–1917). *Moonlight Marine*, 1870–90. Oil and possibly wax on wood panel, 11½ x 12 in. (29.2 x 30.5 cm). The Metropolitan Museum of Art, Samuel D. Lee Fund, 1934

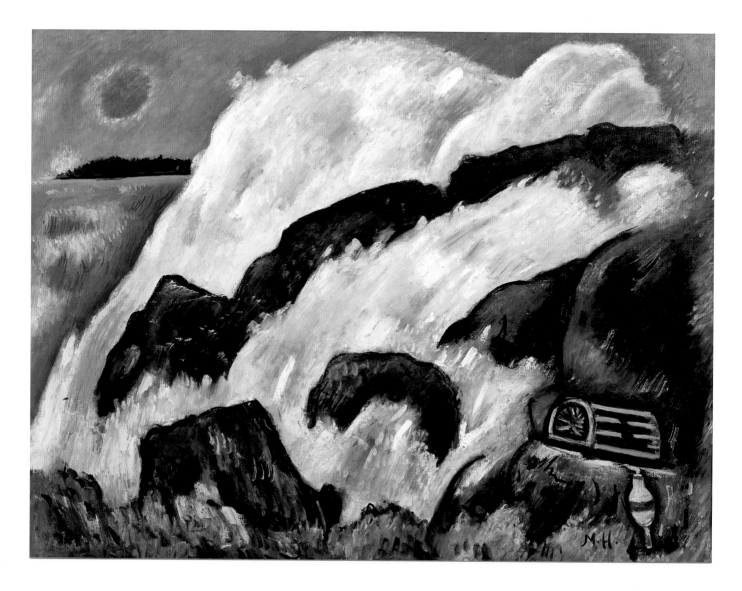

83 | *After the Hurricane*, 1938. Oil on canvas, 30 x 40⅛ in. (76.2 x 101.9 cm). Portland Art Museum, Oregon, Ella M. Hirsch Fund

Hartley announced his new identity as "the painter from Maine," it was retitled to relate it less to the Canadian province and more to Hartley's native state.[57] It became a painting of the North Atlantic, of both Nova Scotia and Maine, suggesting that, for Hartley, the coastal regions of province and state were interchangeable. The ferocious surf against the rocky shore at the center of *Northern Seascape* reappears in several of Hartley's Maine seascapes — *After the Hurricane* (fig. 83), *The Wave*, and *Storm Down Pine Point Way, Old Orchard Beach*, among them (see figs. 101, 105).

In 1942 Hartley painted a second version of *Northern Seascape* as well as related seascapes inspired by his new residence in Corea, Maine, which to his mind resembled Eastern Points, Nova Scotia. The painter Waldo Peirce introduced Hartley to Corea on a motoring excursion to Down East Maine: "[Peirce] drove me along the coast & we looked at a wonderful little fishing town called Corea . . . and God! was it a beauty! — a real fishing village — so like the place I had in Nova Scotia."[58] Hartley was so taken with Corea that he spent the next four summers there, renting the upper floor

of the house owned by the Youngs — the lobster-man Forrest Young and his wife Katie, who ran a restaurant during the summer tourist season.

Corea (fig. 84; and see figs. 156, 157) is a small fishing village in the town of Gouldsboro, north of Bar Harbor, with nearby sites that offer sweeping views of the Atlantic, in particular, Schoodic Point in Winter Harbor. Here, tourists can view the surf crashing against dark basalt and granite ledge, a North Atlantic scene that would have recalled for Hartley the violent waters of the Canadian Maritimes. Hartley painted this ongoing drama in what became his final great seascape series. *Off the Banks at Night* (fig. 85), done on a larger scale than *Northern Seascape*, resembles the earlier painting in the flat, angular boulders in the foreground, the waves beating against the shore reminiscent of Winslow Homer, the two schooners riding the crests, and the heavy white-outlined clouds inspired by Ryder. The red underpainting lends the work a violent tone, allusive to the Mason tragedy. *Evening Storm, Schoodic, Maine* and *Evening Storm, Schoodic, Maine, No. 2* (see figs. 102, 103), both the same size as *Off the Banks at Night* and both nocturnal seascapes, make up a series of elegiac works in which the powerful presence of the ocean memorializes the Mason boys and perhaps the recent deaths of young men in the world war then raging. Hartley had been made painfully aware of the human cost of war when he lost his friend and (perhaps) lover Karl von Freyburg during World War I. The U.S. Navy base in Winter Harbor, not far from Corea, with its sailors readying for war, would have brought to mind the loss of von Freyburg as well as that of the Mason boys. The series constitutes Hartley's late Dark Landscapes: it reenvisions his early Ryderesque canvases of the Maine mountains and draws on his experience in Nova Scotia and the Nova Scotia paintings.

In Corea, Hartley returned to another subject he had painted in Canada: the church in the landscape. In 1940, during his first summer

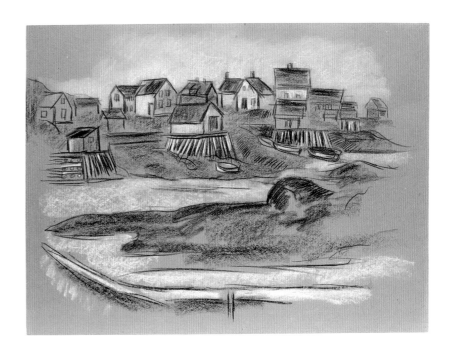

in the village, Hartley began sketching the local Baptist church, an important historical structure erected in 1890.[59] It was little used by 1940, and the upper story was made available to him as a studio. Hartley produced numerous paintings and drawings of the church, some of the façade and tower, others of the building surrounded by wild, overgrown nature and stacks of lobster traps as, for example, in *Lobster Fishermen's Church by the Barrens* (fig. 86). With its Ryderesque clouds, dark colors, mystical light, and red underpainting, the nocturnal scene recalls the seascape series discussed above and replays the mood of the Nova Scotia paintings.

Nova Scotia inspired Hartley's Maine and Maine inspired Hartley's Nova Scotia. In the summer of 1938 he painted portraits of the Mason family not in Canada but in Vinalhaven, a town on Fox Island, Maine, and a fishing community not unlike Eastern Points, Nova Scotia. As Hartley wrote, the island was "as near like N[ova] S[cotia] as anything out of it can be."[60] Here he painted three figural works, *Nova Scotia Fishermen* (1938; IBM Corporation), *Fishermen's Last Supper* (1938;

private collection), and *Albert Pinkham Ryder* (see fig. 50). These were followed by individual portraits of the Mason family. The Nova Scotia "archaic portraits," as Hartley called them, became models for his Maine figural works. With their broad chests, hairy bodies, large hands for laboring, and frontal and hieratic poses, the figures in *Down East Young Blades*; *Canuck Yankee Lumberjack at Old Orchard Beach*; *Madawaska — Acadian Light-Heavy*; and *Flaming American (Swim Champ)* (see figs. 78, 108, 118, 120) share a family resemblance with Alty in *Adelard the Drowned, Master of the "Phantom"* (1938–39; Frederick R. Weisman Art Museum) and Hartley's other Nova Scotia fishermen.

A painting that gives us both Canadian and Maine fishermen, *Knotting Rope* (see fig. 124) was painted between the Nova Scotia portraits and the Maine figural works. Although it has been read as a tribute to the Mason family, the massive hands and rope being references to Francis Mason,[61] the absence of a specific person or context encourages a broader interpretation. The immense hands and forearm tying a heavy rope signify the hardiness, physical labor, and bodily strength that Hartley admired in both the Nova Scotia and the Maine fishermen.

Conclusion

Maine was always with Hartley. As he wrote in his autobiography, "I had remembered my own country — never a time that I haven't remembered — never a time that it has been ever more to me

85 | *Off the Banks at Night*, 1942. Oil on hardboard, 30 x 40 in. (76.2 x 101.6 cm). The Phillips Collection, Washington, D.C.

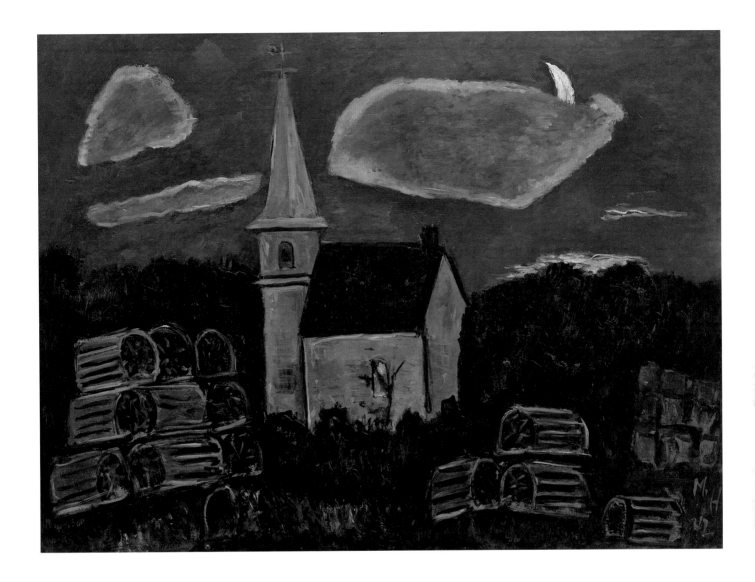

than when I have been out of it."[62] That Maine traveled with Hartley is due to many factors: his own memories, the similarities he perceived between Maine and the places he visited, the merging of places as part of the experience of travel, and a response to increasing pressure to identify himself as a Maine painter. Hartley's Maine was a place that extended out to diverse parts of Europe and North America and that was defined by those locales. Hartley wrote about geography being "trivial" to explain the merging of places he experienced in his travels. But Hartley's Maine in fact shows how important geography was to him, how he endeavored to understand the physical and emotional dimensions of the region, and how that region resonated with other locales that made Maine not provincial but a place of the world.

86 | *Lobster Fishermen's Church by the Barrens,* 1942. Oil on masonite, 30 x 40 in. (76.2 x 101.6 cm). Collection of Karen and Kevin Kennedy

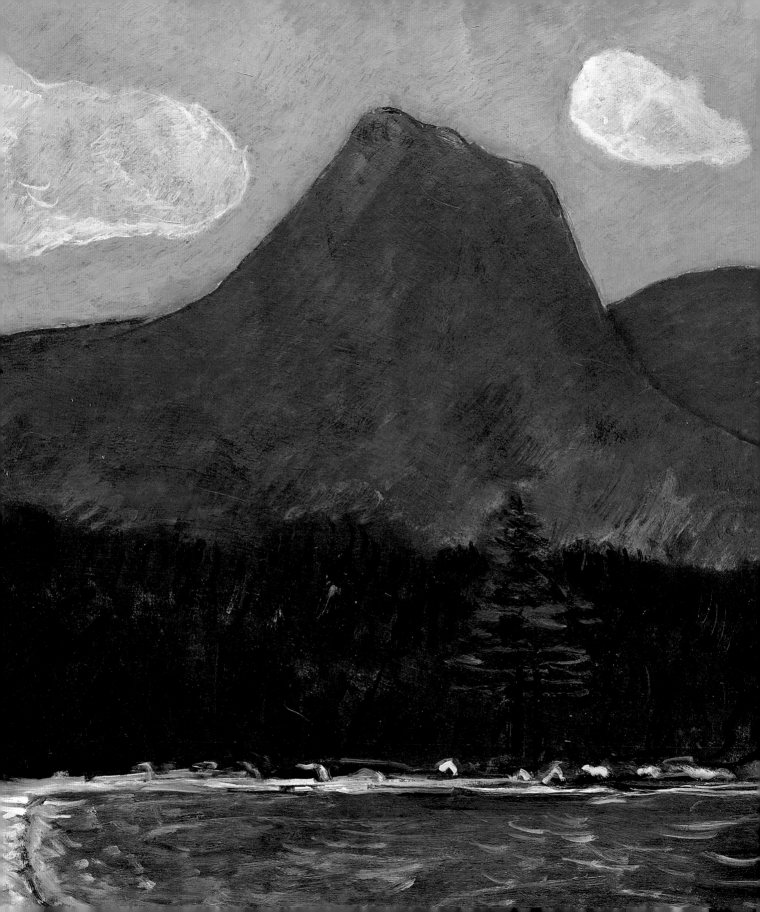

AN AMBIVALENT PRODIGAL

Marsden Hartley as "The Painter from Maine"

Randall R. Griffey

*There is never a time I don't feel homeless. But I was born that way and it will probably be like that always.** — Marsden Hartley, 1938

No Place Like Home

Compelling and triumphant narratives of home-coming — of coming full circle, of personal, artis-tic, and spiritual completeness late in life — course throughout critical responses to Marsden Hartley's late paintings of Maine, both during and following the painter's lifetime. Beginning at the artist's final exhibition at Alfred Stieglitz's gallery An American Place in 1937, when Hartley declared himself "the painter from Maine,"[1] and extending through successive shows at the Hudson D. Walker Gallery (1938–40), the Macbeth Gallery (1941 and 1942), and Paul Rosenberg & Co. (1943), New York critics and visitors to his exhibitions gradually, but decid-edly, accepted — even celebrated — his coarsely rendered views of Maine's people and terrain as authentic expressions of a repentant prodigal son. "Marsden Hartley has come home at last," the critic Elizabeth McCausland proclaimed in her review of the 1940 solo show at Hudson Walker: "Hartley's physical return home," she concluded, "has had the tangible result of releasing his powers as an artist."[2]

McCausland's conviction that Hartley's return to Maine after years of seemingly rudderless travel throughout Europe and across the United States, Mexico, and Nova Scotia imbued his art with greater aesthetic clarity and integrity extended well beyond the artist's death in 1943. Echoes of this seductive homecoming narrative reverberated into the late twentieth century and spiked once more in 1980, on the occasion of the seminal retro-spective at the Whitney Museum of American Art, the foundation for most of the work on the artist that has followed. As Theodore F. Wolff observed in his review of the Whitney exhibition for the *Christian Science Monitor*: "All one needs to do is walk through the show to see that Hartley the art-ist wore a succession of masks until he pulled them off once and for all within the dark, wet woods of Maine, in the shadow of Mt. Katahdin. And with that act he came home, both to the place of his birth and to himself."[3]

This reassuring narrative of a destiny fulfilled has served as a frame through which many have interpreted Hartley's late career as coming full circle. However, a more critical assessment of his public identity as the painter from Maine reveals it to have been a gradual, indirect, even strategic process marked by contradiction and

* Hartley to Norma Berger, August 15, 1938, Marsden Hartley Collection, Yale Collection of American Literature, Beinecke Rare Book & Manuscript Library, Yale University, New Haven.

◀ *Mount Katahdin, November Afternoon*, detail of figure 133

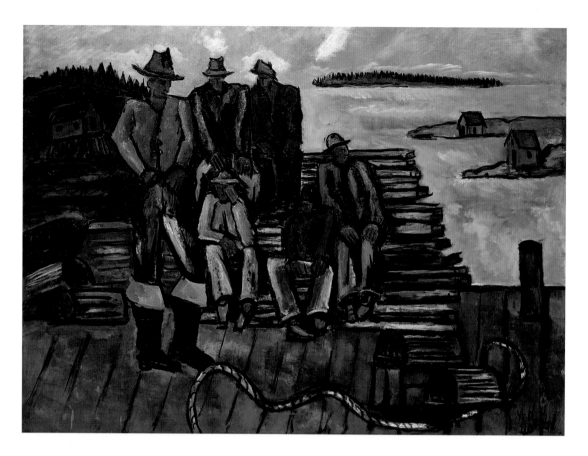

87 | *Lobster Fishermen*, 1940–41. Oil on hardboard (masonite), 29¾ x 40⅞ in. (75.6 x 103.8 cm). The Metropolitan Museum of Art, Arthur Hoppock Hearn Fund, 1942

ambivalence as much as by profound connection and spiritual revelation.[4] Hartley's self-promotion as the painter from Maine was not — to extend Wolff's metaphor — the removal of the last in a series of false masks. Rather, it was another kind of performance, a deliberate, intellectually and aesthetically sophisticated construction of a public self that encouraged a perception of him as a great American artist at a time when the identification of an artist with a specific place was tantamount to cultural renown.

"Conscientious Sincerity"

Encountering the paintings and works on paper that Hartley made in Maine and of Maine during the last six years of his life, one can easily understand why McCausland, Wolff, and many others were so convinced by their truthfulness, nativeness, and artistic integrity. As Charmion von

Wiegand observed in her glowing review of the 1940 exhibition with Hudson Walker: "Hartley's craftsmanship has the conscientious sincerity and simplicity of a Maine woodsman who hews, peels and erects his logs from the forest for a safe and sturdy shelter."[5] And indeed, Hartley's late paintings pulsate with a vibrant, audacious directness that reflects authentic expression and deep connection to his subject. Composed to be unartful, filled with irregular, non-naturalistic, but still recognizable, forms often with heavy black outlines that reinforce their power, the late images of Maine are unpretentious yet grand — everyday, but epic in scope and meaning.

Drawing on the time Hartley spent in the coastal village of Corea, *Lobster Fishermen* (figs. 87, 88), presents a carefully crafted expression of authenticity and unpretentious grandeur. Six men gather on the harbor pier, which, littered

with lobster traps, offers a view beyond to three buildings and a wooded island (likely Outer Bar Island).[6] The manly gathering is anchored by a disproportionately large figure in an attention-grabbing hot-pink shirt who towers heroically over the scene. The group is compressed, sitting shoulder to shoulder in close proximity that speaks not only of camaraderie but of physical intimacy. Group identity is enhanced by the rendering of the pier, which seems to tip upward as much as it recedes into the distance, an intentional rejection of linear perspective and a characteristic of naïve or folk art, which Hartley greatly admired.[7] Hartley allowed the board support to show through the thin layers of paint, accentuating the picture's crude, almost unfinished quality, a feature that registers as "honest" in its lack of finesse. The support is, furthermore, appropriate to his subjects: hardy, plebeian fishermen. Hartley's signature appears in the lower right corner in the abbreviated form of initials, simply and boldly drawn, like hatchmarks in a tree, projecting a terse, no-nonsense, Yankee character.

The Painter from Maine

Hartley first proclaimed his Yankee heritage in 1932, in a solo exhibition, "Pictures of New England by a New Englander," at the Downtown Gallery, on West Thirteenth Street. A poem that he wrote titled "Return of the Native" served as the catalogue foreword. Owned and run by Edith Halpert, the Downtown Gallery was an institutional and commercial torchbearer for American Scene painting and, as such, was a logical venue for the painter's decided return — albeit a brief one in this instance — to native subject matter after having exhibited landscape paintings from France the previous year at An American Place.[8] Halpert presented twenty paintings by Hartley of Dogtown, a long-abandoned settlement surrounded by strange, primeval-looking rock formations near Cape Ann, Massachusetts. Dogtown's rocky,

88 | *Study for "Lobster Fishermen,"* 1940. Pastel on paperboard, 21¼ x 27 in. (54 x 68.6 cm). The Metropolitan Museum of Art, Arthur Hoppock Hearn Fund, 1956

otherworldly topography resonated with Hartley; he would return to paint the site in 1934 and again in 1936, developing his rough-hewn late style (fig. 89).

Hartley's poem "Return of the Native" testifies to the affirming and restorative effects of returning home: "He who finds will / to come home, / will surely find old faith, / made new again, / and lavish welcome." The prominent *New York Times* art critic Edward Alden Jewell suggested that Hartley had found himself, both personally and artistically: "[Hartley] reveals the Down East country as a state of mind — and one that is likely to appeal to the public at large as unique. . . . There is an unyielding hardness, as of iron, in the poetry of this man's brush."[9] Despite the "lavish welcome" that would inevitably await him were he to mine more deeply native subjects in his art, Hartley chose to cut short his homecoming in 1932, instead decamping to Mexico (1932–33), Germany (1933–34), Bermuda (1935), and Nova Scotia (1935 and 1936), among other destinations throughout the early and mid-1930s.

89 | *Mountains in Stone, Dogtown*, 1931. Oil on academy board, 18 x 24 in. (45.7 x 61 cm). Palmer Museum of Art at The Pennsylvania State University, University Park

To the degree that Hartley's 1932 showing at the Downtown Gallery focused on his New England roots, the exhibition set the proverbial stage for the 1937 show at An American Place, where his more specific ties to Maine were underscored. The exhibition catalogue included a poetic essay by Hartley titled "On the Subject of Nativeness — A Tribute to Maine," in which he casts himself as a repentant prodigal son, returning home in search of forgiveness for his many years of geographic and cultural infidelity. Addressing his homeland directly he implores: "I say to my native continent of Maine, be patient and forgiving, I will soon put my cheek to your cheek, expecting the welcome of the prodigal, and be glad of it, listening all the while to the slow, rich, solemn music of the Androscoggin, as it flows along."[10] Interpreting Hartley's late career as a triumphant homecoming, critics such as McCausland thus essentially followed the artist's lead.

As Donna Cassidy explores in her essay in this volume, Hartley declared himself the painter from Maine in an exhibition that curiously lacked even a single view of the state. Instead, it included additional paintings of Dogtown and works that reflected on his experiences of 1935 and 1936 in Nova Scotia — still lifes, stormy, symbolic coastal scenes, and emblematic, regional landscapes that, in retrospect, presage the Maine subjects a few years later.[11] Presumably in anticipation of the confusion with which such an obvious and contradictory omission would be met, Hartley offered in the exhibition brochure a somewhat strained explanation:

If there are no pictures of Maine in this present exhibition, it is due entirely to forward circumstance and never in any sense to lack of interest, my own education having begun in my native hills, going with me — these hills wherever I went, looking never more wonderful than they did to me in Paris, Berlin, or Provence.

Dogtown and Nova Scotia then, being the recent hunting ground of my art endeavors, are as much my native land as if I had been born in them, for they are of the same stout substance and texture, and bear the same steely integrity.[12]

Painters of Maine

Hartley, in his desire to be recognized as Maine's greatest modern interpreter, found himself vying with several other artists, including his friends Waldo Peirce and Carl Sprinchorn.[13] Most formidable was his fellow Stieglitz circle artist John Marin (see fig. 4), whose rootedness in American culture, unlike that of the peripatetic Hartley, had never been called into question. In particular, Marin's 1936 retrospective at the Museum of Modern Art no doubt stoked Hartley's competitive spirit and played on his lingering insecurities, as it marked the first one-man show of a Stieglitz circle artist to be mounted at the prestigious institution. "Here, at last, Marin comes before us in his full stature as an artist," asserted Edward Alden Jewell in *The New York Times*.[14] In addition, the exhibition, organized by Stieglitz, lauded the acclaimed watercolorist — a New Jersey not a Maine native — not only as an important American artist but as a great painter of Maine. The state was essential to Marin's artistic development,

wrote one of the contributors to the catalogue, E. M. Benson: "The Maine coast, more than any other single locale, was the nursery and testing-ground of Marin's art. . . . Here especially he went to school with his environment, drawing wisdom from the waves, the surf-washed stones and shells sparkling in the pockets of the sand."[15]

As confirmation of Marin's successful encroachment on his home turf, the 1936 MoMA retrospective surely unnerved Hartley, who, perhaps as a favor to Stieglitz, contributed an essay to the catalogue, as he had previously for exhibitions of Arthur Dove and Georgia O'Keeffe. The scenario placed the painter in the awkward position of granting Marin his imprimatur and thereby potentially relinquishing his own association with the region. In his essay Hartley extols Marin's skill and accomplishment in watercolor, but not without also noting the medium's historically feminine and lowbrow associations.[16] And on the inevitable topic of Maine, while he provides a lengthy endorsement of Marin's talent, he also asserts his own native credentials in the same rhetorical breath:

No one has known better what the prescribed [water-color] wash can do, no one has made it more powerful, more velvety, more metallic, more acrid or more sinister and more provocative of the great sources of nature and especially the sea and the shores that bound it, alas my native land of Maine which I am always being told about by one good painter, this being Marin, and a lot of bad painters, but Marin gets those still, esoteric stretches where islands float in other world ethers, and gives them the look of prearranged mirages.[17]

In retrospect, Hartley's description of Maine as "my native land" in his tribute to Marin points to his very next exhibition, where he claimed for himself the title "the painter from Maine." Moreover, that he probably wrote the essay while living in Nova Scotia likely encouraged him to merge the similarities between the two contiguous regions in the explanation he wrote for the exhibition catalogue to account for the absence of Maine pictures from the show.

Hartley and Regionalism

Among the first Maine landscapes Hartley exhibited after declaring himself the painter from Maine was *Smelt Brook Falls* (fig. 90), a painting he included with Nova Scotia and other Maine pictures at his inaugural exhibition in 1938 at the Hudson D. Walker Gallery, at 38 East Fifty-Seventh Street. His annual exhibitions with Hudson Walker, from 1938 to 1940, were crucial to his reception by critics and to his rise in stature as the acknowledged painter from Maine. *Smelt Brook Falls* was a product of the summer Hartley had spent in Georgetown with Isabel Lachaise, widow of the sculptor Gaston Lachaise. The vertically oriented composition focuses on the waterfall's powerful rush toward the viewer, who seems placed in the foreground pool. In this regard, the painting revisits a compositional scheme Hartley had explored around 1910 in pictures such as *Untitled (Maine Landscape)* (see fig. 33). The later painting is (for Hartley) pleasing and relatively picturesque. Similar adjectives might apply also to *Camden Hills from Baker's Island, Penobscot Bay* (fig. 91), also a vertical composition, bilaterally composed, with trees as a framing device. Hartley elaborated on this format in a small group of interior still lifes with window views beyond, including *Sea Window — Tinker Mackerel* (fig. 92) and *Summer, Sea, Window, Red Curtain* (see fig. 66), in which the watery vistas appear much like pictures within pictures.

Presenting a range of Maine subjects, the Hudson Walker exhibition constituted Hartley's full-fledged entrée into Regionalism, a nativist movement in American art that had coalesced and gained in influence since his 1932 show at the Downtown Gallery. Announced to a broad audience in December 1934, when the Missouri painter Thomas Hart Benton appeared on the cover of *Time* magazine, Regionalism answered the call for cultural rootedness in American art by championing local subject matter as an antidote to

90 | *Smelt Brook Falls*, 1937. Oil on commercially prepared paperboard (academy board), 28 x 22⅞ in. (71.1 x 58.1 cm). Saint Louis Art Museum, Eliza McMillan Trust

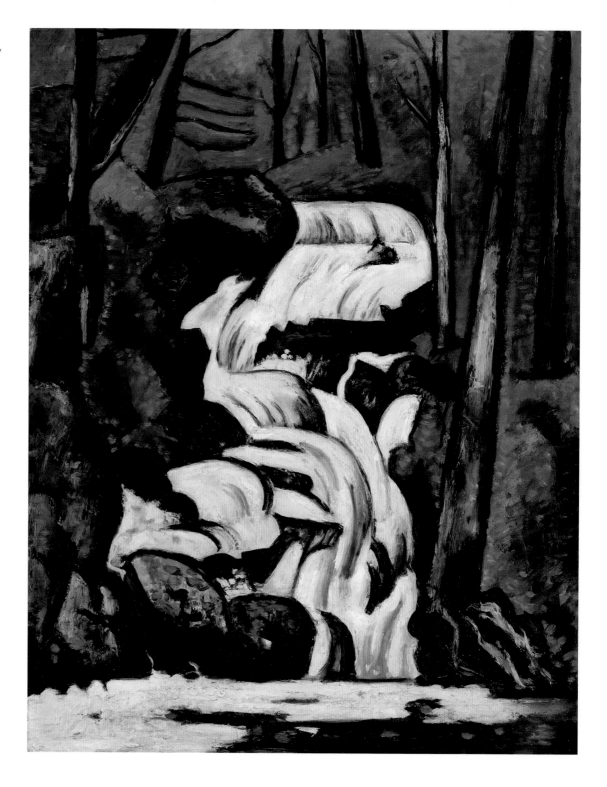

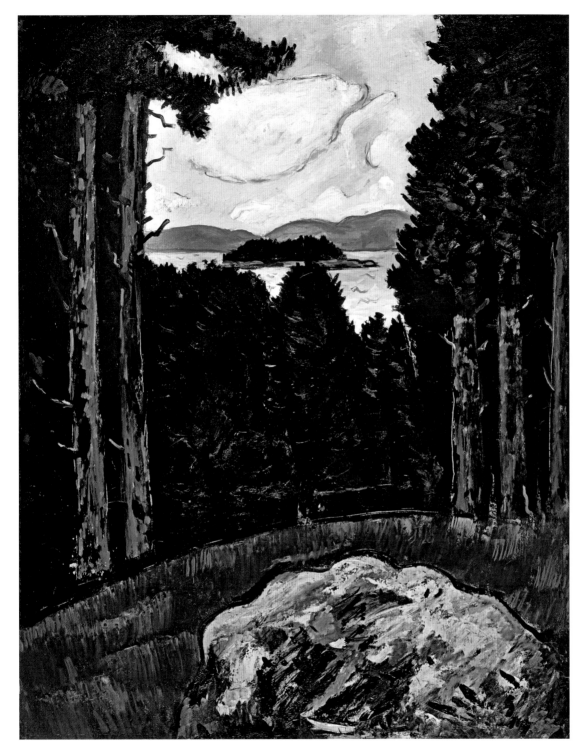

91 | *Camden Hills from Baker's Island, Penobscot Bay*, 1938. Oil on academy board, 27½ x 21⅝ in. (69.9 x 54.9 cm). Stedelijk Museum, Amsterdam, Gift of Hudson D. Walker, New York

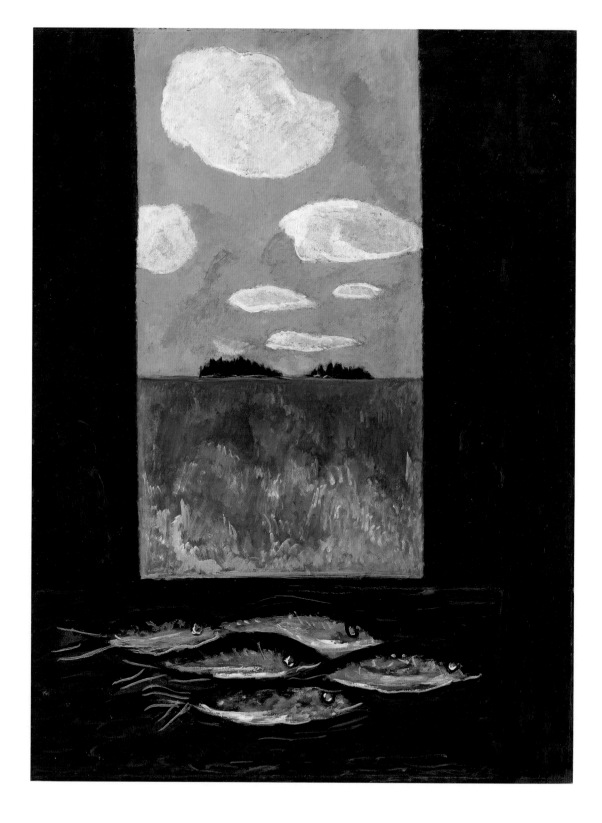

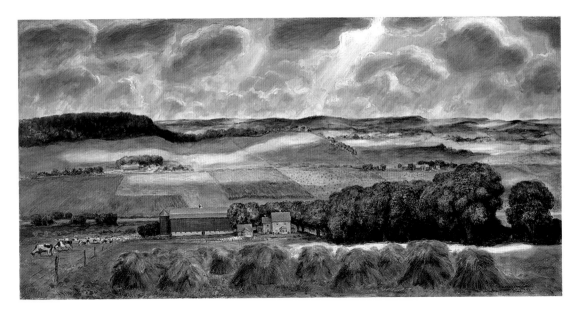

93 | John Steuart Curry (1897–1946). *Wisconsin Landscape*, 1938–39. Oil on canvas, 42 x 84 in. (106.7 x 213.4 cm). The Metropolitan Museum of Art, George A. Hearn Fund, 1942

imported ideas and aesthetics, namely, European modernism. While Hartley openly criticized such well-known Regionalist painters as Benton and Grant Wood, his Maine subjects share more with midwestern Regionalism ideologically than he may have liked to admit.[18] As James M. Dennis noted in describing Wood's Regionalist manifesto, *Revolt Against the City* (1935), "Its sentiments of personal identification with a region, one's native locale in particular, correspond to Hartley's rhetoric."[19]

Interestingly, in an unpublished essay Hartley acknowledged a degree of kinship with midwestern Regionalism and, moreover, offered John Steuart Curry mild praise, saying the Kansan "is the most convincing of all [the midwestern Regionalists] because he introduces nothing between himself and the origins of his experience," adding, "I believe in [Regionalism] basically . . . as I believe in my own return to the salt smitten rocks and the thunder-driven forests of my native Maine — as well as those majestic rivers that come down from North Katahdin country."[20] Hartley's ties to Regionalism — to Curry, specifically — were strengthened when his own *Lobster Fishermen* (see fig. 87) and Curry's idyllic panoramic *Wisconsin*

94 | Paul Sample (1896–1974). *Beaver Meadow*, 1939. Oil on canvas, 40 x 48¼ in. (101.6 x 122.6 cm). Hood Museum of Art, Dartmouth College, Hanover, Gift of the artist, Class of 1920, in memory of his brother, Donald M. Sample, Class of 1921

Landscape (fig. 93) both entered the collection of the Metropolitan Museum of Art in 1942, following their prizewinning appearances in the museum's wartime exhibition "Artists for Victory."[21]

As a comparison of *Lobster Fishermen* with *Wisconsin Landscape* suggests, Hartley's hard-bitten Maine compositions accentuate, by contrast, the relative aesthetic elegance that works by his midwestern contemporaries often exhibit. This difference in style and sensibility is owed in large part to divergent art-historical sources. Whereas Hartley evoked the untutored hand of the folk

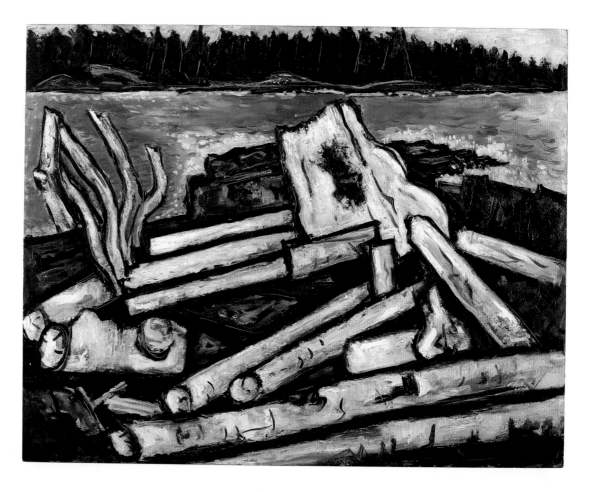

painter, with references to Paul Cézanne and Winslow Homer (discussed below), his midwestern contemporaries took their cues from the European Old Masters — Benton from Tintoretto and other sixteenth-century artists, Grant Wood from the Flemish Primitives, and Curry occasionally from Michelangelo (*Wisconsin Landscape* notwithstanding).

Despite their grounding in the Old Masters, the midwestern Regionalists were, somewhat surprisingly, more inclined than was Hartley to depict material evidence of the modern world, such as telephones and cars. Much the same could be said of Hartley's fellow New Englander Paul Sample, whose *Beaver Meadow* (fig. 94) shows the past (signified by the carriage and church) co-existing harmoniously with the present (the automobile

and churchgoers). By stark contrast, Hartley omitted any hint of technology and industry — cars and highways and other eyesores of modern life.

So far as Hartley's pictures would suggest, Maine's economy rested primarily, as it had for generations, on logging. Early, frenetic drawings show lumberjacks forcefully chopping and sawing wood (see figs. 18, 42, 43). But these workers are absent from such paintings as *Ghosts of the Forest*, *Abundance*, *Logjam (Backwaters Up Millinocket Way No. 3)*, and *Logjam, Penobscot Bay* (figs. 95–98), which focus on the end product of lumbering rather than its strenuous process. In *Abundance*, a lone axe embedded in the stacks evokes the great labor inherent in this rural occupation and its environmental consequences. These paintings bring to mind Maine's lumber industry and its

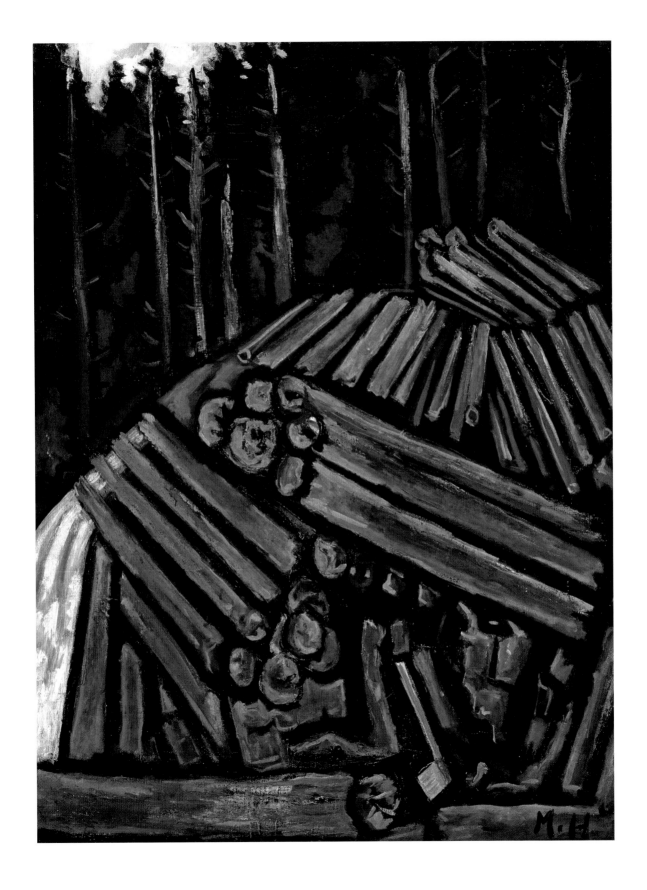

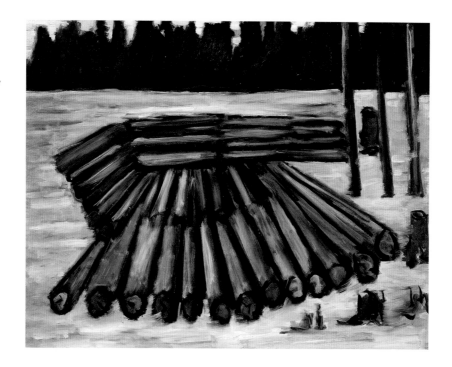

97 | *Logjam (Backwaters Up Millinocket Way No. 3),* 1939-40. Oil on masonite, 22 x 28 in. (55.9 x 71.1 cm). CU Art Museum, University of Colorado, Boulder

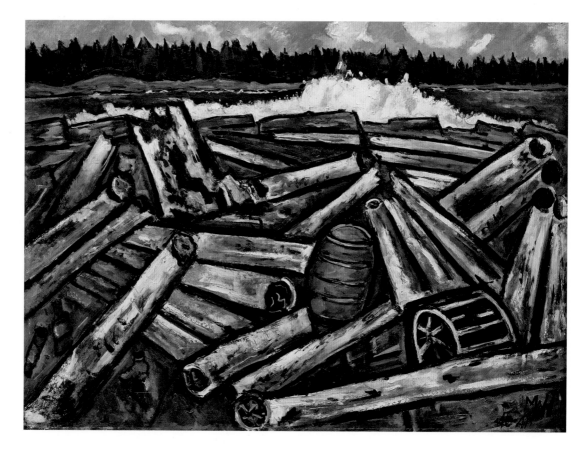

98 | *Logjam, Penobscot Bay,* 1940-41. Oil on masonite, 30 x 40⅞ in. (76.2 x 103.8 cm). Detroit Institute of Arts, Gift of Robert H. Tannahill

impact on the landscape and the great rivers — the Androscoggin, the Penobscot — which served as aquatic superhighways for the transportation of the harvested wood to the paper mills. Indeed, Hartley's logging images allude to the Great Northern Paper Company, which, based in Millinocket, held a virtual monopoly on the industry throughout the early twentieth century. When *Abundance* was exhibited at Hudson Walker's gallery in 1940, Hartley added the designation "for the office of a lumber company in the north," likely with the Great Northern in mind. Characteristically, however, he omitted any sign of manual labor or machinery, an omission that becomes even more evident when the painting is compared with John Beauchamp's mural *Logging in the Maine Woods*, installed in the Millinocket Post Office in 1942 (fig. 99), which celebrates the physical work of lumberjacking in addition to the state's natural resources. Hartley was less interested in narrative than in the repetitive interlocking and overlapping forms that the subject of logging provided, the kind of patterning at which he excelled. The logging pictures — logs neatly stacked and logs haphazardly piled — are also meditations on order and disorder.

Claiming the Coast: Winslow Homer's Centenary

Critical to Hartley's declaration of himself as the painter from Maine was his adoption of Maine's coastline as a signature subject. Whereas his early paintings of Maine focused on the state's western hills, beginning in 1936 he turned his attention to the sublime but potentially dangerous northern coastlines along the mainland and its surrounding islands (fig. 100). This shift is first evident in *Northern Seascape, Off the Banks* (see fig. 81), in which two boats embattled by raging waters and jagged rocks refer iconographically to Alty and Donny Mason, brothers who were drowned at sea in September 1936 off the coast of Eastern Points,

Nova Scotia (see pages 98–99 in this volume). Hartley would reprise and enlarge this composition in *Off the Banks at Night* (see fig. 85).

Hartley's adoption of the Maine coast can be attributed in part to his response to Marin's 1936 retrospective at the Museum of Modern Art. But Marin's show also coincided with another occasion that year about which Hartley was undoubtedly acutely aware: the centennial anniversary of the birth of Winslow Homer, the most heralded painter associated with Maine. In the years following Homer's death in 1910, his stature grew to legend, often concurrently with that of his contemporaries Thomas Eakins and Albert Pinkham Ryder. Individually and together, this trio entered the American cultural canon as a result of the dozens of monographic and group exhibitions mounted and studies published of their work throughout the early twentieth century, including the three-man show organized by Alfred H. Barr Jr. in 1930 at the Museum of Modern Art, an exhibition that Hartley attended. In a review not published in his lifetime, Hartley describes the exhibition as "a very revealing affair," but concludes that "none of these three artists has anything whatsoever to do with the other."[22]

The Homer centenary in 1936 generated another wave of museum and gallery exhibitions and tributes. In addition to commemorative installations at the Philadelphia Museum of Art,

99 | John W. Beauchamp (1906-1957). *Logging in the Maine Woods*, 1942. Mural, Millinocket Post Office

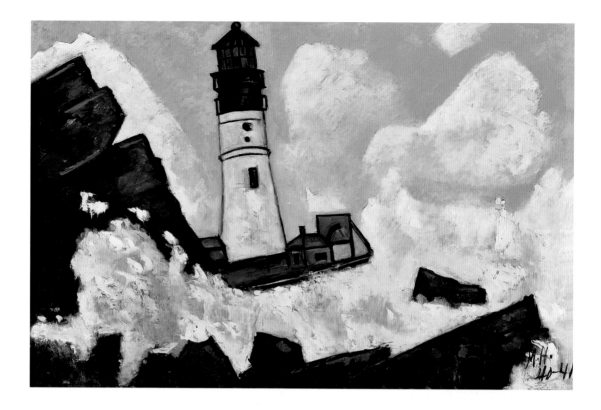

the Metropolitan Museum, and the Macbeth Gallery, as well as in Homer's house at Prouts Neck, the capstone event was the retrospective at the Whitney Museum of American Art, organized by Lloyd Goodrich, who would become one of the towering figures in Homer studies. In this context, critics heralded Homer's late paintings of the coastline at Prouts Neck as among the most exalted expressions of American art. As the critic for *Art Digest* wrote, "Homer found his great theme [in]. . . the sea and the rugged life of sea-folk," a recipe for success that would prove true also for Hartley.[23]

While Hartley had little use for the Philadelphian Thomas Eakins, he heartily embraced the two New Englanders — the Yankees. As several scholars, including Elizabeth Finch in this volume, have discussed, Hartley's exposure in 1909 to Ryder's visionary imagery, particularly his seascapes, profoundly anchored and reinforced his commitment to imaginative, memory-based painting. Homer's imagery, by contrast, exemplified nineteenth-century American Realism, an unmannered transcription of the observable world. In his collection of art criticism, *Adventures in the Arts: Informal Chapters on Painters, Vaudeville, and Poets,* published in 1921, Hartley devoted an entire chapter to Homer, praising him for his "Yankeeism of the first order," to which he attributed the painter's "fierce feeling for truth, a mania, almost, for actualities."[24] Hartley's praise, however, is notably measured: "Homer will not stimulate for all time . . . because his mind was too local. There is nothing of universal appeal in him." Moreover, he concluded, "It was Florida that produced the chef d'oeuvre in him."[25]

Revealingly, Hartley's criticism in 1921 that Homer was "too local" disappeared when he published thoughts about the Prouts Neck painter on two occasions in 1937, the year following the painter's centenary and during the heyday of

Regionalism. For one, in "On the Subject of Nativeness — A Tribute to Maine," the genesis of his own prodigal narrative, Hartley relocates the source of Homer's greatest artistic achievement from Florida to Maine, asserting that Homer "spent the most expressive part of his life at Prout's Neck."[26] Hartley claimed even closer personal and artistic identification with Homer in an article that appeared in the August 1937 edition of *Yankee* magazine, in which he confessed, "I have always been proud as a Yankee that Homer's inspiration and his sense of dramatic nature were derived chiefly from my native rocks, at Prout's Neck, Maine."[27] Framing Homer's localism now as a virtue, Hartley positioned himself as heir apparent to his artistic legacy, a title that some critics had bestowed upon Marin.

Between 1940 and 1942, Hartley produced three paintings of waves that powerfully evoke Homer's precedent, specifically the latter's epic pictures of the coast: *The Wave*; *Evening Storm, Schoodic, Maine*; and *Evening Storm, Schoodic, Maine, No. 2* (figs. 101–103). Massive waves dominate these compositions, expanses of sea and dark, stormy skies reminiscent of Ryder. Under Hartley's brush, the water has undergone a kind of transubstantiation, becoming rock-like and iconic. As Bruce Robertson has written of *Evening Storm, Schoodic, Maine*, "This is Homer's *Northeaster* [see fig. 6] modernized, made even more elemental and more powerful."[28] Rising up from the ocean, the wave is a threatening presence that confronts the viewer. The painting recalls Hartley's *Eight Bells Folly: Memorial to Hart Crane* (fig. 104), an

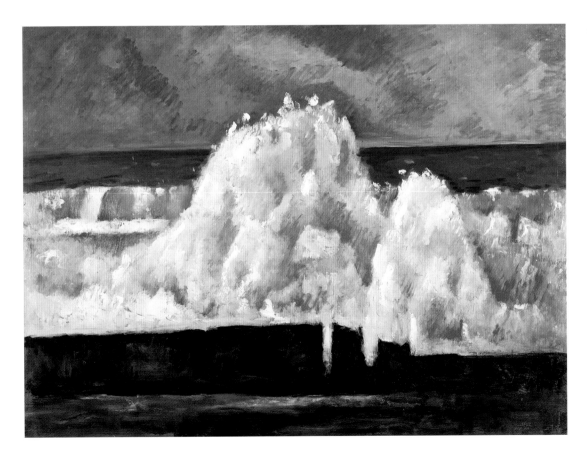

101 | *The Wave*, 1940–41. Oil on masonite-type hardboard, 30¼ x 40⅞ in. (76.8 x 103.8 cm). Worcester Art Museum

102 | *Evening Storm, Schoodic, Maine,* 1942. Oil on hardboard (masonite), 30 x 40 in. (76.2 x 101.6 cm). The Museum of Modern Art, New York, Acquired through the Lillie P. Bliss Bequest, 1943

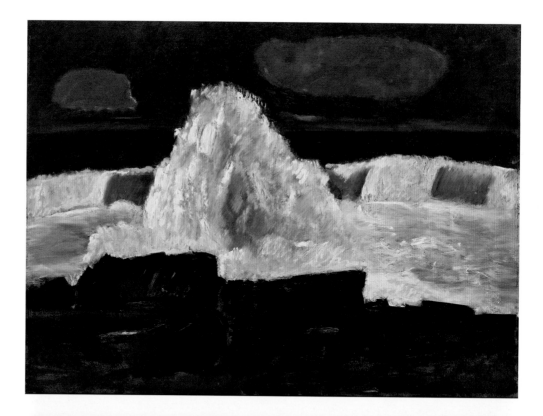

103 | *Evening Storm, Schoodic, Maine, No. 2,* 1942. Oil on hardboard (masonite), 30 x 40½ in. (76.2 x 102.9 cm). Brooklyn Museum, Bequest of Edith and Milton Lowenthal, 1992

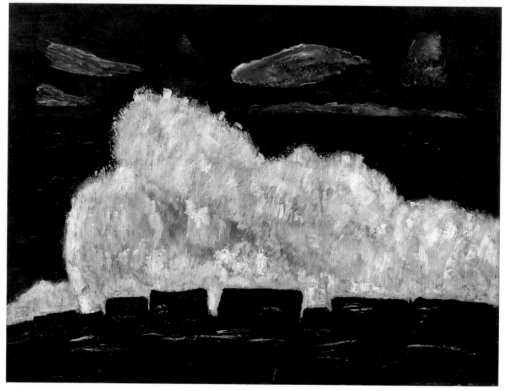

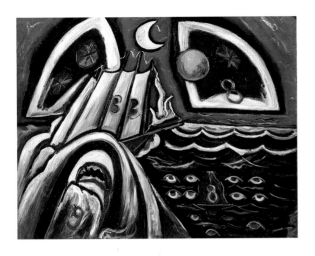

iconographically complex painting that commemorates the suicide of the poet Hart Crane at sea in 1933 by including a ravenous maw attacking a ship in the water.[29]

Hartley's symbolic conjoining of the ocean with death extended well beyond Crane's suicide to the Mason brothers and served as the theme of *Sea Burial* (1941), the final collection of poetry published in his lifetime. Associations with death account for the elegiac quality that infuse Hartley's coastal paintings, such as *Storm Down Pine Point Way, Old Orchard Beach* (fig. 105). This haunting depiction of three wave columns lapping onto a desolate beach testifies to the aesthetic daring and profundity of Hartley's fusion of Homer and Ryder reduced to basic elements, schematically rendered.

104 | *Eight Bells Folly: Memorial to Hart Crane*, 1933. Oil on canvas, 37⅝ x 45⅛ in. (95.6 x 114.6 cm). The Frederick R. Weisman Art Museum at the University of Minnesota, Minneapolis, Gift of Ione and Hudson D. Walker

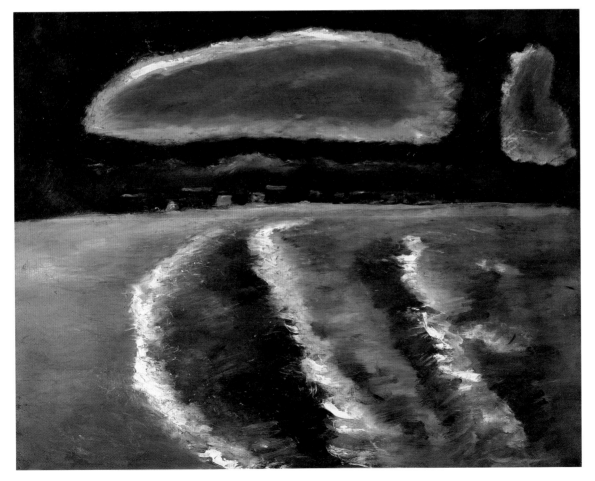

105 | *Storm Down Pine Point Way, Old Orchard Beach*, 1941–43. Oil on hardboard (masonite), 22 x 28 in. (55.9 x 71.1 cm). Crystal Bridges Museum of American Art, Bentonville, Arkansas

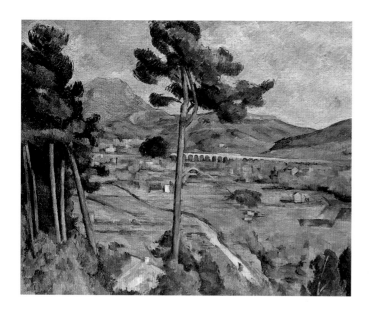
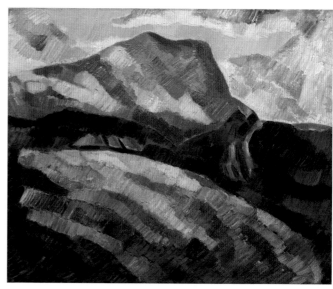

106 | Paul Cézanne
(1839–1906). *Mont Sainte-
Victoire and the Viaduct
of the Arc River Valley*,
1882–85. Oil on canvas,
25¾ x 32⅛ in. (65.4 x
81.6 cm). The Metropolitan
Museum of Art, H. O.
Havemeyer Collection,
Bequest of Mrs. H. O.
Havemeyer, 1929

107 | *Mont Sainte-Victoire*,
ca. 1927. Oil on canvas,
20 x 24 in. (50.8 x 61 cm).
Collection of Jan T. and
Marica Vilcek, Promised
Gift to the Vilcek
Foundation

108 | *Canuck Yankee
Lumberjack at Old
Orchard Beach*, 1940–41.
Oil on masonite-type
hardboard, 40⅛ x 30 in.
(101.9 x 76.2 cm). Hirshhorn
Museum and Sculpture
Garden, Smithsonian
Institution, Washington,
D.C., Gift of Joseph H.
Hirshhorn, 1966

Channeling Cézanne in Maine

The other great artistic touchstone for Hartley was another "Regionalist," but of a different variety and from a different region. While Homer's coastal views from Prouts Neck in combination with Ryder's dark marines came to bear on Hartley's late coastal seascapes, the work of Paul Cézanne pervades much of the late oeuvre. Hartley first saw paintings by the French Post-Impressionist in 1911, during a visit to the private New York collection of Henry and Louisine Havemeyer, a trove that included still lifes, portraits, and landscapes, including *Mont Sainte-Victoire and the Viaduct of the Arc River Valley* (fig. 106).[30] Hartley took many stylistic and technical cues from Cézanne at different stages of his career, occasionally with derivative results. He also wrote frequently about Cézanne in essays and personal correspondence. In one essay he compares Cézanne's accomplishments in painting with Walt Whitman's in poetry and prose.[31] In 1926 and again in 1927, an especially unsettled period for Hartley, he even lived in Aix-en-Provence and painted Cézanne's signature landscape subject, Mont Sainte-Victoire (fig. 107).

Hartley's late career reflects a deep and complex understanding of the French master. The figures in *Flaming American (Swim Champ)* and *Young Seadog with Friend Billy*, for example (see figs. 120, 122), sit impassively like Madame Cézanne in her many portraits. Hartley's lobster fishermen appear descended from Cézanne's static and similarly plebeian card players. Even his unfinished surfaces bring to mind Cézanne's practice of allowing the ground to show through. But perhaps most meaningfully, his paintings of Mount Katahdin follow Cézanne's model of sustained devotion to Mont Sainte-Victoire.

Hartley's most explicit and specific response to Cézanne is *Canuck Yankee Lumberjack at Old Orchard Beach* (fig. 108). Showing a deeply tanned male bather standing centrally against stacked expanses of beach, sea, and sky with arms and legs akimbo, the painting is based on sketches that Hartley made at Old Orchard Beach (figs. 109–115), a working-class summer destination known as a venue for bawdy hijinks.[32] To compose *Canuck Yankee Lumberjack* and *On the Beach* (see fig. 116), a related painting of a couple and a lone male figure

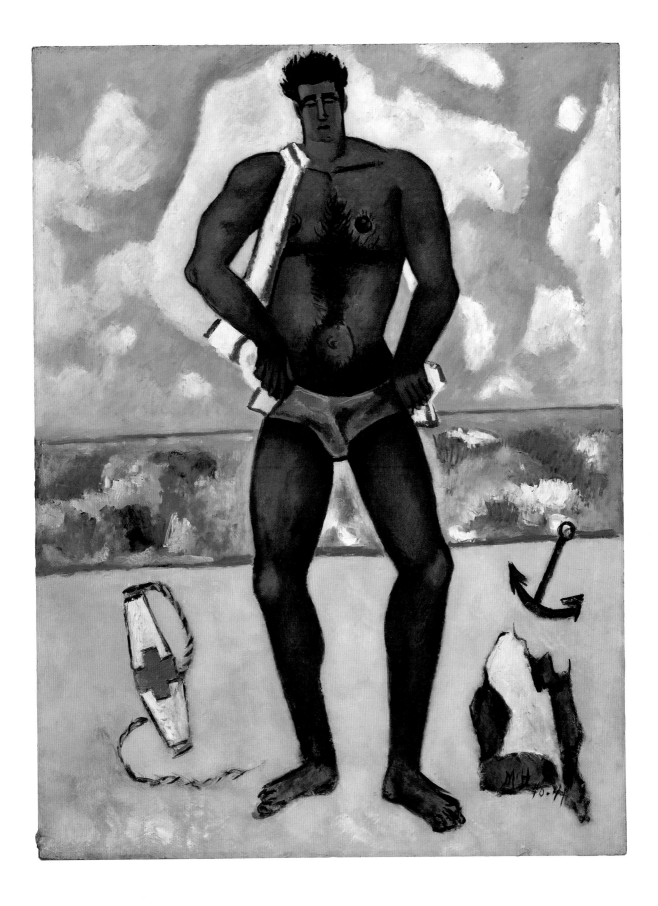

109 | *Untitled (Four Bathers at Old Orchard Beach),* ca. 1940. Graphite on paper, 4½ x 7 in. (11.4 x 17.8 cm). Bates College Museum of Art, Lewiston, Marsden Hartley Memorial Collection, Gift of Norma Berger

110 | *Untitled (Male Figure, Rope, and Buoy at Old Orchard Beach),* ca. 1940. Graphite on paper, 4¾ x 7¼ in. (12.1 x 18.4 cm). Bates College Museum of Art, Lewiston, Marsden Hartley Memorial Collection, Gift of Norma Berger

111 | *Untitled (Male Torso),* ca. 1940. Graphite on paper, 4¾ x 6 in. (12.1 x 15.2 cm). Bates College Museum of Art, Lewiston, Marsden Hartley Memorial Collection, Gift of Norma Berger

112 | *Untitled (Two Male Figures at Old Orchard Beach),* ca. 1940. Graphite on paper, 4½ x 7½ in. (11.4 x 19.1 cm). Bates College Museum of Art, Lewiston, Marsden Hartley Memorial Collection, Gift of Norma Berger

113 | *Untitled (Couple at Old Orchard Beach),* ca. 1940. Graphite on paper, 4½ x 7 in. (11.4 x 17.8 cm). Bates College Museum of Art, Lewiston, Marsden Hartley Memorial Collection, Gift of Norma Berger

114 | *Untitled (Four Figures at Old Orchard Beach),* ca. 1940. Graphite on paper, 4½ x 7 in. (11.4 x 17.8 cm). Bates College Museum of Art, Lewiston, Marsden Hartley Memorial Collection, Gift of Norma Berger

115 | *Untitled (Lone Male Figure, Front View),* ca. 1940. Graphite on paper, 11¾ x 9 in. (29.8 x 22.9 cm). Bates College Museum of Art, Lewiston, Marsden Hartley Memorial Collection, Gift of Norma Berger

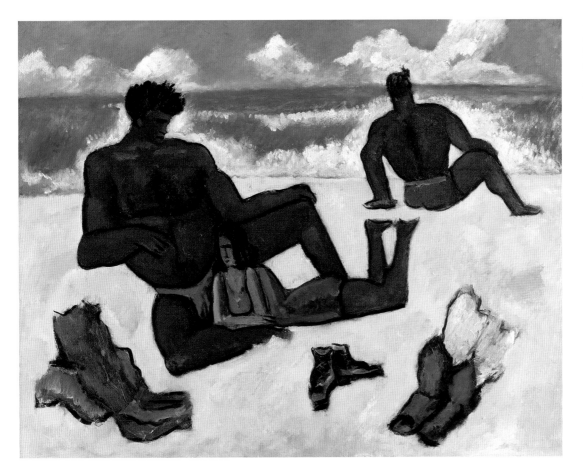

116 | *On the Beach*, 1940. Oil on masonite-type hardboard. 22 x 28 in. (55.9 x 71.1 cm). Ted and Mary Jo Shen, Courtesy James Reinish & Associates, Inc. and Meredith Ward Fine Art, New York

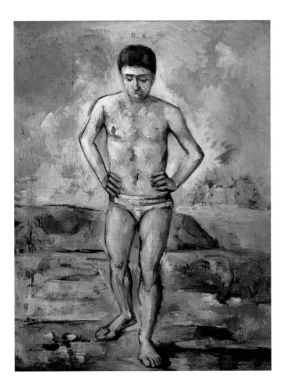

sunbathing, Hartley used details from the sketches and rearranged them on the canvas. *Canuck Yankee Lumberjack* unambiguously conjures Cézanne's *The Bather* (fig. 117), a painting Hartley would have known from his visits to the Museum of Modern Art, where it entered the collection in 1934.[33] In 1940, MoMA lent this work to the exhibition "Masterpieces of Art" at the New York World's Fair, where Hartley could also have seen it, along with the Metropolitan's (formerly Havemeyer) *Mont Sainte-Victoire and the Viaduct of the Arc River Valley* and *The Card Players*, which may have sparked his own interpretations of related subjects. Hartley's male bather, however, is darker, his tanned skin silhouetted against a bright cloud-filled sky, and more erotically charged, with his bulging pink swim trunks occupying center stage and bisected

117 | Paul Cézanne (1839–1906). *The Bather*, ca. 1885. Oil on canvas, 50 x 38⅛ in. (127 x 96.8 cm). The Museum of Modern Art, New York, Lillie P. Bliss Collection

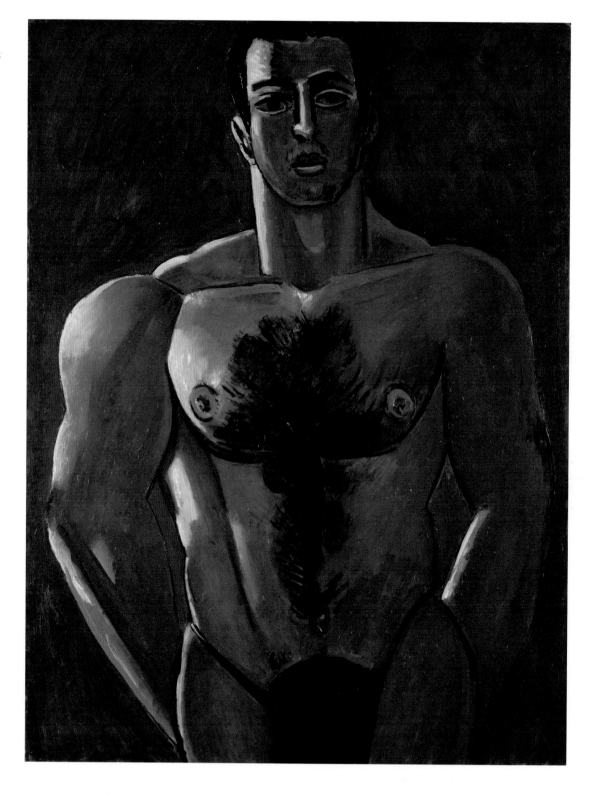

118 | *Madawaska—Acadian Light-Heavy*, 1940. Oil on hardboard (masonite), 40 x 30 in. (101.6 x 76.2 cm). The Art Institute of Chicago, Bequest of A. James Speyer

by the horizon line. This particular pink hue connects Hartley's bather to the standing man in *Lobster Fishermen* (see fig. 87), which he painted around the same time.

Embodying Maine

Canuck Yankee Lumberjack is one in a group of distinctive figure compositions that Hartley painted in his final years. Together, they constitute a fraternity of stoic, often solitary, rural hunks — lobster fishermen, lumberjacks, and athletes. The men in Hartley's paintings have awkward, unnaturally constructed, blocky bodies that assert a hyperphysicality, a quality enhanced by the absence of extraneous details in the spaces they inhabit. Hartley's decidedly anti-academic, intentionally unrefined technique imbues the figures with an alluring combination of toughness and tenderness, an unconventional sensuality that renders them immediate yet remote. In general, they confront the viewer directly (*On the Beach* is a notable exception). The most striking among them, such as the figures in *Madawaska — Acadian Light-Heavy* (fig. 118) and *Canuck Yankee Lumberjack*, are isolated, like saints, and, as in the latter, often with attributes — a buoy, a fish, antlers, a piece of rope — here regional rather than explicitly religious.

Imposing in their blunt corporality and partial nudity, the powerful male bodies in Hartley's paintings find multiple and provocative corollaries in the artist's extant personal effects, which include several photographs of seminaked and naked men (some known by name, others not), as well as fitness magazines he collected over many years (fig. 119).[34] In view of this cache, Hartley's late male figure paintings appear to be bold, even audacious extensions of private desire into the public arena in the mid- and late 1930s, when, in the wake of the repeal of Prohibition in 1933, local and state authorities increasingly surveilled and criminalized homosexuality.[35] That Hartley daringly flaunted social mores by exhibiting these paintings led art

119 | Shirtless man standing on a rock. Marsden Hartley Collection, Yale Collection of American Literature, Beinecke Rare Book & Manuscript Library, Yale University, New Haven

historians in the 1980s and 1990s to enshrine him within the newly formed canon of gay modern artists. Critics in the painter's own day, however, turned a blind eye to their homoerotic potency (if they recognized it at all), emphasizing — even lauding — their "masculine," "American," and "primitive" character, qualities they mapped furthermore on to the artist's public artistic identity.[36] When Hartley exhibited *Flaming American (Swim Champ)* (fig. 120) and *Madawaska — Acadian Light-Heavy* at the Hudson D. Walker Gallery in 1940, he identified them as wall panels "for a junior gym" and "for a training gym," respectively, designations that placed these images within homosocial and normalizing spatial contexts.

Hartley's figures are not portraits, as the sitters' identities are not revealed. This suppression of the sitters' names could be seen to parallel the secrecy that surrounded and obscured homosexual identity throughout his lifetime. A case in point is the figure in *Flaming American*. As Hartley disclosed in private correspondence, his muse was the nephew of his friend Claire Evans.[37] William (Bill) Moonan was a Yale senior and freestyle swimming star (fig. 121), and Hartley met him in July 1939, when

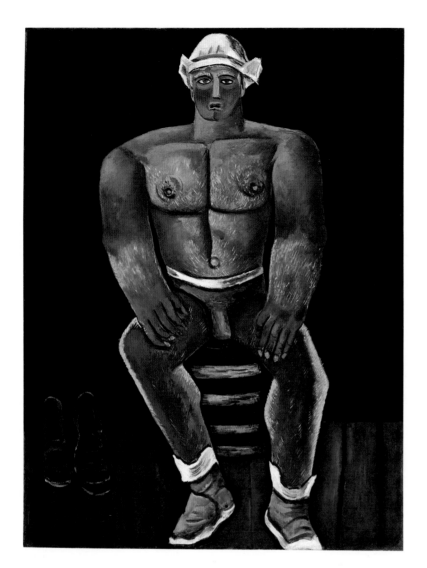

120 | *Flaming American (Swim Champ)*, 1939–40. Oil on canvas, 40⅜ x 30¾ in. (102.6 x 78.1 cm). Baltimore Museum of Art, Purchase with exchange funds from the Edward Joseph Gallagher III Memorial Collection

121 | William (Bill) Moonan, ca. 1939. Marsden Hartley Collection, Yale Collection of American Literature, Beinecke Rare Book & Manuscript Library, Yale University, New Haven

they both arrived as guests at Evans's Bagaduce Farm, in West Brooksville, Maine.[38] In the painting Hartley diminishes Moonan's hydrodynamism, instead emphasizing the swimmer's physical bulk — he looks as though he would sink like a rock rather than remain afloat in water. Indeed, the great bulk of the figure in *Flaming American* stands in stark contrast to Moonan's long, and quite elegant, proportions, which are featured in a small group of unprinted photo negatives in Hartley's possession that show the Yale swimmer posing on coastal rocks.[39] In the painting Moonan's body is illumined in a warm golden glow.

As *Canuck Yankee Lumberjack* and *Flaming American* suggest, Hartley's lobstermen, lumberjacks, hunters, and athletes, despite their stasis, throb with life. Aggressively asserting their physical vitality while at the same time projecting a saint-like divinity, they call to mind Walt Whitman, whom the painter described, together with Cézanne, as among the great liberating voices in the arts.[40] Hartley's invocation of a kind of corporeal spirituality evokes passages from Whitman's notoriously sensual "Song of Myself," from the poetry collection *Leaves of Grass*:

Divine am I inside and out, and I make holy whatever
 I touch or am touch'd from,
The scent of these arm-pits aroma finer than prayer,
This head more than churches, bibles, and all the
 creeds.
If I worship one thing more than another it shall be
 the spread of my own body, or any part of it.[41]

Like Whitman, Hartley used the language of worship and veneration to suggest sensuality and desire, but whereas Whitman's authorial "I" celebrates his own physical divinity, Hartley occupied a different position vis-à-vis the figures he painted, which are perpetually at a psychological remove.

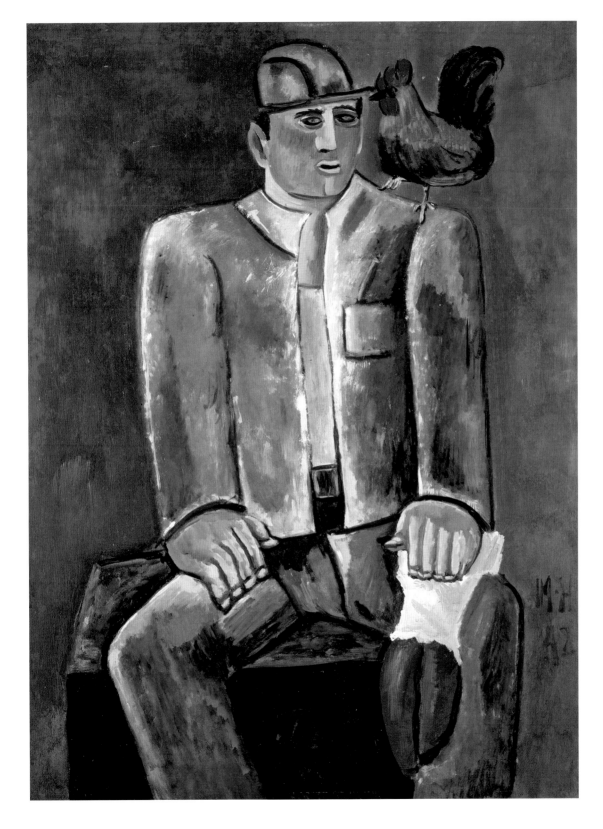

122 | *Young Seadog with Friend Billy*, 1942. Oil on canvas, 39½ x 29 in. (100.3 x 73.7 cm). Private collection, Bloomfield Hills, Michigan

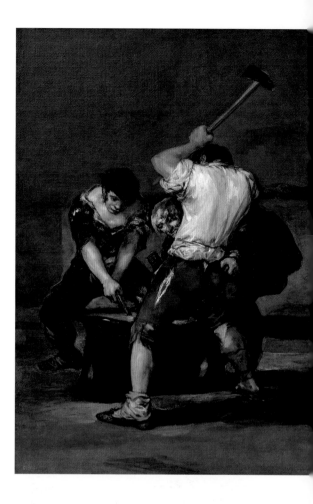

123 | Adolf Ziegler (1892–1959). *The Four Elements: Fire, Water and Earth, Air*, 1937. Oil on canvas, 66⅞ x 106¼ in. (169.9 x 269.9 cm). Pinakothek der Moderne, Bayerische Staatsgemälde-sammlungen, Munich

FACING PAGE
124 | *Knotting Rope*, 1939–40. Oil on board, 28 x 22 in. (71.1 x 55.9 cm). Private collection, New York

125 | Francisco de Goya y Lucientes (1746–1828). *The Forge*, ca. 1815–20. Oil on canvas, 71½ x 49¼ in. (181.6 x 125.1 cm). The Frick Collection, New York, Henry Clay Frick Bequest

"I only wish I were a big husky brute, a prize fighter or something like it," he confessed to his niece Norma Berger many years earlier. "It makes me terribly envious when I see men swimming or running or boxing."[42] Thus, Hartley's figures appear inflected by his own sense of difference, which grew stronger as he became older and weaker with age. Enhancing their musculature to superhuman proportions, the painter inscribed his desire and implied difference on to their bodies to a degree that borders on masochism.

Even so, Hartley gave a few of his figures at least one of his own physical attributes: piercing blue eyes. Proud of his bright baby blues, he bestowed them on the figures in *Young Hunter Hearing Call to Arms*, *Down East Young Blades* (see figs. 77, 78), *Flaming American*, and *Young Seadog with Friend Billy* (figs. 120, 122), suggesting self-reference. This feature is most emphatic in *Young Seadog with Friend Billy*, his final figure painting, which Hartley conceived as a self-portrait, albeit one in which he appears imaginatively as a young sailor.[43]

The combination of blue eyes and blond hair in *Young Hunter*, *Flaming American*, and *Down East Young Blades* also illuminates the racial and Aryan biases that Hartley harbored throughout his life, articulated in a letter of 1933: "It seems as if the good old Anglo-Saxon[s] were sort of

being stamped out."[44] Removed from recent waves of immigration and heterogeneous populations in New York, Maine was a place in which Hartley imagined a vital Yankee "race" composed of a eugenically desirable blend of Northern European, French Canadian, and, in some instances, Portuguese bloodlines.[45] To the degree that Hartley's male figure paintings promoted a particular notion of ethnic superiority, they found a rather unfortunate contemporaneous parallel in the official art of Nazi Germany. However, the anti-academism of the American's style disavows the neoclassicism of the idealized bodies depicted by Arno Breker and Adolf Ziegler (fig. 123), among other painters and sculptors working for the Third Reich.

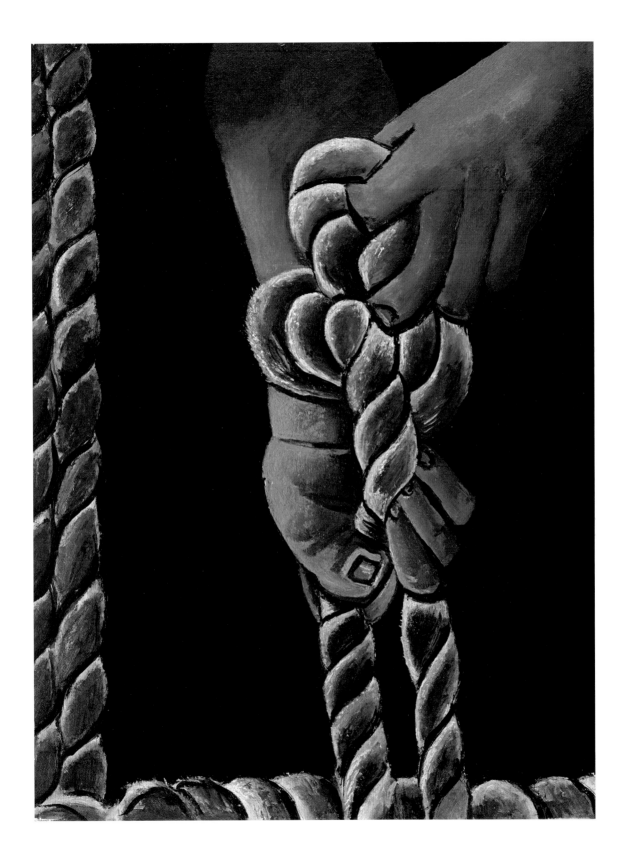

Hartley's irrepressible need to monumentalize the male figure was also part of a broader cultural phenomenon in American art in which the working-class male body grew to epic scale, often in post offices, civic buildings, and train stations, among other public buildings across the country. Images of supernaturally muscular men proliferated throughout the early twentieth century, fueled by class conflict and the emergence of labor unions.[46] The pervasive cultural and artistic exaltation of the working-class male body extended well into the 1930s in the context of the Works Progress Administration, the most ambitious of Roosevelt's New Deal programs for the unemployed. Hartley served brief stints in the WPA Federal Art Project, in the easel division, in 1934 and 1936.[47] His figures, however, diverge from the vast majority of WPA depictions of laborers in their perpetual inactivity, their detachment from actual work.

A notable exception is *Knotting Rope* (fig. 124), a stark and inventive picture of two hulking, disembodied hands twisting thick cords of rope, a composition that in subject harkens back to Hartley's early, frenetic drawings of Maine workers (see figs. 42, 43), but with its taut, intertwined forms recalls the abstract patterns of the German Officer series (see fig. 7). This memorable depiction of straining muscular forearms against a dark ground furthermore brings to mind Goya's *The Forge* (fig. 125), a resonant depiction of blunt physical force that Hartley described in an essay as "that brilliant piece of modern painting." It ranked with Rembrandt's *The Polish Rider* as his two favorite paintings in the Frick Collection. "These pictures are like great music to me," Hartley wrote, "because they burn into my acute senses like . . . bronze bells and great voices."[48]

Claiming Mount Katahdin

Hartley's most profound artistic response and tribute to Cézanne remains his series of approximately fifteen paintings of Mount Katahdin, which he

began in 1939 and which ended with his death in 1943. The paintings of Katahdin and its immediate environs extended his lifelong fascination with the mountain as a subject, an interest that has been attributed to a wide range of factors, from the spiritual to the commercial.[49] Several of Hartley's writings suggest that he identified personally with mountains, seeing them, like himself, as remote, isolated, and lonely.[50] Echoing Hartley's early paintings of Maine's western hills, the Katahdin series marks the culmination of the most enduring and dramatic thematic arc in Hartley's oeuvre.

In his personal correspondence, Hartley expressed his desire not only to be identified publicly with Katahdin, but to serve as its "official portrait painter."[51] Throughout the fall of 1939 he made plans and preparations for a pilgrimage to the site, which, following an overnight stay at Cobbs Camp (fig. 126), occurred over eight days in October. The view of Katahdin — which rises to nearly 5,300 feet — that he adopted for the paintings, which shows the mountain's profile to its most impressive effect, came on the recommendation of his hiking

companion, Caleb Warren Scribner, the chief fish and game warden of the district. Elaborating on sketches he made of the mountain looming over Katahdin Lake (figs. 127, 128), Hartley developed a compositional scheme as the basis for the pictures. The scheme generally consists of four component parts: lake, foothills, mountain, and a strip of sky often with rock-like clouds, a combination that reprises his earliest paintings of Maine (see fig. 32).

In emulation of Cézanne's repeated views of Mont Sainte-Victoire, Hartley in the Katahdin paintings adjusted and refined these compositional elements in both shape and tone, in a sustained series that literary historian Emily Setina has related to his editing process as a writer.[52] The serialty and seasonality of the Katahdin paintings also call to mind the views of Mount Fuji by Hokusai and Hiroshige (fig. 129), artists Hartley also admired and considered as he returned over time to his mountain subject: "I never tire of [Katahdin] — after all Hiroshige did 80 wood blocks of Fujiyama why can't I do 80 Katahdins — and each time I do it I feel I am nearer the truth."[53]

In the context of the Katahdin project, Hartley used the mountain and its surroundings to explore the profound tension between permanence (in the form of monumental geology) and change (the seasons and the passage of time). The recurring focus in the late work on permanence and monumentality, most evident in the Katahdin series, evokes Hartley's own aspiration to achieve high stature and a far-reaching legacy as an artist (figs. 130–135).[54]

Association with Katahdin was a critical dimension of Hartley's campaign to be recognized as Maine's greatest and most representative artist. As

Cassidy has argued, the mountain served as a popular geological synecdoche for the state generally, not only for native Mainers but for those residing far beyond the state's borders. Indeed, Katahdin figured prominently in headlines and news stories across the country throughout the 1920s and 1930s for reasons ranging from the much heralded completion in August 1937 of the Appalachian Trail, with Katahdin as its northernmost terminus, to captivating accounts of hikers gone missing in its famously treacherous terrain. The harrowing saga of the twelve-year-old hiker Donn Fendler especially gripped the Northeast throughout July 1939, only three months before Hartley's journey in October. The boy's disappearance for eight days, which unleashed an army of more than three hundred rescuers accompanied by bloodhounds, filled

newspaper columns across the country. That young Fendler's home was in Rye, New York, meant that the story was covered extensively in *The New York Times*, from his disappearance to his homecoming celebration.[55] Thus Katahdin was not only iconic for Mainers, it was also timely, especially for New Yorkers, as Hartley claimed the mountain as his own.

1939: Cézanne's Centenary

That Hartley's determination to adopt Katahdin for himself coalesced in 1939 must be attributed both to the allure of the mountain as an icon of state identity and to the art-historical and cultural circumstances specific to that year. Nineteen thirty-nine marked the centenary of Cézanne's birth — January 19, 1839 — an anniversary

commemorated throughout the year with a host of exhibitions, tributes, and publications in London, Lyon, and Paris, among other locations. The occasion was a source of such national pride that France issued a commemorative stamp (fig. 136), which combined the painter's *Self-Portrait* (ca. 1895; private collection) with a depiction of Mont Sainte-Victoire, a conflation that underscored visually and symbolically the artist's deep connection to his home.

The centenary and the commemorative stamp made headlines also in America: "Next Thursday marks the hundredth anniversary of the birth of Paul Cézanne, the father of modern painting — that wholly unpredicted, greatly controversial, superbly defiant break with the past," critic R. E. Turpin announced in the January 15, 1939, edition of *The New York Times*.[56] The message carried by the article's headline — "Cézanne Still Dominates the Era He Launched" — was reinforced by a wide range of exhibitions and other events. American art journals, among them *Art Digest* and *Arts Magazine*, announced the publication of the commemorative stamp. Not least of all, *The New York*

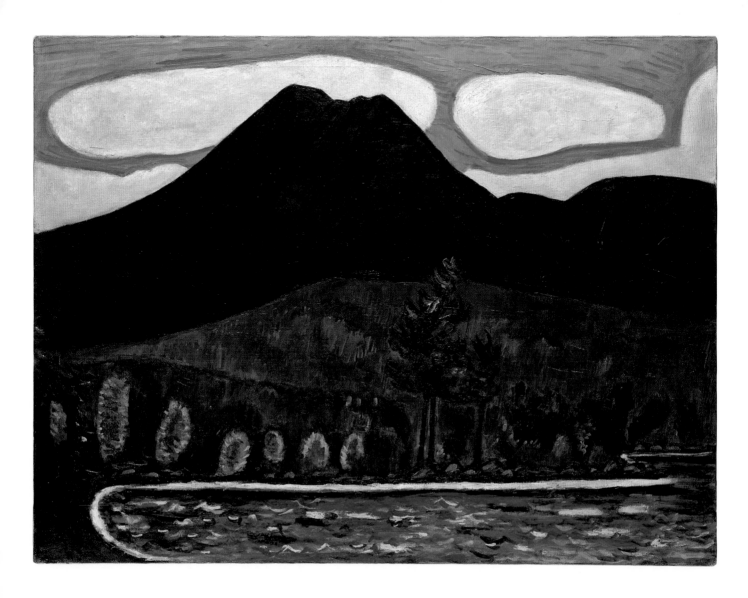

132 | *Mount Katahdin,
Autumn, No. 2*, 1939–40.
Oil on canvas, 30¼ x
40¼ in. (76.8 x 102.2 cm).
The Metropolitan Museum
of Art, Edith and Milton
Lowenthal Collection,
Bequest of Edith
Abrahamson Lowenthal,
1991

Times, on March 26, reproduced the stamp's design and described it as "a portrait of the painter against a background of the Pyrenees."[57]

News of the Cézanne stamp reached Hartley, who concluded a friendly letter on June 2 to fellow artist Max Weber, "Don't you think it remarkable in these times that the French gov't has issued a Cezanne [*sic*] postage stamp." Reflecting on their recent encounter at the World's Fair, where they both had paintings in the exhibition of contemporary art, Hartley noted that the context of

impending war enhanced the stamp's relevance: "I feel the survival of the artistic spirit so valuable these days with the general disturbances at hand."[58] As evidence of Cézanne's inviolable position in France's cultural pantheon, the centenary stamp would have figured prominently in Hartley's imagination as he sought recognition as a great American artist. Indeed, it offered a key to the means by which national greatness could be achieved, and bestowed by association with place. Thus Mount Katahdin, Maine's counterpart

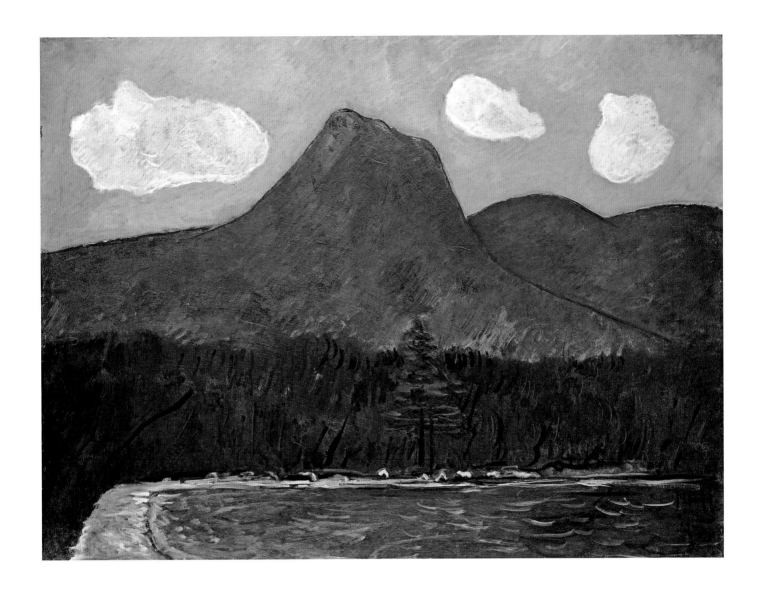

to Aix's Mont Sainte-Victoire, fell squarely in Hartley's sights. As he wrote to his friend Helen Stein on September 29, the month before his trip, "I must get that Mt. for future reason of fame and success."[59]

Promoting Katahdin

It was important for Hartley not only to paint Katahdin, but also to underscore his connection to the site both in Maine and in New York. A photograph published in the *Bangor Daily News*

on February 8, 1940, marks the earliest instance of Hartley's efforts to this end (fig. 137). Printed ostensibly to announce the painter's temporary position as a teacher at the Bangor Society of Art, the image, accompanied by the headline "Katahdin As Seen By Bangor Painter," exemplifies the radical transformation in artistic identity that Hartley underwent from the 1910s to the 1930s. Whereas Alfred Stieglitz's photographic portrait from 1916 (see fig. 1) shows a remote, intense, cosmopolitan aesthete wrapped in a heavy black coat and elegant

133 | *Mount Katahdin, November Afternoon,* 1942. Oil on masonite, 30 x 40 in. (76.2 x 101.6 cm). The Nelson-Atkins Museum of Art, Kansas City, Missouri, Gift of Mrs. James A. Reed in memory of Senator James A. Reed through the Friends of Art

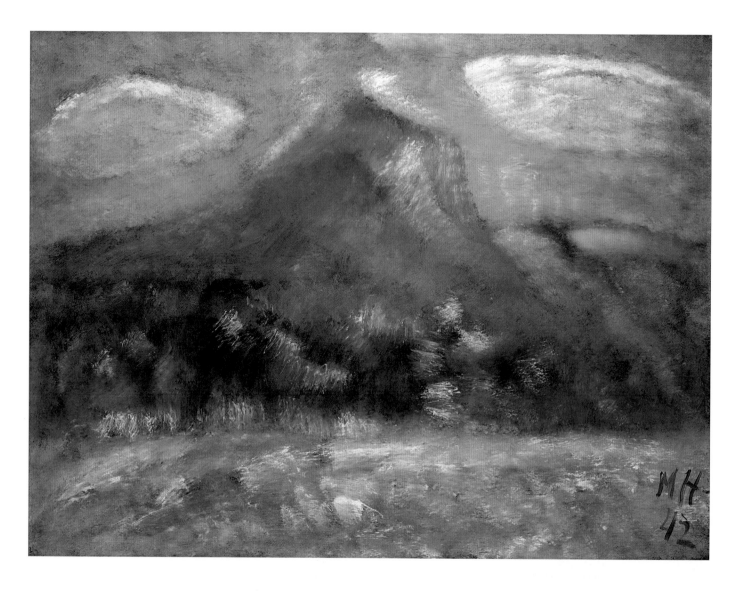

134 | *Mount Katahdin, Snowstorm*, 1942. Oil on masonite. 30 x 40 in. (76.2 x 101.6 cm). Michael Altman Fine Art & Advisory Services, LLC, New York

scarf, in the image from 1940 the painter — without a trace of the urbane sophisticate — addresses his viewer directly, wears a down-home plaid shirt and striped vest, and holds a smoking pipe. "Mr. Hartley, after years in Paris, Munich and New York, has returned to his native state and is painting mountain, shore and forest," proclaims the extended caption.[60]

On the easel next to Hartley is *Mount Katahdin, Autumn, No. 2* (see fig. 132), testament to the arduous and transformational experience of scaling the mountain the previous October. The

photograph subtly integrates the painter with his subject. Standing very close to each other, almost touching, both Hartley and his canvas face the viewer, without ceremony — the new painting even lacks a proper frame. Dressed in warm, rural attire, Hartley could easily inhabit the rugged autumnal landscape. His sloping shoulders echo and extend Katahdin's contours. And his ovoid head seems to hover over his body like one of the irregularly shaped clouds floating heavily above.

A month after the Bangor photo shoot, *Mount Katahdin, Autumn, No. 1* (see fig. 131) appeared on

the cover of the catalogue for Hartley's third and final exhibition at the Hudson D. Walker Gallery. In addition to *Autumn, No. 1* and *Autumn, No. 2*, two other paintings of Katahdin were included: *Mount Katahdin, Maine, First Snow, No. 1* (1939–40; private collection) and *Mount Katahdin, Maine, First Snow, No. 2* (Newark Museum). The exhibition marked a dramatic upturn in Hartley's fortunes, as critics praised the vitality and authenticity of his most recent efforts. "No less an authority than Waldo Peirce vouches for it that Hartley is seeing Maine with fresh unjaundiced eyes," wrote the critic for *Magazine of Art*, "and anyone who has seen the two amazing Mount Katahdin canvases (*Autumn* and *First Snow*) will not think Peirce is guilty of overstatement."[61]

Convincing in its portrayal of Hartley's confident ease and comfort in his role as the painter from Maine, the *Bangor Daily News* photograph betrays none of — obfuscates, even — the emotional turmoil that his personal correspondence from this time lays bare. A letter to Hudson Walker written in December 1939 (between his trip to Mount Katahdin in October and his appearance in the local newspaper the following February) reveals desperation and a more fraught relationship with his home state than the photograph would suggest and that art historians and critics have tended to admit. Hartley complains of illness and a lack of money ("God knows I never needed a boost more than I do now and by boost I mean money."), a concern he expressed frequently in

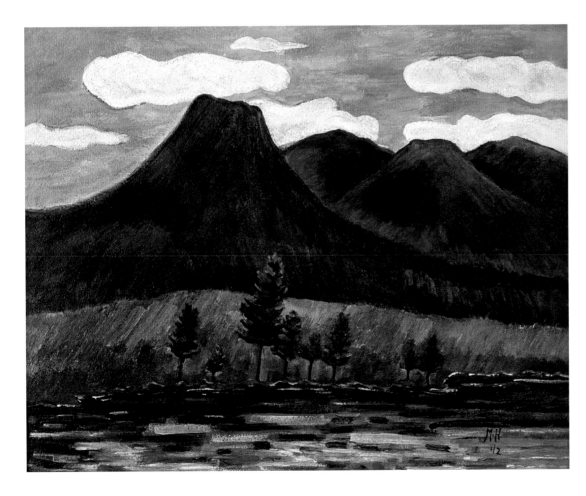

135 | *Blue Landscape*, 1942. Oil on commercially prepared paperboard (academy board), 16 x 20 in. (40.6 x 50.8 cm). Princeton University Art Museum, Museum Purchase, Fowler McCormick, Class of 1921, Fund and Kathleen Compton Sherrerd Fund for Acquisitions in American Art

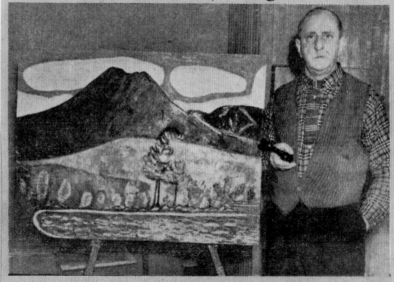

Katahdin As Seen By Bangor Painter

This view of Mount Katahdin was painted by Marsden Hartley, American artist who was born in Lewiston, Maine, and who for the winter months is in Bangor as an instructor for the Bangor Society of Art.

Mr. Hartley, after years in Paris, Munich and New York has returned to his native state and is again painting mountain, shore and forest. He has made a wide reputation as an artist, and the Art society feels fortunate in having him this winter as an instructor in painting and sketch classes.

Mr. Hartley stands beside his canvass.

136 | Commemorative stamp of Paul Cézanne, 1939

137 | "Katahdin As Seen By Bangor Painter," *Bangor Daily News*, February 8, 1940. Marsden Hartley Collection, Yale Collection of American Literature, Beinecke Rare Book & Manuscript Library, Yale University, New Haven

his correspondence, especially to his dealers. In addition to cautioning Walker against underpricing his paintings for well-heeled collectors — namely, Duncan Phillips — Hartley unleashes midway through his letter a raw, heart-wrenching, misogynistic bitterness that bespeaks struggle, neglect, and years of personal and professional loss: "I am pent up in a lot of things. . . . I am a first class hater now — I hate life and I hate art — lots of men turn on their wives later in life and never speak to 'em — I've been married too long to art to tolerate the bitch any longer."[62] Hartley takes aim even at his students at the Bangor Society of Art ("[a] class of pathetic old ladies who have passed their menopause").[63] While association with Maine offered Hartley his greatest opportunity for artistic renown in 1930s American culture, it came with a price he occasionally resented, particularly the extended periods of isolation that rural life entailed.

Achieving a "High Spot"

Around 1940 Hartley drew up plans for a modest two-story house, calling it "High Spot, House for Me on a Granite Ledge." In addition to exterior elevations, the plans include two revealing views of the living room (fig. 138), appointed with simple furnishings and maps of Maine. One of Hartley's portraits of Abraham Lincoln takes pride of place over the mantel, while another painting of an unidentified male figure appears on the opposite wall. The most telling detail is the single rocking chair near the fireplace, which, like the caption for the plan, indicates that Hartley expected to live out his remaining years companionless, save for the men conjured by the works of art in his midst. Hartley's unrealized plan for High Spot poignantly expresses his yearning for a home while at the same time evoking its absence. The self-proclaimed painter from Maine never really settled there,

either physically or psychologically. Hudson Walker put the matter another way in an interview with Elizabeth McCausland in 1959: "Hartley died as a resident of Maine [but] . . . his property was all in New York. He had nothing in Maine except a few paintings."[64]

While Hartley never completed his plans for High Spot, he did, before his death, achieve another kind of elevated position — recognition as a great American painter. In addition to positive reviews, awards, and the acquisition of his work by museums and private collectors, Hartley in the final months of his life received undeniable proof of his newfound stature: a contract with the New York gallery recently opened by the renowned French dealer Paul Rosenberg, an association that strengthened his connection to Cézanne (whose work Rosenberg also represented), and plans for a retrospective at the Museum of Modern Art.

Hartley died at the age of sixty-six in early September 1943, and the MoMA show became a memorial exhibition the following year. Many believed that he had died in his prime — indeed, before his time: "Hartley's death did not come too soon to allow him satisfaction and realization. It was too soon for the world, for it terminated a still vigorous and clearly visioned painting career," read the obituary in *Art Digest*.[65] One is tempted to speculate how Hartley, had he lived longer, would have responded to the new ideas and stimuli that emerged in American art after World War II. What we know, however, is that his complex personal and artistic engagement with Maine late in his career elevated him to the stature to which he aspired.

138 | *"High Spot," House for Me on a Granite Ledge*, ca. 1940. Graphite on paper. Bates College Museum of Art, Lewiston, Marsden Hartley Memorial Collection

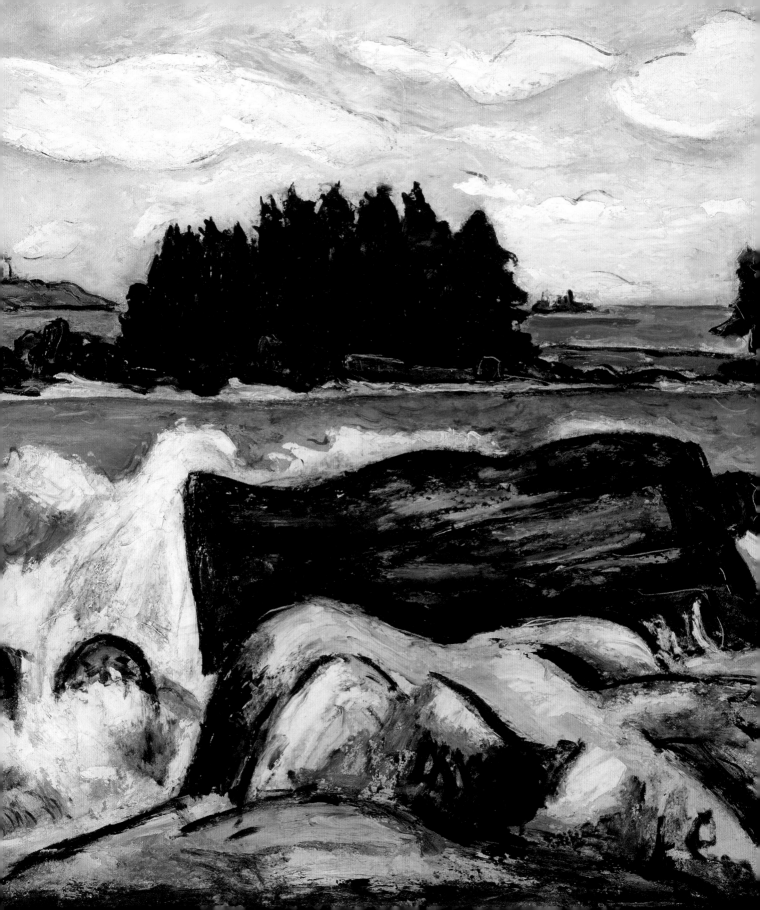

HARTLEY AND HIS POETRY

Richard Deming

Marsden Hartley is of course known primarily as a painter, for this is certainly how he has made his lasting and significant mark in history. Frequently, however, the descriptor "poet" is adjoined to that of "painter," indicating the extent to which these two aspects of Hartley were interconnected, even as they remained distinct endeavors. That being said, while as a painter he has come to be regarded as one of the foremost figures of American modernism, as a poet, his writing, despite periodically having its advocates, has never received sustained or focused attention. Indeed his poetry, if not his writing in general, is often on the verge of being forgotten altogether. Hartley's commitment to writing poetry, however, the body of work he produced, and his efforts to see that work in the public domain indicate that writing was more than just a private avocation.[1] Being a poet was important to Hartley's sense of his identity and may have been an ongoing way in which he anchored himself and his thinking, no matter where he traveled, to New England and its intellectual history.

Throughout much of his adult life, writing was for Hartley largely a daily practice, one that continued until his death at the age of sixty-six, his productivity only increasing the older he became. One might have assumed that as his prominence as a painter continued to grow, his interests would have shifted almost exclusively to visual art, especially in view of the fact that recognition of his literary efforts peaked in the early 1920s. Thereafter, his presence as a writer was far less in evidence, as if Hartley, in his midcareer efforts to be identified as an artist and a writer associated with Maine, narrowed public awareness of his poetry so that it did not infringe on his reputation as a painter. While Hartley's poems do not become exclusively regional in their focus until the 1930s and 1940s, specific references abound, as if some conversation about place were occurring between the paintings and the poems.

As a modernist, Hartley's pedigree could not be finer. As Hartley's connection to the Stieglitz circle locates his paintings within the earliest formulations of modernism and places him squarely within that aesthetic framework, he counted among his friends, peers, and interlocutors such literary figures as Gertrude Stein, Marianne Moore, Ezra Pound, Hart Crane, Mabel Dodge Luhan, Djuna Barnes, Arthur Kreymborg, Robert McAlmon, and, perhaps most significantly, William Carlos Williams.

It was Hartley who introduced Williams to McAlmon (fig. 139), sparking a friendship and a historically important collaboration that resulted in the founding of the magazine *Contact*. In its brief life, *Contact* provided an American base for avant-garde writing both in the United States and abroad, creating within its pages a transatlantic conversation about contemporary aesthetic currents. Appropriately, Hartley, himself devoted to a

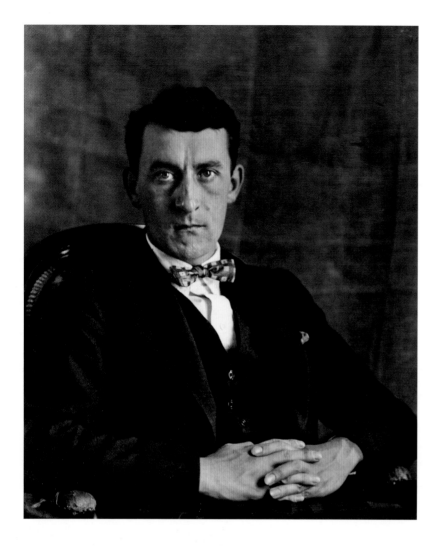

139 | Berenice Abbott (1898–1991). Robert McAlmon, ca. 1925. Sterling and Francine Clark Art Institute, Williamstown

fecund interchange between the regional and the cosmopolitan, the American and the European, would be a contributor to *Contact*'s first issue in 1920. In their mission statement cum manifesto, Williams and McAlmon state that the magazine had been initiated by the editors' "faith in the existence of native artists who are capable of having, comprehending and recording extraordinary experiences."[2] This faith was not an expression of American chauvinism, a belief that American arts and letters were better than those in Europe. Rather, it was a recognition of cultural, aesthetic, and epistemological experiences that arose from association with place. In this context Williams

and McAlmon could make a case for the possibilities of an American imagination and thereby "discover" an American aesthetic. To ignore the local is to deny life as it is lived. This is the basis for a faith in the local as an aesthetic principle.

Hartley did more than socialize with those writers who would in time be counted among the most influential literary forces of the twentieth century. His own poems appeared in many of the magazines and journals crucial to establishing the ground of what would become known as modernism. *The Little Review*, *Poetry*, *Contact*, *The Dial*, and *Others: A Magazine of the New Verse* all published Hartley's work in the 1920s (and even earlier), just as seminal poems by Pound, T. S. Eliot, D. H. Lawrence, and William Carlos Williams were appearing in the same pages. In fact, Hartley's first collection, *Twenty-Five Poems*, was published in 1923 by McAlmon's press, Contact Editions. During that same *annus mirabilis*, McAlmon would also publish Ernest Hemingway's first book, *Three Stories & Ten Poems*, as well as Williams's revolutionary hybrid of poetry, prose, and poetics, *Spring & All*.

Hartley's publications were not simply the result of editorial favors gained as the benefit of the artist's persistent and canny strategic networking, although such perseverance was certainly part of the equation. They were, at least in the middle part of his life, often evidence of serious editorial investment. For example, Harriet Monroe (fig. 140), founder of *Poetry* and its editor from 1912 until her death in 1936, featured in the magazine two special portfolios of Hartley's poems, "Kaleidoscope" (1918) and "Sunlight Persuasions" (1920). Monroe had not immediately embraced Hartley's work, although there was initially a great deal of correspondence back and forth surrounding Hartley's initial submissions of his work to be considered for the magazine. Over time, artist and editor forged a mutual understanding of each other's poetic values. Monroe did eventually give Hartley a substantial forum for both his poetry

and his prose. The essay "The Business of Poetry" appeared in 1919. It is surprising that an essay setting out a poetics would come so early in a poet's career, even if at the time Hartley was already in his forties. In the November 1923 issue of *Poetry*, Monroe herself reviewed *Twenty-Five Poems* in positive terms, although she noted that Hartley had left out of the collection the very work that she had published in the magazine.[3] Years later, in 1932, she would publish two more Hartley poems. Even after Monroe died, the editors of *Poetry* maintained its stake in Hartley's literary legacy, publishing a long and sympathetic review of his posthumous *Selected Poems* in 1946.[4]

Hartley's poetry, while it never achieved the same renown as his painting, did meet with some limited success during his lifetime and in the decades following his death. In addition to *Twenty-Five Poems*, two other collections were published: *Androscoggin* (Falmouth Publishing House) in 1940 and *Sea Burial* (Leon Tebbets Editions) in 1941. The publishers for the latter two books were essentially the same operation, located in Portland and run by the same person, Leon Tebbetts, a Maine native and a journalist, editor, and illustrator in his own right.

The poems in *Androscoggin*, the stronger of the two collections, were clearly inspired by Hartley's return to his home state and reflect his ongoing meditation on the landscape. It is, after all, the collection that includes the poem "Return of the Native," whose title, borrowed from Thomas Hardy, would come to serve as a metaphor for Hartley's life and career. In the poem "'Lewiston Is a Pleasant Place,'" Hartley writes, "I admire my native city because / it is part of the sacred secret rite / of love of place." The poems of *Androscoggin*, in their recurring references to specific places — the Androscoggin River, Georgetown, Penobscot Bay, Robinhood Cove — signify that they partake of the "sacred secret rite of love of place," and that this love had for Hartley a spiritual dimension.

The poems — as well as the paintings — serve as devotional acts. In their return, through memory, to childhood loneliness ("childhood . . . was hard, it is always / hard to be alone at the wrong time"), they are acts that invoke the power of art to transform experience and to reveal its capacity for meaningfulness.

If Hartley was motivated by a desire to establish himself as the quintessential painter of Maine, producing books of poems about Maine that could have been written only by someone who knew the area directly and intimately would no doubt help bolster his claim to authenticity and native authority.[5] Having those books published by a Maine native would, moreover, not only demonstrate but even amplify the impression that the "local genius" ran through Hartley in every possible way. At each turn, Hartley could be seen as an artist using his impressions of Maine, and of New England in general, to create a full spectrum of work. In this sense, the poems were in the service of his artistic reputation.

Hartley's *Selected Poems* appeared in 1945, just after his death (fig. 141). Edited by Henry W. Wells of Columbia University, this collection would achieve a higher profile than either of Hartley's

previous collections, having been published by the estimable Viking Press. Nevertheless, the volume did not long remain in print. In 1987, *The Collected Poems of Marsden Hartley*, edited by Gail R. Scott, was published under the auspices of the small but important Black Sparrow Press (fig. 142).[6] While that volume too did not stay long in print, it is significant that Black Sparrow was the publisher because it was a press focused on presenting the group that came to be known as the Black Mountain poets — Robert Duncan, Charles Olson, Denise Levertov, and Edward Dorn, among them — and such younger writers as Robert Kelly, John Yau, and Diane Wakoski, who were clearly influenced by that earlier generation. The connection to Black Sparrow thus places Hartley's work within an ongoing tradition of American avant-garde poetry.

Robert Creeley, one of the foremost poets to come of age in post–World War II America, was the ideal choice to provide an introduction to Hartley's poems. Himself a New England poet, Creeley had long been aligned with a modernist tradition that linked him to William Carlos Williams and Ezra Pound. In his essay Creeley notes that Hartley's poems had first been brought to his attention when Williams submitted a review essay about Hartley to *The Black Mountain Review*, the seminal literary journal that Creeley edited in the 1950s.

Noting Hartley's "extraordinary genius as an artist," Creeley provides a moving context for reading the poetry, characterizing it as "specifically personal, an expression of feeling, a various response to the world *out there* he feels he can afford."[7] He is especially taken by the poet-painter's attempts to craft an authentic voice: "Its authenticity, of course, is immense and it is both intensely local and universal at one and the same time."[8] In referring to the simultaneous interest in the local as well as the universal, Creeley positions Hartley aesthetically quite close to Williams, although the

poems rarely share Williams's emphasis on image and formal innovation. Hartley's poems often employ high-blown rhetoric (the word "doth" appears with surprising frequency), as well as awkward and somewhat arbitrary rhymes, and they tend to explain themselves rather than allowing the lines to elicit a range of aesthetic responses and interpretations. Perhaps born of a sentimental allegiance to Maine, to Williams, or to Hartley's paintings, Creeley overlooks the poems' missteps in his efforts to contextualize Hartley's poetry for new readers. His characterization of Hartley's poetics offers another frame for reading the verse, as he places the work along a continuum of American Romanticism and its Transcendentalist tenet that the specific is the path to the universal.

Creeley was likely aware of Hartley's professed claim to a lineage of nineteenth-century American Romanticism, a literary mode that was largely centered in New England, which would have appealed to Hartley's sense of local genius. Hartley, in "Concerning Fairy Tales and Me," the opening essay of his collection *Adventures in the Arts: Informal Chapters on Painters, Vaudeville, and Poets* (1921), indicates that Ralph Waldo Emerson, the primary theorist of American Transcendentalism, had a catalytic effect on him:

I had early made the not so inane decision that I would not read a book until I really wanted to. One of the rarest women in the world, having listened to my remark, said she had a book she knew I would like because it was so different, and forthwith presented me with Emerson's Essays, the first book that I have any knowledge of reading, and it was in my eighteenth year.[9]

In his autobiography, "Somehow a Past" (unpublished during his lifetime; fig. 143), Hartley writes that his first experience of reading Emerson "felt as if [he] had read a page of the Bible."[10] This story of discovering Emerson is certainly a bit of self-mythologizing. It is unlikely, for instance, that Hartley did not read a book until he was eighteen. Also in "Somehow a Past" he identifies "the

woman" as Nina Waldeck, one of his teachers at the Cleveland School of Art, which would suggest that he was actually twenty-one when he was given Emerson's book.[11] The difference in the reported age could be merely faulty memory, but eighteen, at the cusp between adolescence and adulthood, figures rather conveniently into a neat coming-of-age narrative, so it is entirely possible that Hartley shifted it for the sake of a good story. Moreover, that it was specifically the essays of Emerson that galvanized his development as an aesthetic thinker also comes across as a crafted epiphany.[12]

143 | First page of manuscript, "Somehow a Past: Prologue to Imaginative Living." Marsden Hartley Collection, Yale Collection of American Literature, Beinecke Rare Book & Manuscript Library, Yale University, New Haven

144 | *Walt Whitman's House*, ca. 1905. Oil on board, 10 x 8 in. (25.4 x 20.3 cm). Private collection

Walt Whitman, to whom Hartley was also spiritually indebted (and about whom Hartley writes in *Adventures in the Arts*), made similar observations about his own Emersonian genesis, commenting that before *Leaves of Grass* appeared, he was "simmering, simmering, simmering" and that it was Emerson who "brought [him] to a boil."[13] Hartley's story echoes Whitman's, a resonance that was likely intentional in light of Hartley's wish to forge an aesthetic identification with the nineteenth-century poet. Interestingly, Hartley's earliest extant work is a painting of Whitman's door (fig. 144), as if to suggest that to become the painter he wanted to be, he had to pass through the door built by the writings of the American Romantics.

Casting a wary eye on the veracity of Hartley's aesthetic conversion narrative should not diminish what that mythology might offer as context for thinking about his work. In his essay "The Business of Poetry," Hartley writes, "Poets have not so much to invent themselves as to create themselves, and creation is of course a process of development."[14] To create suggests that one uses the means and materials at hand. To invent is to have something emerge independent of any past or tradition. In his mythologizing, Hartley created a public self out of an Emersonian tradition of New England arts and letters, thereby confirming the idea that the specific and local (in this case, New England) is the means for discovering the universal. At the very least, that inheritance links Hartley fully as a writer to a New England sensibility.

From the beginning, Hartley responded to Emerson's emphasis on the role of the imagination. Nature and the material world are made accessible through sense impressions, and the intellect, or imagination, works to find or attach meaning to the patterns therein discerned. The poet uses the imagination to discover the meanings latent in things and objects, and in nature. As Emerson argues in "The Poet," the insight that reveals meaning "is a very high sort of seeing, which does not come by study, but by the intellect being where and what it sees, by sharing the path, or circuit of things through forms, and so making them translucid to others."[15] It is the poet's mission to make this circuit "translucid."

The world is thus never experienced directly, but by way of the generative abilities of the intellect, the imagination. For Emerson, the poet harnesses the intellect to reveal its transformative power:

The thought of genius is spontaneous; but the power of picture or expression, in the most enriched and flowing nature, implies a mixture of will, a certain control over the spontaneous states, without which no production is possible. It is a conversion of all nature into the rhetoric

of thought, under the eye of judgment, with a strenuous exercise of choice.[16]

How much this last sentence sounds like Hartley's assertion that the transmutation of art reveals "the proper evaluation of life as idea, of experience as delectable diversion."[17] For both Emerson and Hartley, the work of art is not the thing itself, or even a representation of the thing itself, but the artist's process of imagining. The work of art is the presentation of experience. The measure of authenticity is the degree to which the idea within that work is recognizable.

Emerson, in an oration delivered in 1837 to the Phi Beta Kappa Society in Cambridge, Massachusetts, titled "The American Scholar," made an early case for America's need to create its own literature and its own art, developments that would both reflect and establish an American identity separate and distinct from the traditions and mores of England and Europe:

Our day of dependence, our long apprenticeship to the learning of other lands, draws to a close. The millions, that around us are rushing into life, cannot always be fed on the sere remains of foreign harvests. Events, actions arise, that must be sung, that will sing themselves.[18]

Emerson — who stood at the very center of the intellectual kiln of mid-nineteenth-century Massachusetts — would have had in mind an America shaped by the New England ethos, an ethical appeal to which Hartley would have been attentive and receptive. In the opening of his essay on Emily Dickinson, he describes Emerson "standing high upon his pedestal preaching of compensations, of friendship, society and the oversoul, leaving a mighty impress upon his New England and the world at large as well."[19]

Hartley would find specific ways to connect such nationalist emphasis in the arts to his own thinking about regionalism. In the essay "Modern Art in America," he writes, "There is no reason whatever for believing that America cannot have as many good artists as any other country. . . .

[A]rt is an essentially local affair and the more local it becomes by means of comprehension of the international character, the truer it will be to the place in which it is produced."[20] While some scholars have foregrounded the many art-historical reasons that Hartley would make this regional connection to Maine, it is clear that his focus also grew out of his debt to Emerson, and that for Hartley, Emerson epitomized a specific way of thinking rooted in New England.

McAlmon, in an unpublished essay about Hartley, saw something quintessentially "New England" in Hartley's thinking as both a painter and a poet:

There has been much talk, and still is much writing . . . on the New England quality, and what it has done to sensibilities, and how it has affected artists. One judges that Marsden Hartley has expressed it cryptically and intensely better than most, while having something of the continental quality and understanding which being a travelled New England provincial has let him have. He at least does not nag, or scold, or sentimentalize. He creates, and sees both painting and poetry as mediums for creation, offering the means for creation far beyond a cry of sentiment or of confusion or of a groping search for a reason to be.[21]

The stoic, unsentimental directness in Hartley's work signifies for McAlmon a "New England quality." McAlmon also uses the word "creation" in ways not dissimilar to the ways in which Hartley uses it.

Yet Hartley's poems offer additional insight into what counts as artistic creation. The opening moment of "Indian Point," a poem that first appeared in *Sea Burial*, is a case in point:

When the surf licks with its tongues
these volcanic personal shapes, which we
defining for ourselves as rocks, accept
them as such, at its feverish incoming
isn't it too, in its way, something like
the plain image of life?[22]

"Indian Point" is in many ways one of Hartley's most successful poems in that it achieves a strong balance between image and rhetoric. It

145 | *Jotham's Island, Off Indian Point, Georgetown, Maine*, 1937. Oil on board, 22⅞ x 28⅞ in. (58.1 x 73.3 cm). Addison Gallery of American Art, Phillips Academy, Andover

also provides insight into the role poetry plays in Hartley's aesthetic, as it comments on the process of perception that painting can only present. In the passage above, Hartley not only comments on but also enacts the process of transmutation, which he first described decades earlier in "The Business of Poetry." He begins with a specific phenomenon, "the surf," which he then transforms into a surrealist metaphor, describing the movements of the waves as "[licking] with its tongues." The surf tastes the shore, or so we might read the trope. But we might also understand the licking motion as akin to a mouth vocalizing or articulating, a reading that becomes more likely as the passage continues. In the next line Hartley breaks down the process of perception: the volcanic shapes are "personal" insofar as "we" define for "ourselves" what the shapes are, and then "we" lay further claim to them when "we" accept them by naming them as "rocks."

To define a thing, to name it, is to acknowledge it, to recognize it by weighing it against our experiences and our knowledge of how words adhere to things. "Rock," for example, is a word we give to a category of things; when it is named it becomes an idea. Hartley's poem offers something like "the plain image of life" in the way it represents daily perceptual experience; we see, then name, and so *know* an object. With Hartley's paintings in mind, "the plain image of life" becomes ironically charged, since his visual art in the latter part of his career rendered images from life. And indeed, Hartley often painted scenes drawn from the landscape around Indian Point — the title of the poem — in Georgetown, Maine (fig. 145). The poem is not, however, an ekphrastic engagement with his paintings — it doesn't necessarily describe a specific work. But we can read it as commentary on his sense of what aesthetic encounters do. It could also be regarded as a critical reading of his work as a painter. Not only does it transmute Hartley's Indian Point paintings into language, it gives a context for what occurs in the process of moving into language.

There are many instances where the poems overlap with the paintings — Albert Pinkham Ryder, Abraham Lincoln, and the Mason family all appear in poems as well as in paintings. The poems, however, tend to overdo in language what the paintings offer more directly and more powerfully as visual experiences. There are other reasons for the limits of Hartley's literary reputation. Despite his proximity to the nexus of the most distinctive modernist writers in America, his own work reveals remarkably little evidence of their influence. His poems rarely sound modernist at all. We might find his poems, each in its own way, naïve, an indication of his being in essence an amateur poet. Yet Hartley provides a rationale for considering the value of "amateurism." As he writes in the conclusion of his essay "The Virtues of Amateur Painting":

There is such freshness of vision and true art experience contained in them. They rely upon the imagination entirely for their revelations, and there is always present in these unprofessional works of art acute observation of fact and fine gifts for true fancy. These amateurs are never troubled with the "how" of mediocre painting; neither are they troubled with the wiles of the outer world.[23]

While Hartley's poems never exhibit a persistent attention to the "how" of craft and expression, as do his paintings, they offered an additional space for him to articulate the ideas that he more directly presented in his visual art. They offered a space for experimenting. The act of writing poetry provided another way in which Hartley could participate in the intellectual and aesthetic tradition of New England. It was an alternate route into the world of things, a means by which he could transform those experiences, quickened by the imagination, into a native and incontrovertible subjectivity.

"THE LIVINGNESS OF APPEARANCES"
Materials and Techniques of Marsden Hartley in Maine

Isabelle Duvernois • Rachel Mustalish

Not unlike Paul Cézanne, Marsden Hartley started and ended his career painting essentially the same region.[1] Hartley's subject was his native Maine, and the works he produced there offer a rare, concentrated view into his artistic path. To better understand his use of materials and techniques, twelve works were closely examined. They date from the early, intimately scaled landscapes on paperboard of 1908–9, during his Post-Impressionist period, to the late, larger compositions on canvas and hardboard (masonite) of 1938–43. This study has revealed that however peripatetic his life and however eclectic his chameleon painting technique, Hartley maintained a distinct core method and visual vocabulary. These are evident in the Maine paintings from both early and late in his career.

The works under study, from the early landscapes to the last paintings made in Corea, document Hartley's consistently physical painting technique. All the early landscapes examined were painted on a similar support: commercially prepared paperboard, made as a support for both paintings and drawings and popular because it was lightweight, rigid, and inexpensive. In general, this type of board — often called academy board — consisted of layers of rough, cheap, often brown unrefined paper covered with smooth paper and a commercially applied ground on both sides. This ground is composed of zinc white pigment bound in a glue binder that has a pale bluish tone and a fine pitted pattern, both identifying features of

these early Hartley works.[2] The board was available in a variety of textures and in standard sizes, from 6 × 9 to 22 × 28 inches, the latter of which Hartley cut to his preferred 12 × 12–inch format. Common to Hartley's small compositions is the presence of an additional, irregularly textured, artist-applied ground of lead white and barium white pigments mixed with oil, which has a pronounced striation pattern often visible as deep grooves under the paint layer.[3]

The textured ground indicates that Hartley found a rough ground layer most effective for holding his bold gestural paint application and thick impastos, seen in such works as *Autumn Color* and *Maine Landscape* (see figs. 25, 41).[4] All these panels display fine cracks originating along the edges that penetrate both ground and paint layers. The chipped edges indicate that the panels were cut fairly soon after the ground-layer priming had been applied (fig. 146).

These striated ground layers are revelatory in the study of Hartley's painting technique, demonstrating that even early on, Hartley integrated dimensionality into his compositions by using texture in addition to color. In such works as *Landscape No. 25*, *The Dark Mountain No. 1*, and *Desertion* (see figs. 27, 39, 44), the bottom part of each composition shows a textured surface created after applying oil paint and either rubbing it or scraping it off of the striated ground layer, as in a frottage technique (fig. 147). Hartley used this

146 | Detail of corner, *The Dark Mountain No. 1* (see fig. 39), showing the cracks through ground and paint layers emanating from the edge and the exposed fibrous corner of the paper-board support

147 | Detail, *The Dark Mountain No. 1*, showing frottage (paint scraped against the ground layer), creating a blurred effect and revealing the dry black medium under the paint

technique in his early Maine paintings to define the composition's rocky foreground and set it apart from the receding mountains. It was one of his first tooling practices, and it would become increasingly prevalent and varied over time.

In addition to the textured ground, some of the early works exhibit the presence of colored priming layers. *Autumn Color* and *Maine Landscape*, for example, have overall layers of deep carmine red and deep purple, respectively, which impart a feathery, semi-transparent texture that shows generously through the upper impastoed layers (fig. 148).[5] Hartley applied these thin layers with a wide bristle brush and then painted the compositions with single strokes of pure, undiluted colors that bear the imprint of the fine bristles. He worked fast and with fluidity, as demonstrated by the interrupted paint strokes that skip over the textured underlayers, providing both visual rhythm and a palpable depth. Hartley worked wet-in-wet, without blending his paints, to keep the colors distinct. He knew well how the colored priming — whether deep purple, red, black, or some other hue[6] — would influence the overall tonality of a composition.[7] By allowing the underlayer to show through, creating what appear to be outlines around the individual brushstrokes, he also achieved dimension within the picture plane, infusing the composition with an animated vibrancy.[8]

For *Landscape No. 25* (see fig. 27), rather than applying an overall colored priming, Hartley isolated certain areas of the composition — the foreground, the large trees, and the sky — with different colors. Possibly using a palette knife, he scraped on flat fields of sienna, dark green, bright red, and ocher to broadly block in trees and rocks in the foreground and applied a thin mauve-gray tone in the sky. With scattered brushstrokes he then roughly defined their shapes and relative placement on the picture plane. By contrast, he painted the mountains in the middle ground in a

very different manner. Here, the tapestry-textured slopes are created by short, tight, vertical brushstrokes, revealing glimpses of exposed white ground. This discrete paint application enlivens the receding planes of the sprawling landscape, which might otherwise have looked flat. The succession of vertically oriented brushstrokes in these early compositions lends a characteristic vertical thrust that is also found in the late works.

The woven-like texture of the pastose brushwork gives to the early landscapes a heightened physicality. This particular painting technique — using long staccato curvilinear strokes going in various directions — echoes Hartley's drawing style at this time, when he was working on a relatively small scale, with the largest paintings measuring between 22 × 28 and 30 × 40 inches. While most of the drawings are small, they are on the same scale as the paintings, which allows for comparisons between the markings drawn with a pencil or crayon and those applied with a brush.

A group of drawings dating from 1908, likely made on pages of a sketchbook or drawing block, which includes *Self-Portrait*, *Old Man in a Rocking Chair*, and *Old Maid Crocheting* (see figs. 14, 16, 17), are rendered in both short curved lines and sharp repeated lines. Hartley's lines are not tentative. They press into the paper, the heavy deposit of graphite giving to such works as *Old Maid Crocheting* a pronounced metallic sheen and to *Self-Portrait* a strong black density. Hartley used lines to create form in light — without sfumato, stumping, or traditional cross-hatching.

In general, Hartley's early Maine landscapes are an explosion of pure color. His palette suddenly assumed a more somber mood after his first encounter with the work of Albert Pinkham Ryder, in 1909. Of the three paintings under study in the Dark Landscapes series, *The Dark Mountain No. 1* (see fig. 39) is truly a transitional work. The preparation, blocking, painting, and tooling all seem to connect Hartley's early and late work. The frottage

technique in the foreground and tree trunks is used to great effect. Prominently visible is the dry black medium used for blocking the main shapes (see fig. 147). The palette, while more restricted and more subdued than in the earlier work, still includes colorful hues. And while the paint surface remains textural, the paint is blended and more thinly applied. Hartley's use of black to partially outline the clouds, trees, and houses is notable here, as are the deep scoring marks he made into the fresh paint layer with the back of his brush. In a manner similar to that seen in the drawings, the tree trunks are scored freely, with multiple broad lines. Both the heavy black outlining and the paint scoring would become prominent in the late work. There are two other paintings in the Dark Landscapes series, *The Dark Mountain No. 2* (see fig. 56), in which the mountain slopes are modeled with thin feathery strokes, and *Desertion* (see fig. 44), in which the only texture — especially visible in the tree trunks — is the result of the intermittent scraping of the paint against the striated ground layer. Both canvases are painted in very thin layers, in contrast to the work of Ryder,

148 | Detail, *Autumn Color* (see fig. 25), showing the deep-purple-colored priming layer beneath the paint

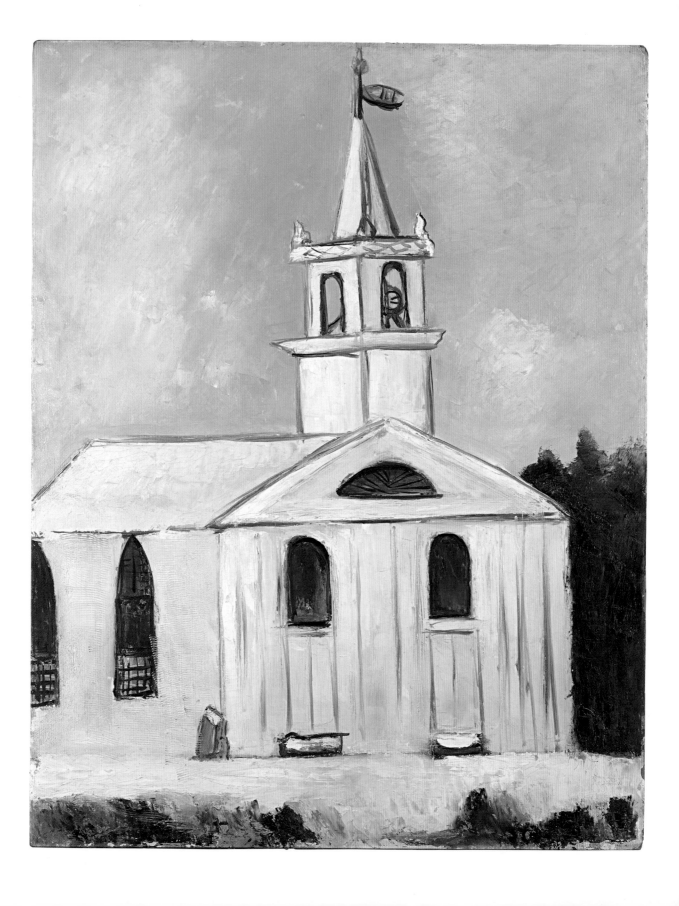

known for his thick-layered compositions, whom Hartley was emulating in this series.

The second group of works under examination depicts specific Maine locales where Hartley either lived or visited between 1938 and 1941, including Vinalhaven, Mount Katahdin, Head Tide, and Corea. During this period, Hartley painted on supports in a number of formats and with a variety of preparations, which is characteristic of his practice in general. At the same time, his technique — such as painting on a colored priming layer — remained consistent with that of the early work even as he incorporated newer methods he had explored over the years.

In this later period Hartley continued to paint on commercially sourced materials, including paperboard, canvas board, and masonite.[9] The luminous *Church at Head Tide, Maine* (fig. 149) is painted on a commercially prepared paperboard; the verso bears the product label "Academy Board," from the F. Weber Company (fig. 150). The board was available in three finishes: smooth, rough, and a finish that was moderately textured, called "new rough" or "stippled," which appears to have been the board used by Hartley. *City Point, Vinalhaven* (fig. 151) was mounted at a later date to a secondary support that covers the reverse, so that we could not ascertain whether a label is present.[10] What is visible, however, is the ground, which is a cool-toned white, finely stippled and textured.[11] The physical characteristics of the two supports show similarities with those of Hartley's early Maine pictures.

Both works display a rough, free painting style and a limited palette. Indications of a cursory underdrawing done with a dark medium, either smeared graphite or a wash-like black paint, are revealed through the loosely applied paint layer and are clearly visible with high magnification.[12] Enabled by the boards' rigidity, Hartley predominantly used a palette knife to apply the paint, lending to the surface a sensuous, creamy texture. As in his early canvases, he worked on top of a colored priming, in this case a light gray, applying the paint with strokes of pure color, randomly blended and alternating between modulation and outlining of the elements.

Hartley animated the flat picture plane with a variety of technical means. In *City Point, Vinalhaven*, for example, the prominent black outlines of the rocky landscape become increasingly thinner as the scene recedes into the distance. He also physically engaged with the paint by scoring and marking it in various ways. Fingerprint impressions are present in the clouds. This unexpected discovery indicates that Hartley used his fingers to add a last, expressive mark. More than any other toolmark, they give us a special and intimate connection to the artist's hand.

Hartley also scored fine sinuous lines into the black paint, loosely drawing thick outlines around the rocks for emphasis. This type of line can also be seen in the drawings *Untitled (Three Fishermen with Fish and Lobster)* and *Untitled (Male Torso)* (see figs. 79, 111), where Hartley, using minimal

149 | *Church at Head Tide, Maine*, 1938. Oil on commercially prepared paperboard (academy board), 28⅛ x 22⅛ in. (71.4 x 56.2 cm). Colby College Museum of Art, Waterville, Bequest of Adelaide Moise

150 | Label on verso of *Church at Head Tide, Maine*, listing sizes and finishes

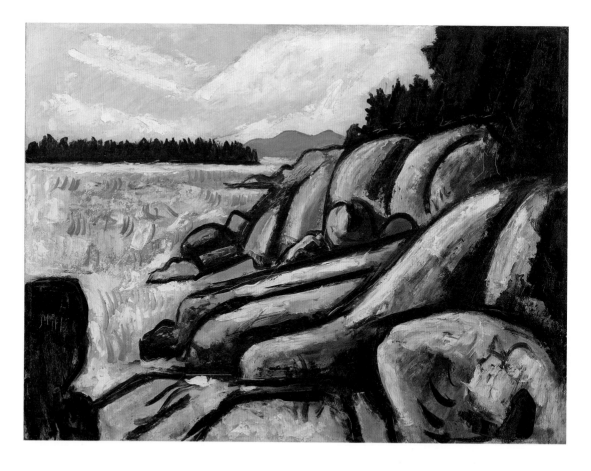

151 | *City Point, Vinalhaven*, 1937–38. Oil on commercially prepared paperboard (academy board), 18¼ x 24⅜ in. (46.4 x 61.9 cm). Colby College Museum of Art, Waterville, Gift of the Alex Katz Foundation

pressure on the pencil, created lines that are supple and flowing. The connection between painting and drawing is again evident in the curved blue strokes, applied with a thinly pointed brush, that seem to bounce on the ocean's surface. There is no sign of a complete underdrawing in these compositions, either to the naked eye or with infrared examination; however, where the ground layer is exposed, faint dry black paint strokes delineating some compositional elements are visible. This technique is akin to that used in the drawings *Untitled (Two Male Figures at Old Orchard Beach)* and *Untitled (Lone Male Figure, Front View)* (see figs. 112, 115), where short, choppy lines give the figures an architectural character and build a framework for the composition.

Hartley's mark-making exhibits a fluidity across different mediums. He developed a method of

"drawing with paint" that can be observed in the late Maine paintings. His use of a palette knife to spread and score the paint as well as various other tooling techniques all suggest great gestural freedom, which he employed to make tangible the rugged terrain and unrelenting force of the elements. *Church at Head Tide, Maine* (see fig. 149) is a key example of such work. In this picture Hartley also expands his exploration of texture. While the composition is essentially planar and frontal, the church is given dimension by the juxtaposition of various surface textures. Most singular is the use of a fine, comb-like tool to score horizontal lines into the fresh white paint to depict the effects of light on the clapboard siding of the church (fig. 152). A coarse black underdrawing shows through the paint surface in several places, and is clearly revealed with infrared examination. In another

instance of mark-making across mediums, the outlines of some of the windows, freely drawn with repeated strokes, are identical to the marks in the pastel *Church at Corea* (see fig. 156).

Similarities and differences in Hartley's techniques and approach to design can also be seen in the three versions of *Lobster Fishermen*: drawing on paper (Bates College Museum of Art), oil on masonite, and pastel on paperboard (see figs. 87, 88). Hartley chose as a support for the pastel a commercial artists' board with a smooth paper surface. Artists who use pastel often choose a textured support, which allows the pigment particles of the pastel to hold fast to the support. Hartley's choice of a smooth board, however, allowed all of his marks, textures, and patterns to be clearly legible and to remain unaffected by the support texture (fig. 153). This approach contrasts notably with that used on his oils on board, where he exploited

the heavily textured grounds to alter the paint application and determine the final appearance.

In the pastel, the figures are for the most part outlined in heavy black strokes and the forms are "filled in" with short strokes of bright colors. Some of the outlines consist of thin sketchy lines, which Hartley likely used to block in the composition, but most are thick and heavy, creating a velvety, dense black texture. The repeated outlines and the perceived shifting of the lines, which is seen also in the pencil drawing and the oil on masonite, could be interpreted as Hartley finding his forms while working through the design. However, the intentionally enlivened surface recalls the nearly vibrating effect seen in the early drawings, among them *Chopping Wood*, of 1908 (see fig. 18), where the lines never settle or cohere. Other small drawing gestures in the pastel, such as the series of white horizontal lines in the water, which represent the effect of light on the foam, in the painting become delicate three-dimensional touches of white paint, lightly tapped onto the surface with the tip of a bristle brush. Light effects were also created by altering the surface. In the painting, using what appears to have been a piece of crumpled fabric,

152 | Detail, *Church at Head Tide, Maine*, showing the comb-like pattern made in the paint on the side of the church

153 | Photomicrograph (6x) of *Study for "Lobster Fishermen"* (see fig. 88), showing the smooth commercial paperboard with powdery pastel on the surface

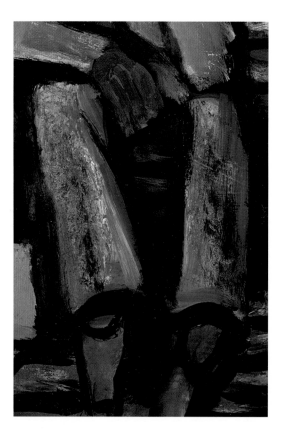

Hartley dabbed white paint over the blue of the fishermen's trousers to obtain a texture that simulates denim (fig. 154).

In the pastel, to render diffused areas that depict elements such as the water, Hartley, after applying the color blue, rubbed the paper either with his fingers, a cloth, or a tortillon so that the individual lines were obliterated, creating amorphous shapes with soft edges. He also used white to enhance the three-dimensionality of the lobster traps, woodpile, and houses and to simulate the effect of light reflecting off the water and clouds. The white contrasts with the light brown of the support paper, which serves as a middle tone in the composition.

The oil version of *Lobster Fishermen* is on a smooth support similar to that used for the pastel, a ⅛-inch-thick masonite panel with a grid texture pressed onto the reverse, a type of support that

Hartley favored for many paintings in the 1940s.[13] To prevent penetration of the oil paint into the fibrous support, he coated the panel with a layer of shellac. Resinous drops on the edges and reverse of the board are evidence that he applied this coating in much the same way as in the early work he added a second ground layer to the already prepared paperboard. As in the pastel, the natural red-brown color of the support, enhanced by the shellac, serves as a middle tone, which Hartley allowed to generously show through the composition (fig. 155). This tone is also reminiscent of the colored priming found in the early Maine landscapes. Characteristically, every shape is prominently defined by oil-rich black outlines. Where the paint is most transparent — in the men's hands, for instance — one can see how these thick lines echo the loosely painted black underdrawing. The outline shifts seen in the pastel, in the left forearm and hand of the standing figure, are also repeated in the painting.

One change from the pastel is that in the painting, the colors of the fishermen's jackets are more varied. The intensity of the palette results from the red-brown undertone showing through and around most elements of the composition. As in his early works, Hartley did not blend the paint but rather worked wet-in-wet, manipulating the surface to render shadow and light. While the pastel and the painting are similar in composition, their spatial organization is different. The absence of a horizon line and the strong presence of the parallel wooden slats in the foreground of the painting contribute to collapsing the space, creating an odd, off-balance vertical thrust to the picture plane. And the men, although firmly planted on the wooden pier, seem to float midair between ocean and sky, contributing to their iconic nature.

A number of unusual features distinguish Hartley's pastel and oil versions of *Church at Corea* (figs. 156, 157). The drawing, on the same type of board as the pastel of *Lobster Fishermen*, is nearly

155 | Ultraviolet fluorescent image of *Lobster Fishermen* (see fig. 87) showing the bright orange fluorescence of the shellac

twice the size of the oil, in contrast to the more traditional relationship, where the drawing is the same size or smaller and is generally assumed to be a study for the painting. In this case, the painting's execution is fast and sketchy, while the drawing is more finished and more developed. Several features in the painting, including the odd tilt of the church and the predominance of black, are diminished in the pastel. In both works the church practically fills the vertical picture plane, the steeple reaching the very top edge of the panel, a visual device that accentuates the church's ominous presence.

In both the pastel and the painting, black plays a primary role. Hartley used it not only to heavily outline the few elements of the composition — a Hartley signature — but to fill in the foreground landscape and the windows and doors of the

church. The oil version is thinly painted, with a limited palette: black, white, and blue on top of a bright red-brown priming layer. This reddish underlayer shows abundantly within the composition and serves a function analogous to that of the shellacked brown masonite surface that Hartley favored for his larger paintings in the 1940s.

The ground also covers an underlying, fully developed still life, evidenced by the paint ridges beneath the surface and readily visible in an X-ray (fig. 158). The hidden composition has a painterly, Cézannesque character and is reminiscent of Hartley's still lifes of the 1920s. Once the still life was completely covered over, the new composition of the church was painted quickly, in a simple sequence. Hartley first used thin washes of blue scumbled with white paint to define the sky area, and then added broad strokes of white

MATERIALS AND TECHNIQUES 161

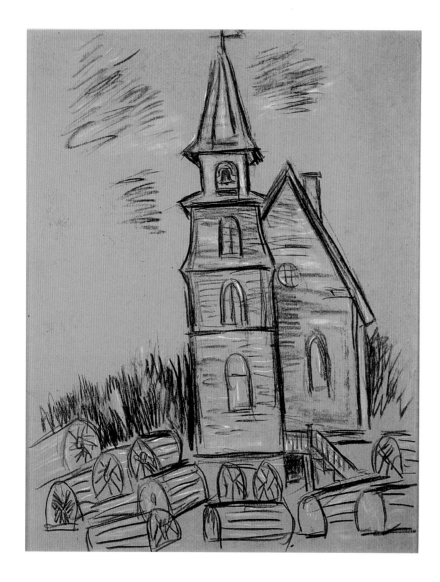

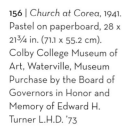

156 | *Church at Corea*, 1941. Pastel on paperboard, 28 x 21¾ in. (71.1 x 55.2 cm). Colby College Museum of Art, Waterville, Museum Purchase by the Board of Governors in Honor and Memory of Edward H. Turner L.H.D. '73

157 | *Church at Corea*, 1941. Oil on canvas board, 19⅞ x 15¾ in. (50.5 x 40 cm). Collection of Karen and Kevin Kennedy

paint to fill in the architecture of the church and the single cloud. The speed with which he painted is suggested by the pink smudges and black paint reticulating on the surface, the result of the red ground being dragged into the upper paint layer. Unlike other late works on solid supports, this composition is devoid of additional toolmarks, indicating that it was painted solely with brushes. The thick white paint obscures the black painted outlines. As in the pastel, they repeat and emphasize the forms, reminiscent of the technique also employed in *Lobster Fishermen*.

Numerous studies and paintings Hartley produced in his last years are of Maine's tallest peak, Mount Katahdin. The Metropolitan Museum's painting *Mount Katahdin, Autumn, No. 2* (see fig. 132), a balanced, deceptively simple composition, captures the mountain's majesty. It is the only work in this study that is painted on a canvas commercially prepared with a white ground. Nevertheless, Hartley again started by applying a red-brown priming layer over the prepared surface. No doubt he did this to replicate the middle tone provided by the masonite boards and drawing supports that he favored at this time. But unlike his many works on hardboard, in this painting the underlayer is not left exposed. Examination with infrared reflectography and X-radiography confirmed the painting's direct execution. The mark-making of the landscape textures — the short, staccato strokes of the red slopes, the trees in the foreground, and the curls in the water — is quite similar to that in the drawing (Bates College Museum of Art). The volume-defining shading

of the black mountains is also similar, although it is revealed only with infrared illumination. Hartley's original paint surface — multiple layers of medium-rich oil paint — was subsequently coated with layers of varnish that have overly saturated the subtly modulated layers of ultramarine blue.[14] As a result, the painting has darkened over time, suppressing the mountain's modeling but enhancing its monolithic presence.

With the Mount Katahdin series, Hartley identified himself definitively as the painter from Maine. "To understand the mountain," he wrote, "one must have a feeling for it, one must know it, sense it in all its moods and aspects, the affirmation and the negation."[15] These late works offer a clear culmination of the artist's creative journey, which began and ended in his native state. This study of a selection of Hartley's paintings, pastels, and drawings from the early and late phases of his career illuminates how the artist developed his forms, adjusted his techniques for effect, and succeeded in obtaining a wide range of colors and textures from his materials. While his palette shifted over the years, his use of layered colors in both grounds and paint allowed him to develop a richness even in his most limited tonal range. The works he made have a tactile quality seen throughout his oeuvre, creating depth and movement independent of the subject matter or medium. Indeed, there was for Hartley little difference between drawing and painting in his approach to form and space, but rather a fluidity in his creative process that liberated him from traditional practice.

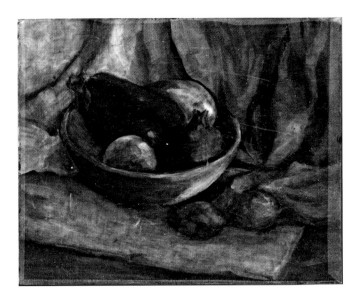

158 | X-radiograph of *Church at Corea*, rotated ninety degrees clockwise, revealing the fully painted still life

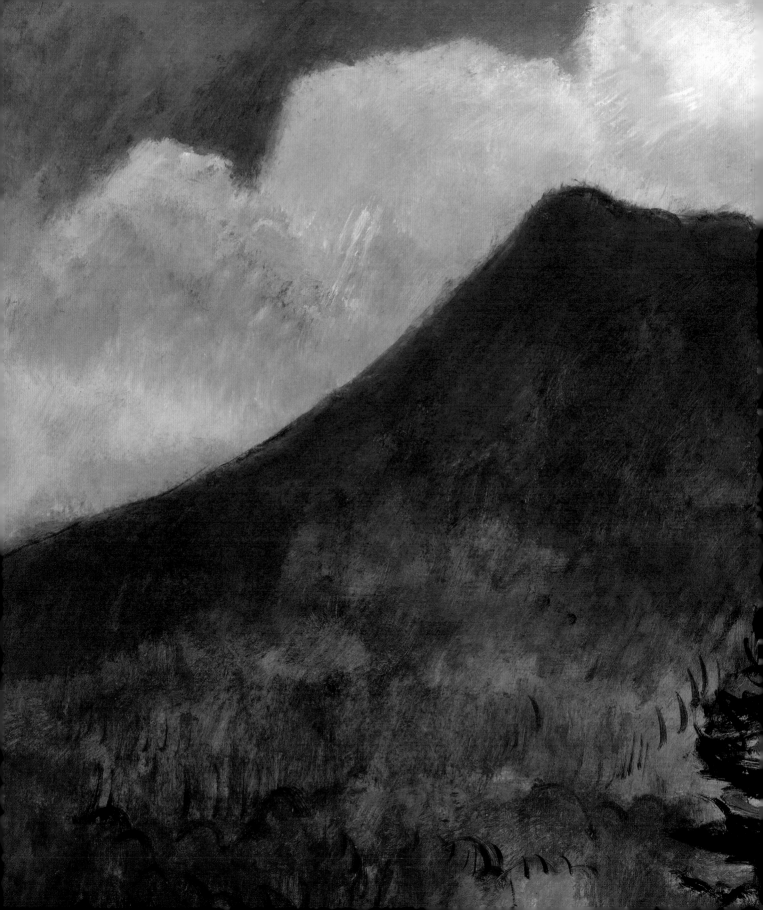

CHECKLIST OF THE EXHIBITION
NOTES · SELECTED REFERENCES
INDEX · PHOTOGRAPH CREDITS

CHECKLIST OF THE EXHIBITION

Shady Brook
1907
Oil on canvas
30 × 24 in. (76.2 × 61 cm)
Lewiston Public Library, Gift of the artist

The Silence of High Noon—Midsummer
ca. 1907–8
Oil on canvas
30½ × 30½ in. (77.5 × 77.5 cm)
Collection of Jan T. and Marica Vilcek, Promised
Gift to the Vilcek Foundation

Carnival of Autumn
1908
Oil on canvas
30⅛ × 30⅛ in. (76.5 × 76.5 cm)
Museum of Fine Arts, Boston, The Hayden
Collection, Charles Henry Hayden Fund

Chopping Wood
1908
Graphite on paper
12 × 9 in. (30.5 × 22.9 cm)
Bates College Museum of Art, Lewiston,
Marsden Hartley Memorial Collection, Gift of
Chris Huntington and Charlotte McGill

Maine Landscape
1908
Oil on commercially prepared paperboard
(academy board)
12¼ × 12⅜ in. (31.1 × 31.4 cm)
Colby College Museum of Art, Waterville,
Gift of the Alex Katz Foundation 2008.217

Maine Woods
1908
Oil on canvas
29½ × 29½ in. (74.9 × 74.9 cm)
National Gallery of Art, Washington, D.C.,
Gift of Bernard Brookman 1991.71.1

Old Maid Crocheting
1908
Graphite on paper
12 × 9 in. (30.5 × 22.9 cm)
Colby College Museum of Art, Waterville,
Museum Purchase from the Mellon Art
Purchase Fund and the A. A. D'Amico Art
Collection Fund 2014.057

Old Man in a Rocking Chair
1908
Graphite on paper mounted on paperboard
12 × 9 in. (30.5 × 22.9 cm)
The Frederick R. Weisman Art Museum at the
University of Minnesota, Minneapolis, Bequest
of Hudson D. Walker from the Ione and Hudson
D. Walker Collection

Sawing Wood
1908
Graphite on paper
12⅛ × 9 in. (30.8 × 22.9 cm)
Whitney Museum of American Art, New York,
Gift of Mr. and Mrs. Walter Fillin 77.39

Self-Portrait as a Draftsman
1908
Lithographic crayon on paper
12 × 9 in. (30.5 × 22.9 cm)
Allen Memorial Art Museum, Oberlin,
Gift of the Oberlin Class of 1945 1945.45
The Metropolitan Museum of Art only

Summer
1908
Oil on academy board
9 × 11⅞ in. (22.9 × 30.2 cm)
The Frederick R. Weisman Art Museum at the
University of Minnesota, Minneapolis, Bequest
of Hudson D. Walker from the Ione and Hudson
D. Walker Collection

Woodcutters
1908
Graphite on paper
12 × 9 in. (30.5 × 22.9 cm)
Bates College Museum of Art, Lewiston,
Marsden Hartley Memorial Collection,
Gift of Chris Huntington and Charlotte McGill

Late Fall, Maine
ca. 1908
Oil on wood
12 × 14 in. (30.5 × 35.6 cm)
Colby College Museum of Art, Waterville,
Gift of the Alex Katz Foundation
Colby College Museum of Art only

Self-Portrait
ca. 1908
Charcoal on paper
11⅞ × 8⅞ in. (30.2 × 22.5 cm)
The Frederick R. Weisman Art Museum at the
University of Minnesota, Minneapolis, Bequest
of Hudson D. Walker from the Ione and Hudson
D. Walker Collection

Landscape No. 36
1908–9
Oil on canvas
30⅛ × 34 in. (76.5 × 86.4 cm)
The Frederick R. Weisman Art Museum at the
University of Minnesota, Minneapolis, Bequest of
Hudson D. Walker from the Ione and Hudson D.
Walker Collection

Hall of the Mountain King
ca. 1908–9
Oil on canvas
30 × 30 in. (76.2 × 76.2 cm)
Crystal Bridges Museum of American Art,
Bentonville, Arkansas 2010.94

Landscape No. 25
ca. 1908–9
Oil on commercially prepared paperboard
(academy board)
12 × 12 in. (30.5 × 30.5 cm)
The Metropolitan Museum of Art, Alfred Stieglitz
Collection, 1949 49.70.48

Song of Winter No. 6
ca. 1908–9
Oil on board
8⅞ × 11⅞ in. (22.5 × 30.2 cm)
Farnsworth Art Museum, Rockland, Maine

The Ice Hole, Maine
1908–9
Oil on canvas
34 × 34 in. (86.4 × 86.4 cm)
New Orleans Museum of Art, Museum Purchase
through the Ella West Freeman Foundation
Matching Fund 73.2

The Dark Mountain
1909
Oil on commercially prepared paperboard
(academy board)
19¼ × 23¼ in. (48.9 × 59.1 cm)
The Art Institute of Chicago, Alfred Stieglitz
Collection 1949.542

The Dark Mountain No. 1
1909
Oil on commercially prepared paperboard
(academy board)
14 × 12⅛ in. (35.6 × 30.8 cm)
The Metropolitan Museum of Art, Alfred Stieglitz
Collection, 1949 49.70.47

The Dark Mountain No. 2
1909
Oil on commercially prepared paperboard
(academy board), mounted to slatted wood board
20 × 24 in. (50.8 × 61 cm)
The Metropolitan Museum of Art, Alfred Stieglitz
Collection, 1949 49.70.41

An Evening Mountainscape
1909
Oil on canvas
30¼ × 30¼ in. (76.8 × 76.8 cm)
Myron Kunin Collection of American Art

Landscape No. 20 (Resurrection)
1909
Oil on academy board
14 × 12 in. (35.6 × 30.5 cm)
Collection of Maurice and Suzanne Vanderwoude,
Courtesy Alexandre Gallery, New York

Winter Chaos, Blizzard
1909
Oil on canvas
34 × 34 in. (86.2 × 86.4 cm)
Philadelphia Museum of Art, The Alfred Stieglitz
Collection 1949

Desertion
1910
Oil on commercially prepared paperboard
(academy board)
14¼ × 22⅛ in. (36.2 × 56.2 cm)
Colby College Museum of Art, Waterville,
Gift of the Alex Katz Foundation 2008.218

Untitled (Maine Landscape)
1910
Oil on board
12⅛ × 12 in. (30.8 × 30.5 cm)
Collection of Jan T. and Marica Vilcek,
Promised Gift to the Vilcek Foundation

Autumn Color
ca. 1910
Oil on paperboard
12¼ × 14⅛ in. (31.1 × 35.9 cm)
The Metropolitan Museum of Art, Anonymous
Gift, in memory of Robert Glenn Price,
1954 54.184.1

Kezar Lake, Autumn Evening
ca. 1910
Oil on commercially prepared paperboard
(academy board)
12 × 12 in. (30.5 × 30.5 cm)
Harvard Art Museums, Fogg Museum, Cambridge,
Bequest of Lee Simonson

Still Life
1917
Oil on glass mounted on board
16½ × 16 in. (41.9 × 40.6 cm)
Private collection

Still Life (Ear of Corn)
1917
Oil on glass mounted on board
20 × 7½ in. (50.8 × 19.1 cm)
Collection of Norma B. Marin

Three Flowers in a Vase
1917
Oil and metal leaf on glass
13⅛ × 7⅝ in. (33.3 × 19.4 cm)
Private collection

Paysage
1924
Oil on canvas
32 × 32 in. (81.3 × 81.3 cm)
The Frederick. R. Weisman Art Museum at the
University of Minnesota, Minneapolis, Bequest
of Hudson D. Walker from the Ione and Hudson
D. Walker Collection

Paysage
1924
Oil on canvas
31⅞ × 31⅞ in. (81 × 81 cm)
Grey Art Gallery, New York University Art
Collection, Gift of Leo M. Rogers, 1972

Mont Sainte-Victoire
ca. 1927
Oil on canvas
20 × 24 in. (50.8 × 61 cm)
Collection of Jan T. and Maria Vilcek,
Promised Gift to the Vilcek Foundation
The Metropolitan Museum of Art only

Smelt Brook Falls
1937
Oil on commercially prepared paperboard
(academy board)
28 × 22⅞ in. (71.1 × 58.1 cm)
Saint Louis Art Museum, Eliza McMillan Trust

City Point, Vinalhaven
1937–38
Oil on commercially prepared paperboard
(academy board)
18¼ × 24⅜ in. (46.4 × 61.9 cm)
Colby College Museum of Art, Waterville,
Gift of the Alex Katz Foundation 2008.214

After the Hurricane
1938
Oil on canvas
30 × 40⅛ in. (76.2 × 101.9 cm)
Portland Art Museum, Oregon,
Ella M. Hirsh Fund

Albert Pinkham Ryder
1938
Oil on commercially prepared paperboard
(academy board)
28 × 22 in. (71.1 × 55.9 cm)
The Metropolitan Museum of Art, Edith and
Milton Lowenthal Collection, Bequest of Edith
Abrahamson Lowenthal, 1991 1992.24.4

Camden Hills from Baker's Island,
Penobscot Bay
1938
Oil on academy board
27½ × 21⅝ in. (69.9 × 54.9 cm)
Stedelijk Museum, Amsterdam, Gift of Hudson D.
Walker, New York

Church at Head Tide, Maine
1938
Oil on commercially prepared paperboard
(academy board)
28⅛ × 22⅛ in. (71.4 × 56.2 cm)
Colby College Museum of Art, Waterville,
Bequest of Adelaide Moise 1986.021

Cobbs Camp II
1938
Charcoal on paper
13½ × 10½ in. (34.3 × 26.7 cm)
Francine and Roger Hurwitz, Indianapolis

Robin Hood Cove, Georgetown, Maine
1938
Oil on commercially prepared paperboard
(academy board)
21¾ × 25⅞ in. (55.2 × 65.7 cm)
Whitney Museum of American Art, New York,
50th Anniversary Gift of Ione Walker
in memory of her husband, Hudson D.
Walker 87.63

Ghosts of the Forest
ca. 1938
Oil on academy board
22⅛ × 28 in. (56.2 × 71.1 cm)
Brooklyn Museum, John. B. Woodward
Memorial Fund 40.711

Birds of the Bagaduce
1939
Oil on board
28 × 22 in. (71.1 × 55.9 cm)
The Butler Institute of American Art,
Youngstown, Ohio

Kennebec River, West Georgetown
1939
Oil on board
22 × 28 in. (55.9 × 71.1 cm)
Private collection, New York

Mount Katahdin
1939
Black crayon on paper
11¼ × 14 in. (28.6 × 35.6 cm)
The Frederick R. Weisman Art Museum at the
University of Minnesota, Minneapolis, Bequest
of Hudson D. Walker from the Ione and Hudson
D. Walker Collection

Young Hunter Hearing Call to Arms
ca. 1939
Oil on masonite
41 × 30¼ in. (104.1 × 76.8 cm)
Carnegie Museum of Art, Pittsburgh,
Patrons Art Fund 44.1.2

Abundance
1939–40
Oil on canvas
40⅛ × 30 in. (101.9 × 76.2 cm)
Currier Museum of Art, Manchester,
New Hampshire

Flaming American (Swim Champ)
1939–40
Oil on canvas
40⅜ × 30¾ in. (102.6 × 78.1 cm)
Baltimore Museum of Art, Purchase with
exchange funds from the Edward Joseph Gallagher
III Memorial Collection BMA 1990.77
The Metropolitan Museum of Art only

Knotting Rope
1939–40
Oil on board
28 × 22 in. (71.1 × 55.9 cm)
Private collection, New York

Logjam (Backwaters Up Millinocket Way
No. 3)
1939–40
Oil on masonite
22 × 28 in. (55.9 × 71.1 cm)
CU Art Museum, University of Colorado, Boulder

Mount Katahdin, Autumn, No. 1
1939–40
Oil on canvas
29⅜ × 39¾ in. (74.6 × 101 cm)
Sheldon Museum of Art, University of
Nebraska–Lincoln, Anna R. and
Frank M. Hall Charitable Trust H–232.1943

Mount Katahdin, Autumn, No. 2
1939–40
Oil on canvas
30¼ × 40¼ in. (76.8 × 102.2 cm)
The Metropolitan Museum of Art, Edith and
Milton Lowenthal Collection, Bequest of Edith
Abrahamson Lowenthal, 1991 1992.24.3

Mount Katahdin, Winter
1939–40
Oil on commercially prepared paperboard
(academy board)
24 × 29½ in. (61 × 74.9 cm)
Ogunquit Museum of American Art

Madawaska—Acadian Light-Heavy
1940
Oil on hardboard (masonite)
40 × 30 in. (101.6 × 76.2 cm)
The Art Institute of Chicago, Bequest of
A. James Speyer 1987.249

On the Beach
1940
Oil on masonitetype hardboard
22 × 28 in. (55.9 × 71.1 cm)
Ted and Mary Jo Shen, Courtesy James Reinish
& Associates, Inc., and Meredith Ward Fine Art,
New York

Small Town, Maine
ca. 1940
Charcoal and white chalk on paper
18 × 24 in. (45.7 × 61 cm)
Collection of AXA. AXA is the brand name of AXA
Equitable Life Insurance Company, New York,
New York, the primary subsidiary of the global
AXA Group (AXA S.A.)

Study for "Lobster Fishermen"
1940
Pastel on paperboard
21¼ × 27 in. (54 × 68.6 cm)
The Metropolitan Museum of Art,
Arthur Hoppock Hearn Fund, 1956 56.77

Down East Young Blades
ca. 1940
Oil on masonite-type hardboard
40 × 30 in. (101.6 × 76.2 cm)
Wadsworth Atheneum Museum of Art, Hartford,
Connecticut, The Douglas Tracy Smith and
Dorothy Potter Smith Fund, The Evelyn Bonar
Storrs Trust Fund, The Krieble Family Fund for
American Art, The Dorothy Clark Archibald and
Thomas L. Archibald Fund

Mount Katahdin No. 1
ca. 1940
Charcoal on paper
12 × 14 in. (30.5 × 35.6 cm)
Bates College Museum of Art, Lewiston, Marsden
Hartley Memorial Collection, Museum Purchase
with Elizabeth A. Gregory MD '38 Fund

Untitled (Couple at Old Orchard Beach)
ca. 1940
Graphite on paper
4½ × 7 in. (11.4 × 17.8 cm)
Bates College Museum of Art, Lewiston,
Marsden Hartley Memorial Collection,
Gift of Norma Berger

Untitled (Four Bathers at Old Orchard Beach)
ca. 1940
Graphite on paper
4½ × 7 in. (11.4 × 17.8 cm)
Bates College Museum of Art, Lewiston,
Marsden Hartley Memorial Collection,
Gift of Norma Berger

Untitled (Four Figures at Old Orchard Beach)
ca. 1940
Graphite on paper
4½ × 7 in. (11.4 × 17.8 cm)
Bates College Museum of Art, Lewiston,
Marsden Hartley Memorial Collection,
Gift of Norma Berger

Untitled (Lone Male Figure, Front View)
ca. 1940
Graphite on paper
11¾ × 9 in. (29.8 × 22.9 cm)
Bates College Museum of Art, Lewiston,
Marsden Hartley Memorial Collection,
Gift of Norma Berger

**Untitled (Male Figure, Rope, and Buoy at Old
Orchard Beach)**
ca. 1940
Graphite on paper
4¾ × 7¼ in. (12.1 × 18.4 cm)
Bates College Museum of Art, Lewiston,
Marsden Hartley Memorial Collection,
Gift of Norma Berger

Untitled (Male Torso)
ca. 1940
Graphite on paper
4¾ × 6 in. (12.1 × 15.2 cm)
Bates College Museum of Art, Lewiston,
Marsden Hartley Memorial Collection,
Gift of Norma Berger

**Untitled (Three Fishermen with Fish
and Lobster)**
ca. 1940
Graphite on paper
11½ × 8¾ in. (29.2 × 22.2 cm)
Bates College Museum of Art, Lewiston,
Marsden Hartley Memorial Collection,
Gift of Norma Berger

**Untitled (Two Male Figures at Old
Orchard Beach)**
ca. 1940
Graphite on paper
4½ × 7½ in. (11.4 × 19.1 cm)
Bates College Museum of Art, Lewiston,
Marsden Hartley Memorial Collection,
Gift of Norma Berger

Black Duck No. 2
1940–41
Oil on masonite
28¼ × 22 in. (71.8 × 55.9 cm)
Museum of Fine Arts, Boston, The Hayden
Collection, Charles Henry Hayden Fund

**Canuck Yankee Lumberjack at Old Orchard
Beach, Maine**
1940–41
Oil on masonite-type hardboard
40⅛ × 30 in. (101.9 × 76.2 cm)
Hirshhorn Museum and Sculpture Garden,
Smithsonian Institution, Washington D.C.,
Gift of Joseph H. Hirshhorn, 1966

The Lighthouse
1940–41
Oil on masonite-type hardboard
30 × 40⅛ in. (76.2 × 101.9 cm)
Collection of Pitt and Barbara Hyde

Lobster Fishermen
1940–41
Oil on hardboard (masonite)
29¾ × 40⅞ in. (75.6 × 103.8 cm)
The Metropolitan Museum of Art,
Arthur Hoppock Hearn Fund, 1942 42.160

Lobster on Black Background
1940–41
Oil on hardboard (masonite)
22 × 28 in. (55.9 × 71.1 cm)
Smithsonian American Art Museum, Washington,
D.C., Gift of Mr. Henry P. McIlhenny

Logjam, Penobscot Bay
1940–41
Oil on masonite
30 × 40⅞ in. (76.4 × 103.8 cm)
Detroit Institute of Arts,
Gift of Robert H. Tannahill

The Wave
1940–41
Oil on masonite-type hardboard
30¼ × 40⅞ in. (76.8 × 103.8 cm)
Worcester Art Museum

Church at Corea
1941
Pastel on paperboard
28 × 21¾ in. (71.1 × 55.2 cm)
Colby College Museum of Art, Waterville,
Museum Purchase by the Board of Governors in
Honor and Memory of Edward H. Turner L.H.D.
'73 1997.038

Church at Corea
1941
Oil on canvas board
19⅞ × 15¾ in. (50.5 × 40 cm)
Collection of Karen and Kevin Kennedy

Mount Katahdin
1941
Oil on masonite
22 × 28 in. (55.9 × 71.1 cm)
Private collection

**Storm Down Pine Point Way, Old Orchard
Beach**
1941–43
Oil on hardboard (masonite)
22 × 28 in. (55.9 × 71.1 cm)
Crystal Bridges Museum of American Art,
Bentonville, Arkansas

Blue Landscape
1942
Oil on commercially prepared paperboard
(academy board)
16 × 20 in. (40.6 × 50.8 cm)
Princeton University Art Museum, Museum
Purchase, Fowler McCormick Class of 1921,
Fund of Kathleen Compton Sherrerd Fund for
Acquisitions in American Art

Evening Storm, Schoodic, Maine
1942
Oil on hardboard (masonite)
30 × 40 in. (76.2 × 101.6 cm)
The Museum of Modern Art, New York, Acquired
through the Lillie P. Bliss Bequest 1943

Evening Storm, Schoodic, Maine, No. 2
1942
Oil on hardboard (masonite)
30 × 40½ in. (76.2 × 102.9 cm)
Brooklyn Museum, Bequest of Edith and Milton
Lowenthal 1992

Lobster Fishermen's Church by the Barrens
1942
Oil on masonite
30 × 40 in. (76.2 × 101.6 cm)
Collection of Karen and Kevin Kennedy

Mount Katahdin, November Afternoon
1942
Oil on masonite
30 × 40 in. (76.2 × 101.6 cm)
Nelson-Atkins Museum of Art, Kansas City,
Missouri, Gift of Mrs. James A. Reed in memory
of Senator James Reed through the Friends of Art

Mount Katahdin, Snow Storm
1942
Oil on masonite
30 × 40 in. (76.2 × 101.6 cm)
Michael Altman Fine Art & Advisory Services,
LLC, New York
The Metropolitan Museum of Art only

Off the Banks at Night
1942
Oil on hardboard
30 × 40 in. (76.2 × 101.6 cm)
The Phillips Collection, Washington, D.C.

Sea Window—Tinker Mackerel
1942
Oil on masonite
40 × 30 in. (101.6 × 76.2 cm)
Smith College Museum of Art, Northampton,
Massachusetts, Purchased with the Sarah J.
Mather Fund

Summer, Sea, Window, Red Curtain
1942
Oil on masonite
40⅛ × 30½ in. (101.9 × 77.5 cm)
Addison Gallery of American Art, Phillips
Academy, Andover, Museum Purchase 1944.81

Sundown by the Ruins
1942
Oil on composition board
22 × 28 in. (55.9 × 71.1 cm)
Whitney Museum of American Art, New York,
Gift of Charles Simon

White Sea Horse
1942
Oil on hardboard
28 × 22 in. (71.1 × 55.9 cm)
Collection of Jan T. and Marica Vilcek,
Promised Gift to the Vilcek Foundation
The Metropolitan Museum of Art only

Young Seadog with Friend Billy
1942
Oil on canvas
39½ × 29 in. (100.3 × 73.7 cm)
Private collection, Bloomfield Hills, Michigan

Dead Plover
1942–43
Oil on masonite
16 × 20 in. (40.6 × 50.8 cm)
Colby College Museum of Art, Waterville,
Gift of the Alex Katz Foundation
Colby College Museum of Art only

NOTES

Abbreviations

AAA Archives of American Art, Smithsonian Institution, Washington, D.C.

YCAL Yale Collection of American Literature, Beinecke Rare Book & Manuscript Library, Yale University, New Haven

Introduction: Marsden Hartley's Maine

Donna M. Cassidy • Elizabeth Finch • Randall R. Griffey

1. Elizabeth McCausland, *Marsden Hartley* (Minneapolis: University of Minnesota Press, 1952): 3.

2. "The Recluse and the Refugee," *Newsweek*, November 13, 1944: 107–8. Marsden Hartley, *Androscoggin* (Portland, Maine: Falmouth Publishing House, 1940). See also, Robert Burlingame, "Marsden Hartley's *Androscoggin*: Return to Place," *New England Quarterly* 31, no. 4 (December 1958): 447–62.

3. Marsden Hartley, "On the Subject of Nativeness — A Tribute to Maine," in *Marsden Hartley: Exhibition of Recent Paintings, 1936* (New York: An American Place, 1937): 5.

4. [Henry, McBride], "Current News of Art and the Exhibitions," *The Sun*, April 9, 1916: 8 (section 6); reprinted in *Camera Work*, no. 48 (October 1916): 58–59 (where Hartley likely read it).

5. Hartley to Alfred Stieglitz, February 8, 1917, Alfred Stieglitz/Georgia O'Keeffe Archive, YCAL.

6. Hartley to Gertrude Stein, October 18, 1913, Gertrude Stein/Alice B. Toklas Papers, YCAL.

7. Stieglitz to Hartley, October 26, 1923, Alfred Stieglitz/Georgia O'Keeffe Archive, YCAL; quoted in Townsend Ludington, *Marsden Hartley: The Biography of an American Artist* (Boston: Little, Brown, 1992): 59.

8. Hartley to Stieglitz, December 18, 1924, Alfred Stieglitz/Georgia O'Keeffe Archive, YCAL.

9. Wanda Corn, *The Great American Thing: Modern Art and National Identity, 1915–1935* (Berkeley: University of California Press, 1999); Teresa A. Carbone, ed., *Youth and Beauty: Art of the American Twenties*, exh. cat., Brooklyn Museum; Dallas Museum of Art; Cleveland Museum of Art (New York: Skira Rizzoli; Brooklyn: Brooklyn Museum, 2011).

10. Townsend Ludington, "Marsden Hartley on Native Ground," in *Modern Art and America: Alfred Stieglitz and His New York Galleries*, ed. Sarah Greenough, exh. cat. (Washington, D.C.: National Gallery of Art; Boston: Bulfinch Press, 2000): 415.

11. Kevin Salatino, ed., *Edward Hopper's Maine*, exh. cat. (Brunswick, Maine: Bowdoin College Museum of Art; Munich and New York: DelMonico Books-Prestel, 2011).

12. *River by Moonlight* is mentioned in "Edmund Marsden Hartley of Lewiston, a Student and Painter of Nature," *Lewiston Saturday Journal*, December 29, 1906: 9.

13. Bruce Robertson, "Marsden Hartley and Self-Portraiture," in *Marsden Hartley*, ed. Elizabeth Mankin Kornhauser, exh. cat., Wadsworth Atheneum Museum of Art, Hartford, Conn.; Phillips Collection, Washington, D.C.; Nelson-Atkins Museum of Art, Kansas City (Hartford, Conn.: Wadsworth Atheneum Museum of Art, 2002): 153.

14. Duncan Phillips, founder and director of the Phillips Collection in Washington, D.C., acquired six paintings by Hartley between 1939 and 1943. The Metropolitan Museum acquired *Lobster Fishermen* (fig. 87) in 1942, after the painting was awarded Fourth Prize at the Museum's "Artists for Victory: An Exhibition of Contemporary Art" (December 7, 1941–February 22, 1942).

15. Hartley to Norma Berger, December 20, 1942, Marsden Hartley Collection, YCAL.

16. William Innes Homer, *Alfred Stieglitz and the American Avant-Garde* (Boston: New York Graphic Society, 1977): 233.

17. Karen Wilkin, "Marsden Hartley: At Home and Abroad," *The New Criterion* 6 (April 1988): 23.

18. Clement Greenberg, "Avant-Garde and Kitsch," *Partisan Review* 6 (Fall 1939): 34–49.

19. Robert M. Coates, "The Art Galleries: Marsden Hartley," *The New Yorker* 35 (January 30, 1960): 70. See also Robert M. Coates, "The Art Galleries: Marsden Hartley's Maine," *The New Yorker* 24 (October 30, 1948): 85; Robert M. Coates, "The Art Galleries: Hartley and Maurer," *The New Yorker* 34 (December 20, 1958): 83–85; "Maine Man," *Time* 44, no. 21 (November 20, 1944): 50; and "Marsden Hartley: Fame Finally Catches Up to Poet-Painter of Maine," *Life*, June 16, 1952: 84–89.

20. Barbara Haskell, *Marsden Hartley*, exh. cat. (New York: Whitney Museum of American Art, 1980). See Roberta Smith, "Review/Art: Hartley's Later Works Show a Talent Distilled," *The New York Times*, June 29, 1990: C15.

21. *The Collected Poems of Marsden Hartley 1904–1943*, ed. Gail R. Scott (Santa Rosa, Calif.: Black Sparrow Press, 1987), and *On Art by Marsden Hartley*, ed. Gail R. Scott (New York: Horizon Press, 1982).

22. Gail R. Scott, *Marsden Hartley: Visionary of Maine*, exh. cat., University of Maine, Presque Isle, and four other Maine venues (Presque Isle: University of Maine, 1982). See also Vivian Barnett, "Marsden Hartley's Return to Maine," *Arts Magazine* 54, no. 1 (October 1979): 172–76.

23. Kornhauser, *Marsden Hartley*.

Becoming "An American Individualist": The Early Work of Marsden Hartley

Elizabeth Finch

1. "Edmund Marsden Hartley of Lewiston, a Student and Painter of Nature," *Lewiston Saturday Journal*, December 29, 1906: 9.

2. Hartley to Horace Traubel, June 2, 1908, in *Heart's Gate: Letters between Marsden Hartley & Horace Traubel, 1906–1915*, ed. William Innes Homer (Highlands, N.C.: Jargon Society, 1982): 64. Emphasis in original.

3. Hartley to Norma Berger, April 2, 1911, Elizabeth McCausland Papers, box 12, folder 6, AAA.

4. Marsden Hartley, "Somehow a Past: A Sequence of Memories Not to Be Called an Autobiography," in *Somehow a Past: The Autobiography of Marsden Hartley*, ed. Susan Elizabeth Ryan (Cambridge, Mass.: MIT Press, 1997): 184.

5. Peter Schjeldahl, "The Searcher: Marsden Hartley's Eloquent Restlessness," *The New Yorker* 78 (February 3, 2003): 93.

6. Clement Greenberg, "Review of Two Exhibitions of Marsden Hartley," *The Nation*, December 30, 1944; reprinted in *Clement Greenberg: The Collected Essays and Criticism*, vol. 1, *Perceptions and Judgments, 1939–1944*, ed. John O'Brian (Chicago: University of Chicago Press, 1986): 247, no. 89.

7. This distinction emerged in the earliest exhibition of Hartley's German works. See Charles H. Caffin, "New and Important Things in Art: Latest Work by Marsden Hartley," *New York American*, April 17, 1916: 8; reprinted in *Camera Work*, no. 48 (October 1916): 60. Caffin notes that Hartley "abandoned the landscapes with which he had been associated previously and set about developing these abstract expressions of his sensations." See also Gail Levin, "Marsden Hartley," in *The Advent of Modernism: Post-Impressionism and North American Art, 1900–1918*, exh. cat., High Museum of Art, Atlanta; Center for the Fine Arts, Miami; Brooklyn Museum; Glenbow Museum, Calgary (Atlanta: High Museum of Art, 1986): 99.

8. Hartley to Franz Marc, May 13, 1913, in "Marsden Hartley's Letters to Franz Marc and Wassily Kandinsky, 1913–1914," ed. Patricia McDonnell, *Archives of American Art Journal* 29, no. 1/2 (1989): 38.

9. Hartley to Richard Tweedy, May 20, 1900, Elizabeth McCausland Papers, box 16, folder 37, AAA.

10. The use of this term dates to the 1880s. See John F. Bauman, *Gateway to Vacationland: The Making of Portland, Maine* (Amherst: University of Massachusetts Press, 2012): 68. See also William MacDonald, "A State of Summer Resorts," *The Nation*, August 19, 1897: 145–46.

11. Hartley to Richard Tweedy, October 9, 1900, Elizabeth McCausland Papers, box 16, folder 37, AAA.

12. In his letter to Tweedy (ibid.), Hartley cites an article on butterflies, the English naturalist and ornithologist Gilbert White's *Natural History and Antiquities of Selborne* (1789), the letters of Henry David Thoreau, and an "essay on love" by the Scottish evangelist Henry Drummond, likely *Love: The Supreme Gift; the Greatest Thing in the World* (1890).

13. Hartley to Richard Tweedy, October 9, 1900, Elizabeth McCausland Papers, box 16, folder 37, AAA.

14. Hartley to Marguerite Karfiol, July 21, 1904, Bernard Karfiol Papers, reel NKa1, AAA.

15. Hartley, "Somehow a Past: A Sequence of Memories," in *Somehow a Past*: 186.

16. Hartley to Marguerite Karfiol, July 21, 1904, Bernard Karfiol Papers, reel NKa1, AAA.

17. Ibid.

18. "And these tend inward to me, and I tend outward to them, / And such as it is to be of these more or less I am, / And of these one and all I weave the song of myself." Walt Whitman, "Song of Myself," section 15, in *Leaves of Grass* (Boston: James R. Osgood, 1881–82): 41–42.

19. Walt Whitman, preface to the first edition of *Leaves of Grass* (Brooklyn, 1855): [iii].

20. In response to urbanism, Western expansion, and waves of immigration, the symbolic value of New England as "the original national home" grew in significance at the turn of the twentieth century; see Julia B. Rosenbaum, *Visions of Belonging: New England Art and the Making of American Identity* (Ithaca, N.Y.: Cornell University Press, 2006): 3.

21. The Volks renovated and expanded an existing farmhouse. They also built four cottages and a studio for Douglas Volk. "We called it 'Hewn Oaks' because the house as you will see is entirely hand-made. . . . Even the hinges are of hammered iron from a native forge." Marion Volk quoted in Alice Frost Lord, "At the Home of the Volks in Lovell: A Center of Art and Handicraft," *Lewiston Journal*, illustrated magazine section, September 10–14, 1904: 1. More frequently the name appears as a single word — Hewnoaks, which is how it is carved into the lintel above the front door of the main house.

22. Hartley to Richard Tweedy, July 10, 1901, Elizabeth McCausland Papers, box 16, folder 37, AAA.

23. Charles H. Caffin, "Art: Some Notable Features of the Twentieth Annual Exhibition of the Society of American Artists," *Harper's Weekly* 42, no. 2153 (March 26, 1898): 310, quoted in Arlene M. Palmer, "Douglas Volk and the Arts and Crafts in Maine," *The Magazine Antiques* 173, no. 4 (April 2008): 118.

24. Unknown author (most likely Douglas or Marion Volk), *Handicrafts Center Lovell* (Center Lovell, Maine: Sabatos Press, 1902), unpaginated.

25. Elizabeth Hutchinson, *The Indian Craze: Primitivism, Modernism, and Transculturation in American Art, 1890–1915* (Durham, N.C.: Duke University Press, 2009): 2–3. Rugs were the principal product of Sabatos Industries, the name the Volks gave to their enterprise. In 1902 they established the Sabatos Handicraft Society to facilitate their community-wide activities.

26. Lord, "At the Home of the Volks in Lovell": 2.

27. Imagery and patterning in Hartley's German paintings, including the Amerika series, resemble aspects of the Volk family productions, especially the weavings of Douglas and Marion Volk's son Wendell. The Hewnoaks estate was dispersed in a 2006 auction, and the Metropolitan Museum acquired three of Wendell Volk's weavings in 2008 (2008.108.1–3). The discovery of this iconographic connection may shed new light on what the art historian Wanda Corn has rightly described as the "strangeness of this series." Wanda M. Corn, "Marsden Hartley's Native Amerika," in *Marsden Hartley*, ed. Elizabeth Mankin Kornhauser, exh. cat., Wadsworth Atheneum Museum of Art, Hartford, Conn.; Phillips Collection, Washington, D.C.; Nelson-Atkins Museum of Art, Kansas City (Hartford, Conn.: Wadsworth Atheneum Museum of Art, 2002): 72.

28. Hartley to Franz Marc, May 29, 1913, in McDonnell, "Marsden Hartley's Letters to Marc and Kandinsky": 39.

29. Marsden Hartley, "Wesley Adams — Maine Trapper," Marsden Hartley Papers, reel 1368, AAA.

30. This understanding of Hartley's interest in folk culture is indebted to the scholarship of Donna Cassidy. See, in particular, "The Folk and the Modernist Primitive," in Donna M. Cassidy, *Marsden Hartley: Race, Region, and Nation* (Hanover, N.H.: University Press of New England, 2005): 169–212.

31. Hartley, "Somehow a Past: A Sequence of Memories," in *Somehow a Past*: 185.

32. Hartley to Shaemas O'Sheel, December 25, 1906, Marsden Hartley Collection, YCAL.

33. Hartley to Arthur Plummer, postmarked June 1, 1911, Marsden Hartley Papers, Special Collections and Archives, Kent State University Libraries (hereafter KSU). Plummer was part owner of the photography studio Flagg and Plummer in Lewiston.

34. Hartley to Shaemas O'Sheel, December 25, 1906, Marsden Hartley Collection, YCAL. The painting Hartley mentions is probably *Storm Clouds, Maine*, 1906–7 (Walker Art Center, Minneapolis).

35. Hartley mentions Franklin Pasture in the 1906 *Lewiston Saturday Journal* article and it appears in two drafts of his autobiography. See Marsden Hartley, "Somehow a Past: Prologue to Imaginative Living," in *Somehow a Past*: 50, and Hartley, "Somehow a Past: A Sequence of Memories," in *Somehow a Past*: 180.

36. Water was also a prominent theme in Hartley's writings about Maine. See, for example, Marsden Hartley, "Hypnosis of Water," unpublished manuscript, circa late 1930s, Marsden Hartley Papers, reel 1369, AAA.

37. Of the Boston murals, Hartley remarked to the *Lewiston Saturday Journal* reporter (see page 41 and note 1 above), "They are perhaps more interesting to me than to any one else on account of their associations."

38. Hartley to Horace Traubel, May 8, 1908, in Homer, *Heart's Gate*: 61. The whereabouts of this work is unknown, and it did not appear in the sale of Fitzgerald's collection following his death in 1926. I am grateful to Randy Griffey for alerting me to this omission.

39. Hartley to Horace Traubel, June 2, 1908, and May 8, 1908, in Homer, *Heart's Gate*: 64, 61.

40. Hartley to Arthur Plummer, postmarked December 18, 1908, Marsden Hartley Papers, KSU.

41. Maurice Prendergast to William Glackens (undated letter draft, ca. 1909), Maurice Brazil and Charles Prendergast Selected Papers, reel 4543, AAA. Prendergast mistakenly identified Hartley as having returned from "the northern part of New Hampshire."

42. Hartley to Shaemas O'Sheel, October 19, 1908, Marsden Hartley Collection, YCAL.

43. The title of this work was the only one to be placed in quotation marks in the list of works for Hartley's first exhibition at 291. It may have been retitled at a later date, as no work by this title is known.

44. Hartley to Horace Traubel, n.d. (postmarked October 29, 1907), in Homer, *Heart's Gate*: 57.

45. Hartley to Alfred Stieglitz, n.d. (received December 20, 1912), in *My Dear Stieglitz: Letters of Marsden Hartley and Alfred Stieglitz, 1912–1915*, ed. James Timothy Voorhies (Columbia: University of South Carolina Press, 2002): 46.

46. Hartley to Norma Berger, July 15, 1910, Marsden Hartley Collection, YCAL.

47. Charles de Kay, "French and American Impressionists," *The New York Times*, January 31, 1904: 23.

48. Marsden Hartley, "Aesthetic Sincerity," *El Palacio* 5, no. 20 (December 9, 1918): 332–33.

49. R[oyal] C[ortissoz], "Art Exhibitions: New Works by Several American Painters," *New-York Herald Tribune*, January 5, 1910: 7, quoted in William H. Gerdts, "Willard Metcalf: Painter Laureate of New England Impressionism," in *Willard Metcalf (1858–1925): Yankee Impressionist*, exh. cat. (New York: Spanierman Gallery, 2003): 69.

50. Alfred Stieglitz to Hartley, October 26, 1923, quoted in Townsend Ludington, *Marsden Hartley: The Biography of an American Artist* (Boston: Little, Brown, 1992): 59.

51. [Sadakichi Hartmann], "Unphotographic Paint: The Texture of Impressionism," *Camera Work*, no. 28 (October 1909): 20.

52. Marsden Hartley, "Somehow a Past: A Sequence of Memories," in *Somehow a Past*: 187; "On the Subject of the Mountain: Letter to Messieurs Segantini and Hodler," 1932, Marsden Hartley Papers, reel 1368, AAA, reprinted in Jeanne Hokin, *Pinnacles & Pyramids: The Art of Marsden Hartley* (Albuquerque: University of New Mexico Press, 1993): 135.

53. Marsden Hartley, "Giovanni Segantini: Painter of Mountains, Worshipper of Nature," manuscript, Marsden Hartley Papers, reel 1369, AAA. I am indebted to Frank Guarnieri for deciphering this handwritten text.

54. Hartley, "Somehow a Past: A Sequence of Memories," in *Somehow a Past*: 186.

55. Hartley to Norma Berger, October 6, 1910, Marsden Hartley Collection, YCAL.

56. Ibid. See also his letters to Berger of October 24, 1910, and November 3, 1910.

57. Hartley to Norma Berger, September 20, 1910, Marsden Hartley Collection, YCAL.

58. Hartley, "Somehow a Past: A Sequence of Memories," in *Somehow a Past*: 185.

59. Albert Pinkham Ryder, "Paragraphs from the Studio of a Recluse," *Broadway Magazine* 14 (September 1905): 10–11; as quoted in Elizabeth Broun, *Albert Pinkham Ryder*, exh. cat., National Museum of American Art, Washington, D.C.; Brooklyn Museum (Washington, D.C.: Smithsonian Institution Press, 1990): 21.

60. Jackson Pollock, "Answers to a Questionnaire," *Arts and Architecture* 61 (February 1944): 14, as quoted in B[ernard] H[arper] Friedman, *Jackson Pollock: Energy Made Visible* (New York: McGraw-Hill, 1972): 21.

61. Hartley, "Somehow a Past: Prologue to Imaginative Living," in *Somehow a Past*: 67.

62. Hartley to Norma Berger, July 15, 1910, Marsden Hartley Collection, YCAL.

63. Ludington, *Marsden Hartley*: 21.

64. Marsden Hartley, "Wesley Adams — Maine Trapper," Marsden Hartley Papers, reel 1368, AAA.

65. See the epigraph at the beginning of this essay.

66. Hartley, "Somehow a Past: A Sequence of Memories," in *Somehow a Past*: 186.

67. Posthumous labels on the reverse of this painting indicate that McCausland was responsible for assigning the subtitle. See also Elizabeth McCausland Papers, box 19, folder 8, AAA. My thanks to Gail Scott for alerting me to this archival information.

68. The inscription on the verso of this painting reads: "Albert Ryder seen out at night//8th Avenue &15th Street." I am grateful to Isabelle Duvernois and Randy Griffey for this information.

69. Bruce Weber, *The Heart of the Matter: The Still Lifes of Marsden Hartley*, exh. cat. (New York: Berry-Hill Galleries, 2003): 74.

The Local as Cosmopolitan: Marsden Hartley's Transnational Maine

Donna M. Cassidy

1. Hartley described the exhibition to Alfred Stieglitz: The group [of American artists] is "in no sense what it should be but they could only take what was available — and the available material is as follows: myself — George Biddle whose new work is much better than his old — John Storrs — Jules Pascin, John Barber — Paul Burlin, Hunt Diederich. [Maurice Sterne also exhibited.] But it is at least a beginning and a real event in the art movements in Paris. . . . I have no doubt but it will lead to a more representative attempt another year during which time we might get more exciting material together. I personally would love to have seen Marin, O'Keefe [sic] & a few others in it but the time was too short." Hartley to Alfred Stieglitz, December 18, 1924, Alfred Stieglitz/Georgia O'Keeffe Archive, YCAL.

2. Ibid., April 18, 1923; Townsend Ludington, *Marsden Hartley: The Biography of an American Artist* (Boston: Little, Brown, 1992): 162–63.

3. Paul Rosenfeld, *Port of New York: Essays on Fourteen American Moderns* (New York: Harcourt, Brace, 1924): 99–100. Hartley undoubtedly picked up his copy of this book when he was in New York in early 1924. He gave a copy to his niece Norma Berger in May 1924, which is now in the Marsden Hartley Library, Bates College, Lewiston, Maine. My thanks to Randy Griffey for bringing this volume to my attention. Rosenfeld articulated these ideas in an earlier essay, "The Paintings of Marsden Hartley," *Vanity Fair* 18, no. 6 (August 1922): 47, 84, 94, 96. Hartley mentions reading this essay in a letter to Stieglitz (September 4, 1922, Alfred Stieglitz/Georgia O'Keeffe Archive, YCAL).

4. Hartley to Alfred Stieglitz, January 21, 1925, Alfred Stieglitz/Georgia O'Keeffe Archive, YCAL.

5. Ibid., April 28, 1923.

6. Hartley to Alfred Stieglitz, October 11, 1915, in *My Dear Stieglitz: Letters of Marsden Hartley and Alfred Stieglitz, 1912–1915*, ed. James Timothy Voorhies (Columbia: University of South Carolina Press, 2002): 195–98.

7. See Wanda Corn, *The Great American Thing: Modern Art and National Identity, 1915–1935* (Berkeley: University of California Press, 1999), and Elizabeth Hutton Turner, *Americans in Paris (1921–1931): Man Ray, Gerald Murphy, Stuart Davis, Alexander Calder*, exh. cat., Phillips Collection, Washington, D.C. (Washington, D.C.: Counterpoint, 1996).

8. Hartley to Rebecca Strand, late summer 1929, Rebecca Salsbury James Papers, YCAL; also available on reel X3, AAA. Hartley also expressed his desire to be a citizen of both America and Europe: "I want to establish myself on both sides of the water — and be the new and not too much heard of citizen of both areas." Hartley to Alfred Stieglitz, December 28, 1922, Alfred Stieglitz/Georgia O'Keeffe Archive, YCAL. Note that Hartley often uses New England and Maine interchangeably.

9. Hartley's family lived in a four-story house on Lincoln Street, below English Hill and near the mills; see Ludington, *Marsden Hartley*: 15–16.

10. Marsden Hartley, "Cleophas and His Own," reprinted in *Marsden Hartley and Nova Scotia*, ed. Gerald Ferguson, exh. cat. (Halifax: Mount Saint Vincent University Art Gallery, 1987): 89.

11. Anne Gordon Atkinson et al., *Green Acre on the Piscataqua: A Centennial Celebration* (Eliot, Maine: Green Acre Bahá'í School Council, 1991): 18.

12. Excerpt from a letter written by Sarah Farmer in 1898, quoted in ibid.: 26.

13. On the Ogunquit art colony, see Thomas Denenberg, "Ogunquit: The Old Fashioned and the Modern," in *Call of the Coast: Art Colonies of New England*, exh. cat. (Portland, Maine: Portland Museum of Art; Old Lyme, Conn.: Florence Griswold Museum; New Haven: Yale University Press, 2009): 54–61; and on Georgetown, see Libby Bischof and Susan Danly, *Maine Moderns: Art in Seguinland, 1900–1940*, exh. cat. (Portland, Maine: Portland Museum of Art; New Haven: Yale University Press, 2011).

14. Hartley to Norma Berger, December 6, 1940, Marsden Hartley Collection, YCAL.

15. Hartley to Isabel Lachaise, August 26, 1940, Gaston Lachaise Papers, YCAL; also available on reel X3, AAA. Richard Blackmur was a literary critic and distinguished Princeton University professor; *The Hound & Horn* was a literary magazine published at Harvard University. Philip Horton published *Hart Crane: The Life of an American Poet* (New York: W. W. Norton, 1937). Within this intellectual circle in Corea during these years (1940–43) were Miriam Colwell (a Maine writer), Chenoweth Hall (a writer, musician, and painter then working for a New York advertising agency), Ruth Storm (a teacher at Evander Childs High School in New York), Mabel Griffin (also a teacher in New York), Louise Young (a photographer and the daughter of the family with whom Hartley lodged), and Ivan Albright (a painter). See also "Oral History Interview with Miriam Colwell, June 10–11, 2005," conducted by Susan C. Larsen at her home in Prospect Harbor, Maine, AAA, www.aaa.si.edu/collections/interviews/oral-history-interview-miriam-colwell-12673. Despite this lively scene, Hartley wrote of his isolation in Corea: "I have almost no social contact at all here, fortunately the folks I live with are simply darlings, everyone loves everyone else, and we do have a sweet time of it." Hartley to Alfred Stieglitz, August 24, 1941, Alfred Stieglitz/Georgia O'Keeffe Archive, YCAL.

16. Robert P. Tristram Coffin, *Kennebec: Cradle of Americans* (New York and Toronto: Farrar & Rinehart, 1937): 6.

17. Barbara Haskell, *Marsden Hartley*, exh. cat. (New York: Whitney Museum of American Art, 1980): 13; "Edmund Marsden Hartley of Lewiston, a Student and Painter of Nature," *Lewiston Saturday Journal*, December 29, 1906: 9.

18. *Paintings by the Impressionists: Collection of the Late Desmond Fitzgerald*, sale cat. (New York: American Art Association, April 21–22, 1927).

See also Fitzgerald and MacKnight mentioned in Hartley's letters to Horace Traubel (May 8 and June 2, 1908), reprinted in *Heart's Gate: Letters between Marsden Hartley & Horace Traubel, 1906–1915,* ed. William Innes Homer (Highlands, N.C.: Jargon Society, 1982): 61, 64.

19. Hartley to Alfred Stieglitz, n.d. [October 31, 1913], in Voorhies, *My Dear Stieglitz*: 120–21. On the Blaue Reiter and *hinterglasmalerei,* see Helmut Friedel and Annegret Hoberg, *The Blue Rider in the Lenbachhaus, Munich* (Munich: Prestel, 2000), and Anne Mochon, *Gabriele Münter: Between Munich and Murnau,* exh. cat., Busch-Reisinger Museum, Cambridge, Mass.; Princeton University Art Museum (Cambridge, Mass.: Busch-Reisinger Museum, Harvard University, 1980).

20. *Source and Inspiration: A Continuing Tradition,* exh. cat. (New York: Hirschl & Adler Folk, 1988): 16.

21. See *Bernard Karfiol,* Monograph no. 12 (New York: American Artists Group, 1945), unpaginated, and Elizabeth Stillinger, *A Kind of Archeology: Collecting American Folk Art, 1876–1976* (Amherst and Boston: University of Massachusetts Press, 2011): 161–62. On Field and the collection of folk art at Ogunquit, see also Doreen Bolger, "Hamilton Easter Field and His Contribution to American Modernism," *American Art Journal* 20, no. 2 (1988): 78–107, and Laurie Eglington, "Current Exhibit Revives Memory of Noted Figure: Art Foundation Vividly Recalls the Many-Sided Personality of Mr. Hamilton Easter Field Artist, Critic, and Patron," *Art News,* October 13, 1934: 3, 5, 10.

22. *Source and Inspiration*: 16. Hartley continued to paint on glass when he returned to New York from Ogunquit and exhibited glass paintings at Ardsley Studios in Brooklyn Heights two years later. He did not want to show them at 291 as he considered them "decoration" and thought Wanamaker's department store a more apt venue. See Bruce Weber, *The Heart of the Matter: The Still Lifes of Marsden Hartley,* exh. cat. (New York: Berry-Hill Galleries, 2003): 40–41. Hartley continued to be interested in folk art throughout his career; see Marsden Hartley, "The Virtues of Amateur Painting," in *Adventures in the Arts: Informal Chapters on Painters, Vaudeville, and Poets* (New York: Boni and Liveright, 1921): 135–36, and Hartley to Rebecca Strand, January 26, 1929, Rebecca Salsbury James Papers, YCAL; also available on reel X3, AAA. Hartley had earlier exposure to the folk-art revival of Douglas and Marion Volk in Center Lovell, Maine.

23. Weber, *Heart of the Matter*: 40.

24. On the Hopi maize symbol, see Gail Levin, "Marsden Hartley's 'Amerika': Between Native American and German Folk Art," *American Art Review* 5, no. 2 (Winter 1993): 120–25, 170–72.

25. Malcolm Cowley, *Exile's Return: A Literary Odyssey of the 1920s* (1934; rev. ed., New York: Viking Press, 1965): 80; see also Caren Kaplan, *Questions of Travel: Postmodern Discourses of Displacement* (Durham, N.C.: Duke University Press, 1996): 70.

26. Derrick R. Cartwright, "We Moderns," in *American Moderns, 1900–1950,* exh. cat. (Chicago: Terra Foundation for the Arts; Giverny: Musée d'Art Américain, 2000): 12; Cowley, *Exile's Return*: 206.

27. Cowley, *Exile's Return*: 83.

28. Stuart Davis, quoted in epigraph in Turner, *Americans in Paris*: 5.

29. Hartley to Alfred Stieglitz, May 23, 1923, Alfred Stieglitz/Georgia O'Keeffe Archive, YCAL.

30. Henry James, *Notes of a Son and Brother* (New York: Charles Scribner's Sons, 1914): 117.

31. Ibid.: 85–86.

32. Hartley to Adelaide Kuntz, May 13, 1929: "[My sister Elizabeth] gave me trifling souvenirs of early family life — which I did not seek or crave but here they are and the news of her death hovers about them, about me and the room — and call for true sentimentality." Marsden Hartley Collection, YCAL; also available on reel X4, AAA.

33. Hartley to Rebecca Strand, January 6, 1929, Rebecca Salsbury James Papers, YCAL; also available on reel X3, AAA. In the letter Hartley also mentions a rocking chair that he wanted to purchase when he was in Bath, Maine, during the summer of 1928. It was, however, too expensive to ship to Paris; ibid., November 25, 1928.

34. On Hartley's Maine trip, see Bischof and Danly, *Maine Moderns.*

35. Hartley to Rebecca Strand, January 6, 1929, Rebecca Salsbury James Papers, YCAL; also available on reel X3, AAA.

36. Hartley to Alfred Stieglitz, October 4, 1927, Alfred Stieglitz/Georgia O'Keeffe Archive, YCAL.

37. Ibid., October 27, 1927.

38. Hartley to John Storrs, November 20, 1926, John Henry Bradley Storrs Papers, series 2, box 2, folder 39, AAA.

39. Hartley to Alfred Stieglitz, November 9, 1929, Alfred Stieglitz/Georgia O'Keeffe Archive, YCAL.

40. Hartley to Rebecca Strand, November 19, 1929, Rebecca Salsbury James Papers, YCAL; also available on reel X3, AAA. See also Alfred Stieglitz to Hartley, February 5, 1929, Alfred Stieglitz/Georgia O'Keeffe Archive, YCAL.

41. Lee Simonson, "Foreword," in *Hartley Exhibition* (New York: The Intimate Gallery [Room 303], Anderson Galleries Building, January 1929): [2].

42. Hartley to Adelaide Kuntz, July 22–23, 1933, Marsden Hartley Collection, YCAL; also available on reel X4, AAA.

43. Ibid., July 12, 1933; Marsden Hartley, "Hamburg," ca. 1933, Marsden Hartley Collection, YCAL.

44. Hartley to Norma Berger, September 20, 1933, Marsden Hartley Collection, YCAL.

45. Hartley to Adelaide Kuntz, November 3, 1933, Marsden Hartley Collection, YCAL; also available on reel X4, AAA.

46. Ibid., July 12, 1933; January 11, 1934; and January 18, 1934.

47. Ibid., September 7, 1933.

48. Ibid., December 1, 1933, and September 7, 1933.

49. Hartley to Edith Halpert, July 12, 1933, excerpted in Garnett McCoy, ed., "Letters from Germany 1933–38," *Archives of American Art Journal* 25, no. 1–2 (1985): 7.

50. See Donna M. Cassidy, *Marsden Hartley: Race, Region, and Nation* (Hanover, N.H.: University Press of New England, 2005): 233–34.

51. The figure recalls Saint Hubertus, patron saint of hunters and trappers. Hartley saw a painting of Hubertus at the Schloss Schleissheim near Munich, in which the courtier-hunter on one knee confronts the deer he has been pursuing while a vision of a cross appears between the deer's antlers. See Marsden Hartley, "Schloss Schleissheim bei Munich," ca. 1933–34, Marsden Hartley Collection, YCAL.

52. Marsden Hartley, "On the Subject of Nativeness — A Tribute to Maine," in *Marsden Hartley: Exhibition of Recent Paintings, 1936* (New York: An American Place, 1937): 1, 2.

53. On Hartley in Nova Scotia, see Ferguson, *Marsden Hartley and Nova Scotia.*

54. Hartley to Alfred Stieglitz, October 28, 1936, Alfred Stieglitz/Georgia O'Keeffe Archive, YCAL.

55. These seascapes include *Off the Banks* (1936; The Phillips Collection, Washington, D.C.), *Stormy Sea No. 2* (1936; Farnsworth Art Museum, Rockland, Maine), and *Stormy Sea No. 3* (1936; Art Gallery of Nova Scotia, Halifax).

56. Hartley to Adelaide Kuntz, September 23, 1936, Marsden Hartley Collection, YCAL; also available on reel X4, AAA.

57. Ferguson, *Marsden Hartley and Nova Scotia*: 148.

58. Hartley to Adelaide Kuntz, September 10, 1939, Marsden Hartley Collection, YCAL; also available on reel X4, AAA.

59. Information from the archives of the Gouldsboro Historical Society, Gouldsboro, Maine, and *Historical Researches of Gouldsboro, Maine* (West Gouldsboro, Maine: Daughters of Liberty; Bar Harbor, Maine: W. H. Sherman, 1904): 101–5.

60. Hartley to Adelaide Kuntz, September 26, 1937, Marsden Hartley Collection, YCAL; also available on reel X4, AAA.

61. Gail R. Scott, essay on *Knotting Rope,* in *American Paintings, Drawings and Sculpture,* sale cat. (New York: Sotheby's, December 2, 2010), lot 33.

62. Marsden Hartley, "Somehow a Past: Prologue to Imaginative Living," in *Somehow a Past: The Autobiography of Marsden Hartley,* ed. Susan Elizabeth Ryan (Cambridge, Mass.: MIT Press, 1997): 141.

An Ambivalent Prodigal: Marsden Hartley as "The Painter from Maine"

Randall R. Griffey

1. Marsden Hartley, "On the Subject of Nativeness — A Tribute to Maine," in *Marsden Hartley: Exhibition of Recent Paintings, 1936* (New York: An American Place, 1937): 1.

2. Elizabeth McCausland, "Marsden Hartley Shows His Recent Paintings," *The Springfield (Mass.) Sunday Union and Republican*, March 17, 1940: 6. The poet William Carlos Williams similarly believed that Hartley's homecoming had elevated his art. After visiting the same exhibition he asserted in an unpublished review, "Hartley is painting better today than he ever could have hoped to have done formerly and the reason becomes more and more apparent. . . . It has to do with the mind, the body, and the spirit drawn gradually together into one life and finally flowering, once." Marsden Hartley Papers, 1900–1967, reel 1368, AAA.

3. Theodore F. Wolff, "Coming Home to Maine," *Christian Science Monitor*, March 21, 1980: 15.

4. This thesis follows Vivian Endicott Barnett: "Marsden Hartley declared himself the painter of Maine not because of circumstances of birth but because of his situation in the spring of 1937." Vivian Endicott Barnett, "Marsden Hartley's Return to Maine," *Arts Magazine* 54, no. 1 (October 1979): 172–76, quotation on 176.

5. Charmion von Wiegand, "Opinions under Postage: Our Readers — The Strongly Native American Art of Marsden Hartley," *The New York Times*, April 14, 1940: x9 (section 9).

6. Gail Levin notes that Hartley took photographs in Corea of docks, traps, buoys, and other objects that appear in this painting. See Gail Levin, "Photography's 'Appeal' to Marsden Hartley," *Yale University Library Gazette* 68, no. 1/2 (October 1993): 13–42, especially 34.

7. See Elizabeth Mankin Kornhauser, "Marsden Hartley and Folk Art," *The Magazine Antiques* 163, no. 1 (January 2003): 150–57.

8. Carol Troyen illuminates the circumstances surrounding the 1932 exhibition in "The 'Nativeness' of 'Primitive Things': Marsden Hartley's Late Work in Context," in *Marsden Hartley*, ed. Elizabeth Mankin Kornhauser, exh. cat., Wadsworth Atheneum Museum of Art, Hartford, Conn.; Phillips Collection, Washington, D.C.; Nelson-Atkins Museum of Art, Kansas City (Hartford, Conn.: Wadsworth Atheneum Museum of Art, 2002): 239–53.

9. Edward Alden Jewell, "Art in Review: Pictures of New England by Marsden Hartley on View at the Downtown Gallery," *The New York Times*, April 26, 1932: 24. Hartley's nativist turn in 1932 earned additional headlines back home, in the *Lewiston Daily Sun*, which featured an article about the Downtown Gallery exhibition. "World of Art — Interprets New England," *Lewiston Daily Sun*, June 3, 1932: 4.

10. Marsden Hartley, "On the Subject of Nativeness — A Tribute to Maine," reprinted in *On Art by Marsden Hartley*, ed. Gail R. Scott (New York: Horizon Press, 1982): 112–15; quotation on 115.

11. See Cassidy's discussion of *Northern Seascape, Off the Banks* and *Off the Banks at Night* (pages 99–101 in this volume). See also Gerald Ferguson, ed., *Marsden Hartley and Nova Scotia*, exh. cat. (Halifax: Mount Saint Vincent University Art Gallery, 1987).

12. Hartley, "On the Subject of Nativeness," in Scott, *On Art by Hartley*: 115.

13. On Hartley's friendly rivalries with Peirce and Sprinchorn, see Troyen, "'Nativeness' of 'Primitive Things.'" On Sprinchorn, see Gail R. Scott, *Carl Sprinchorn: King of the Woods*, exh. cat. (Lewiston, Maine: Bates College Museum of Art, 2002).

14. Edward Alden Jewell, "Paintings by Marin to Be Shown Today — Museum of Modern Art Will Present Its Retrospective One-Man Exhibition: Collection Wins Praise —Works by Noted American Artist Include 160 Water-Colors, 21 Oils and 132 Etchings," *The New York Times*, October 21, 1936: 25.

15. E. M. Benson, "John Marin — 'And Pertaining Thereto,'" in *John Marin: Watercolors, Oil Paintings, Etchings*, exh. cat. (New York: The Museum of Modern Art, 1936): 29.

16. Marsden Hartley, "As to John Marin, and His Ideas," in *John Marin*: 16: "Marin has lifted water colour painting out of the embroidery class, out of the class of minor accomplishments of the idle ladies and fussy bachelors. . . . [He] has made of it a major medium."

17. Ibid.: 17.

18. In an essay unpublished in his lifetime, "Is There an American Art," Hartley pointedly calls into question the sincerity of Wood's and Benton's artistic Americanness. "It is quite plausible," he writes, "that Mr. Grant Wood realized the strength of his ideas as he was milking cows back home while he was sitting on the terrace of the Dôme in Paris. . . . So much for the candor and the piety of Mr. Wood's spirit." Regarding Benton: "Anyone can find that he has looked well and long at Rubens and Greco to name only two great European artists." See Marsden Hartley, "Is There an American Art," in Scott, *On Art by Hartley*: 196–200; quotation on 197. Hartley was much harsher on Benton in a private letter to Rogers Bordley in August 1939, asserting that "Benton [was] stuffing his disguised modern art in the name of pure Americanism up their arses and down their throats." Hartley to Bordley, August 11, 1939, Elizabeth McCausland Papers, box 13, folder 6, AAA.

19. James M. Dennis, *Renegade Regionalists: The Modern Independence of Grant Wood, Thomas Hart Benton, and John Steuart Curry* (Madison: University of Wisconsin Press, 1998): 236.

20. Marsden Hartley, "The Education of an American Artist. Second Stage — Or the Intake of Modernism," circa late 1930s, Marsden Hartley Collection, YCAL; also available in the Marsden Hartley Papers, 1900–1967, reel 1369, AAA.

21. Curry's *Wisconsin Landscape* received First Prize; Hartley's *Lobster Fishermen* received Fourth Prize.

22. Marsden Hartley, "Eakins, Homer, Ryder," in Scott, *On Art by Hartley*: 168–72; quotations on 168, 169.

23. "Philadelphia Shows Homer, the Individualist," *Art Digest* 10 (June 1, 1936): 37.

24. Marsden Hartley, "Winslow Homer," in *Adventures in the Arts: Informal Chapters on Painters, Vaudeville, and Poets* (New York: Boni and Liveright, 1921): 42.

25. Ibid.: 47, 49.

26. Hartley, "On the Subject of Nativeness," in Scott, *On Art by Hartley*: 113.

27. Marsden Hartley, "The Six Greatest New England Painters," *Yankee* 3 (August 1937): 14–16.

28. Bruce Robertson, *Reckoning with Winslow Homer: His Late Paintings and Their Influence*, exh. cat. (Cleveland: Cleveland Museum of Art, 1990): 161.

29. Crane threw himself overboard the S.S. *Orizaba* en route from Mexico to the United States on April 27, 1932. On Hartley's response to Crane's suicide and the painting *Eight Bells Folly*, see Townsend Ludington, *Marsden Hartley: The Biography of an American Artist* (Boston: Little, Brown, 1992): 215–19.

30. Hartley to Gertrude Stein, October 1913, reproduced in *The Flowers of Friendship: Letters Written to Gertrude Stein*, ed. Donald Gallup (New York: Knopf, 1953): 84–86. Hartley's reference to the Havemeyer collection appears on page 85. Later, he reminisced about this experience in his (posthumously published) autobiography. See *Somehow a Past: The Autobiography of Marsden Hartley*, ed. Susan Elizabeth Ryan (Cambridge, Mass.: MIT Press, 1997): 66.

31. Hartley, "Whitman and Cézanne," in *Adventures in the Arts*: 30–36.

32. Jill C. Cournoyer, "Victorian Retreat to Amusement Capital: The Transformation of Old Orchard Beach, Maine, at the Turn of the Century," master's thesis, University of Southern Maine, Portland, 1996.

33. Cézanne's *Grand Baigneur* was first shown publicly in New York in 1921, in the exhibition "Impressionist and Post-Impressionist Paintings," at The Metropolitan Museum of Art.

34. Many of Hartley's personal effects and photographs have been digitized by and are preserved in the Beinecke Rare Book & Manuscript Library, Marsden Hartley Collection, YCAL.

35. As historian George Chauncey has explained: "Rather than initiating a new era of laissez-faire tolerance in urban life, as is often imagined, Repeal inaugurated a more pervasive and more effective regime of surveillance and control. Repeal made it possible for the state to redraw the boundaries of acceptable sociability that seemed to have been obliterated in the twenties. This had enormous consequences for gay life, for those boundaries were drawn in a way that marginalized and literally criminalized much of gay sociability." George Chauncey, *Gay New York*:

Gender, Urban Culture, and the Making of the Gay Male World, 1890–1940 (New York: Basic Books, 1994): 334–35.

36. On the critical reception of Hartley's late work, see Randall R. Griffey, "Marsden Hartley's Late Paintings: American Masculinity and National Identity in the 1930s and '40s," PhD diss., University of Kansas, Lawrence, 1999.

37. Hartley to Adelaide Kuntz, August 1, 1939, Marsden Hartley Collection, YCAL; also available on reel X4, AAA.

38. My thanks to Karen Williams, Librarian, Thomas J. Watson Library, The Metropolitan Museum of Art, and to Deborah Evans for their help in identifying Bill Moonan as Hartley's subject in *Flaming American*.

39. Moonan has been identified as the man appearing in the following photo negatives in the Marsden Hartley Collection, YCAL: [William Moonan] in bathing suit sitting on a rock (Object ID 10553843), [William Moonan] in bathing suit leaning against rocks (Object ID 10553837), and [William Moonan] in bathing suit reclining on a rock (Object ID 10553873). Presumably, Hartley took these photographs of Moonan near Bagaduce Farm in July or August 1939.

40. Hartley, "Whitman and Cézanne," in *Adventures in the Arts*: 30–36. Hartley scholar Jonathan Weinberg has rightly observed, "Hartley's working-class bathers — lifeguards and lumberjacks — are his final attempt to merge the art of Cézanne and Whitman. These Yankees . . . are Whitman's heroes recast in Cézanne's form." Jonathan Weinberg, *Speaking for Vice: Homosexuality in the Art of Charles Demuth, Marsden Hartley, and the First American Avant-Garde* (New Haven: Yale University Press, 1993): 193.

41. Walt Whitman, "Song of Myself," section 24, in *Leaves of Grass* (Boston: James R. Osgood, 1881–82): 49.

42. Hartley to Norma Berger, July 15, 1910, Marsden Hartley Collection, YCAL.

43. As Bruce Robertson has written: "The painting shows a virile young man, an epitome of healthy outdoor living. It belongs to the group of representative figures of Maine that occupied Hartley from 1941, all of them brawny young men. In this painting, Hartley becomes one of them, the young man he never was, blending in with the local community, part of a family." Bruce Robertson, "Marsden Hartley and Self-Portraiture," in Kornhauser, *Marsden Hartley*: 162. Hartley to Carl Sprinchorn, October 5, 1942: "a likeness [of] one seated, my beautiful blue and black plaid cap on — some burning spots of blue for eyes — Billy the Bantam on my shoulder which is a daily trick and a lobster hanging down from left hand or left knee — all very typical and I have every reason to believe will be a *likeness*, that is for *me*." Elizabeth McCausland Papers, box 13, folder 10, AAA.

44. Hartley to Adelaide Kuntz, December 12, 1933, Marsden Hartley Collection, YCAL; also available on reel X4, AAA.

45. See Donna M. Cassidy, *Marsden Hartley: Race, Region, and Nation* (Hanover, N.H.: University Press of New England, 2005), especially chapters 6 and 8.

46. One of the leading historians of American labor is David Brody; see his *Workers in Industrial America: Essays on the Twentieth-Century Struggle* (New York: Oxford University Press, 1980).

47. On representations of workers in the 1930s, see Laura Hapke, *Labor's Canvas: American Working-Class History and the W.P.A. Art of the 1930s* (Newcastle: Cambridge Scholars, 2008), and Erika Doss, "Toward an Iconography of American Labor: Work, Workers, and the Work Ethic in American Art, 1930–1945," *Design Issues* 13, no. 1 (Spring 1997): 53–66. Doss asserts (p. 55) that "representations of muscular producers . . . helped to deflect Depression era anxieties about unemployment, and undercut worries about the roles and responsibilities of masculine breadwinners." See also Barbara Melosh, *Engendering Culture: Manhood and Womanhood in New Deal Public Art and Theater* (Washington, D.C.: Smithsonian Institution Press, 1991).

48. Marsden Hartley, "The Meaning of Painting," Norma Berger Papers, YCAL. Hartley prepared this unpublished essay as the basis of a lecture he delivered at the University of Maine, Orono, in January 1941.

49. On Hartley's interest in mountains, see Jeanne Hokin, *Pinnacles & Pyramids: The Art of Marsden Hartley* (Albuquerque: University of New Mexico Press, 1993), and Townsend Ludington, *Seeking the Spiritual: The Paintings of Marsden Hartley*, exh. cat., Ackland Art Museum, University of North Carolina at Chapel Hill; Babcock Galleries, New York (Ithaca, N.Y.: Cornell University Press, 1998).

50. See especially Hartley's essay, unpublished in his lifetime, "On the Subject of the Mountain: Letter to Messieurs Segantini and Hodler," in which Hartley explains: "Mountains are things, entities of a grandiose character, and the one who understands them best is the one who can suffer them best, and respect their profound loneliness." Marsden Hartley Papers, YCAL. The essay appears in Hokin, *Pinnacles & Pyramids*: 135–37.

51. Hartley used the phrase "official portrait painter" in many letters, including Hartley to Helen Stein, September 29, 1939, Helen Stein Papers Relating to Marsden Hartley, reel 4130, AAA.

52. Emily Setina, "'Mountains Being a Language with Me': Marianne Moore, Marsden Hartley, and Modernist Revision," *Modernism/Modernity* 22, no. 1 (January 2015): 153–82.

53. Hartley to Carl Sprinchorn, October 23, 1942, Elizabeth McCausland Papers, box 13, folder 10, AAA.

54. On the topic of Hartley's concern for his reputation and legacy, see Randall R. Griffey, "Marsden Hartley's Lincoln Portraits," *American Art* 15, no. 2 (Summer 2001): 35–51.

55. "Rye Boy, 12, Is Lost on Mount Katahdin, Me.," *The New York Times*, July 19, 1939: 15.

"Katahdin Hunt Futile: Fifth Day of Search Yields No Sign of Rye, N.Y., Boy," *The New York Times*, July 23, 1939: 4. "Fendler Boy Found Alive in Woods Eight Days after Becoming Lost: Cries of Westchester Lad, Sore and Nearly Naked, Heard by Maine Camp Owner — Lived on Berries, He Tells Parents," *The New York Times*, July 26, 1939: 1, 3.

56. R. E. Turpin, "Cézanne Still Dominates the Era He Launched," *The New York Times Magazine*, January 15, 1939: 6–7, 19, 21.

57. La Rue Applegate, "New Issues from Afar: Yugoslavia Marks a Postal Centenary — Honor for Cézanne — Ecuador Items," *The New York Times*, March 26, 1939: 8 (section 11).

58. Hartley to Max Weber, June 2, 1939, Max Weber Papers, box 2, folder 54, AAA.

59. Hartley to Helen Stein, September 29, 1939, Helen Stein Papers Relating to Marsden Hartley, reel 4130, AAA.

60. "Katahdin As Seen By Bangor Painter," *Bangor Daily News*, February 8, 1940, Scrapbook, Marsden Hartley Collection, YCAL.

61. [Howard Devree], "Marsden Hartley," *Magazine of Art* 33, no. 4 (April 1940): 233.

62. Hartley to Hudson Walker, transcribed undated letter, Elizabeth McCausland Papers, box 17: 2–4, AAA, www.aaa.si.edu/collections /container/viewer/Typescripts-of-Letters-to -Hudson-Walker-280987.

63. Ibid.

64. Hudson Walker, Elizabeth McCausland, and Mary Bartlett Cowdrey, "Marsden Hartley," *Archives of American Art Journal* 8, no. 1 (January 1968): 9–21; quotation on 16.

65. M[aude] R[iley], "Death Takes Hartley," *Art Digest* 18 (October 1, 1943): 29.

Hartley and His Poetry

Richard Deming

1. In his foreword to Hartley's *Selected Poems* (New York: Viking Press, 1945), Henry W. Wells states that the painter kept his poetry "largely to himself, cherishing it at times almost as a secret, rarely publishing it, and never striving for publicity" (iii). That doesn't seem quite accurate, however, since clearly Hartley did publish books and poems. Furthermore, Hartley's correspondence with writers such as Robert McAlmon and William Carlos Williams as well as his many letters to the Maine State Library angling to have himself listed officially as a "Maine writer" suggest otherwise. Emily Setina's insightful essay "'Mountains Being a Language with Me': Marianne Moore, Marsden Hartley, and Modernist Revision" chronicles Hartley's relationship with Moore and his efforts to enlist her help not only in placing his work but also in getting her to contribute the introduction to a collection of his poetry; *Modernism/Modernity* 22, no. 1 (January 2015): 153–82.

In any event, the archives in the Marsden Hartley Collection, YCAL, do not bear out Wells's claim but rather point to Hartley's desire to have

his public self reflect stereotypical New England reserve.

2. William Carlos Williams and Robert McAlmon in *Contact* 1 (December 1920): 1.

3. Harriet Monroe, "Puck in the Boulevards," *Poetry* 23, no. 2 (November 1923): 105–7.

4. Hildegarde Flanner, "Reviews: Poems of a Painter," *Poetry* 68, no. 4 (July 1946): 220–24.

5. Hartley's efforts to be officially recognized as a "Maine writer" by the Maine State Library was yet another way that he attempted to support such claims.

6. Gail Scott titled the volume *The Collected Poems of Marsden Hartley, 1904–1943* (Santa Rosa, Calif.: Black Sparrow Press, 1987), although it includes a number of poems that were previously unpublished. These were discovered in the Marsden Hartley Collection, YCAL. This means that the volume is actually somewhere between a standard "collected poems" and a "complete poems."

7. Robert Creeley in Scott, *Collected Poems*: 16.

8. Ibid.: 18. It is important to note that by "local" Creeley does not mean a locating reference to a specific place. As he writes in his essay "A Note on the Local," "The local is not a place but a place in a given man — what part of it he has been compelled or else brought by love to give witness to in his own mind." Thus, what Creeley means by "local" is an emphasis on the specificity of objects and things and their capacity to bear emotional freight projected on to them rather than how they might be made to stand as symbols for signifying abstract meaning. *The Collected Essays of Robert Creeley* (Berkeley: University of California Press, 1989): 480.

9. Marsden Hartley, "Concerning Fairy Tales and Me," in *Adventures in the Arts: Informal Chapters on Painters, Vaudeville, and Poets* (New York: Boni and Liveright, 1921): 7.

10. Marsden Hartley, "Somehow a Past: Prologue to Imaginative Living," in *Somehow a Past: The Autobiography of Marsden Hartley*, ed. Susan Elizabeth Ryan (Cambridge, Mass.: MIT Press, 1997): 67.

11. Marsden Hartley, "Excerpts from 'Somehow a Past: A Sequence of Memories Not to Be Called an Autobiography,'" in *Somehow a Past*: 181.

12. In a variation of this narrative in "Somehow a Past," Hartley writes that he was in his "first twenties" when he was given Emerson's book, making that crucial moment slightly later in his life, though arguably still within the transitional time between post-adolescence and adulthood. Ibid.

13. As quoted in John Townsend Trowbridge, "Reminiscences of Walt Whitman," *Atlantic Monthly* 89, no. 2 (February 1902): 166.

14. Marsden Hartley, "The Business of Poetry," *Poetry* 15, no. 3 (December 1919): 153.

15. Ralph Waldo Emerson, "The Poet," in *Essays: Second Series* (Boston: James Munroe, 1844): 28, reprinted in *Essays and Lectures*, ed. Joel Porte (New York: Library of America, 1983): 459.

16. Ralph Waldo Emerson, "Intellect," in *Essays* (Boston: James Munroe, 1841): 278, reprinted in Porte, *Essays and Lectures*: 423.

17. Hartley, "Concerning Fairy Tales and Me," in *Adventures in the Arts*: 8.

18. Ralph Waldo Emerson, "The American Scholar," in *Nature: Addresses and Lectures* (Boston: James Munroe, 1849): 78, reprinted in Porte, *Essays and Lectures*: 53.

19. Hartley, "Emily Dickinson," in *Adventures in the Arts*: 198.

20. Hartley, "Modern Art in America," in *Adventures in the Arts*: 61, 62.

21. Robert McAlmon, "Marsden Hartley: Poet," Marsden Hartley Collection, box 13, YCAL. In an accompanying letter, dated January 16, 1941, McAlmon writes, "Do what you want with the article," adding, "I don't get accepted in America, so you must handle the article yourself."

22. Reprinted in Scott, *Collected Poems*: 285.

23. Hartley, "The Virtues of Amateur Painting," in *Adventures in the Arts*: 143.

"The Livingness of Appearances": Materials and Techniques of Marsden Hartley in Maine

Isabelle Duvernois • Rachel Mustalish

1. The quotation in the title of this essay is commonly attributed to Marsden Hartley: "I want to paint the livingness of appearances."

2. No blue pigment was identified in the ground, its bluish tonality being strictly an optical effect. Fourier transform infrared reflectography (FTIR) analysis showed an identical spectrum for the following works: *Autumn Color*, *Landscape No. 25*, *The Dark Mountain No. 1*, *Maine Landscape*, *Desertion*, and *The Dark Mountain No. 2* (figs. 25, 27, 39, 41, 44, 56). FTIR was conducted by Julie Arslanoglu, Senior Research Scientist, and Clara Granzotto, Andrew W. Mellon Fellow, Department of Scientific Research, The Metropolitan Museum of Art.

3. The top ground layers were differentiated by FTIR by their variable relative amounts of lead white (in the form of cerussite) and barium sulfate.

4. *After Snow*, circa 1908, and *Mountain Lake — Autumn*, circa 1910, in the Phillips Collection, Washington, D.C., are painted on similar 12 × 12–inch prepared paperboard supports and display the identical double ground structure, colors, and texture on both sides of the panel. We thank, at the Phillips Collection, Elizabeth Steele, Conservator, and Christine Romano, graduate conservation intern, for sharing this information.

5. Raman spectroscopy and scanning electron microscopy/energy-dispersive spectroscopy X-ray spectroscopy (SEM/EDS) analyses identified ultramarine blue as the main pigment in the deep purple underlayer of *Autumn Color*.

6. The two early landscapes in the Phillips Collection, *After Snow* and *Mountain Lake — Autumn* (see note 4 above) have alizarin red- and black-colored priming layers, respectively.

7. Stephen Kornhauser and Ulrich Birkmaier discuss Hartley's sketchbook color experiments in "Marsden Hartley's Materials and Working Methods," in *Marsden Hartley*, ed. Elizabeth Mankin Kornhauser, exh. cat., Wadsworth Atheneum Museum of Art, Hartford, Conn.; Phillips Collection, Washington, D.C.; Nelson-Atkins Museum of Art, Kansas City (Hartford, Conn.: Wadsworth Atheneum Museum of Art, 2002): 265–77.

8. Infrared examination of the early landscapes did not detect the presence of underdrawing.

9. Masonite is a high-density fiberboard engineered and manufactured for the home building industry. For further discussion, see Kornhauser and Birkmaier, "Hartley's Materials and Working Methods": 266.

10. The verso of the F. Weber Company's academy boards were often coated with black matte paint. Hartley's 1938 *Albert Pinkham Ryder* (see fig. 50) is painted on such a support.

11. Scientific analyses of the ground layers of both works revealed identical compositions, likely confirming their common source and manufacturer. They were found to be mainly composed of calcite and barium white, and possibly lead white, bound in a drying oil (linseed oil). Attenuated total reflection–FTIR (ATR–FTIR) and pyrolysis–gas chromatography/ mass spectrometry (Py–GC/MS) analyses were conducted by Julie Arslanoglu and Clara Granzotto.

12. Infrared examination indicates that Hartley made only minor changes to the original black sketch.

13. *Lobster on Black Background* (see fig. 73) is painted on an identical support and preparation. For examining this painting, we thank Tiarna Doherty, Chief Conservator, and Amber Kerr, Paintings Conservator, at the Smithsonian American Art Museum, Washington, D.C.

14. ATR–FTIR analysis revealed that the picture was first coated with a natural resin varnish. On Hartley's use of varnish, see Kornhauser and Birkmaier, "Hartley's Materials and Working Methods": 272. A cross section of the mountain's paint layer showed, from bottom to top, four distinct layers: brown (mostly red and yellow ocher mixed with umber), bright blue (predominantly ultramarine mixed with traces of cobalt and titanium white), dark blue (predominantly zinc white mixed with sparse ultramarine), and a transparent top blue layer (abundant ultramarine mixed in a medium-rich matrix).

15. Marsden Hartley, "On the Subject of the Mountain: Letter to Messieurs Segantini and Hodler" (1932), Marsden Hartley Papers, reel 1368, AAA, as quoted in Kornhauser, *Marsden Hartley*: 323, under no. 95.

SELECTED REFERENCES

SELECTED PUBLISHED WRITINGS BY MARSDEN HARTLEY

"Kaleidoscope." *Poetry* 12, no. 4 (July 1918): 195–201.

"Aesthetic Sincerity." *El Palacio* 5, no. 20 (December 9, 1918): 332–33.

"The Poet of Maine." *The Little Review* 6, no. 3 (July 1919): 51–55.

"The Business of Poetry." *Poetry* 15, no. 3 (December 1919): 152–58.

"Sunlight Persuasions." *Poetry* 16, no. 2 (May 1920): 59–70.

Adventures in the Arts: Informal Chapters on Painters, Vaudeville, and Poets. New York: Boni and Liveright, 1921. Reprinted, New York: Hacker Art Books, 1972.

Twenty-Five Poems. Paris: Contact Publishing, 1923.

"On the Subject of the Mountain: Letter to Messieurs Segantini and Hodler," 1932. Marsden Hartley Papers, reel 1368, AAA. Reprinted in Jeanne Hokin, *Pinnacles & Pyramids: The Art of Marsden Hartley:* 135–37. Albuquerque: University of New Mexico Press, 1993.

"Somehow a Past," a group of manuscripts with various subtitles: "Prologue to Imaginative Living," "A Sequence of Memories Not to Be Called an Autobiography," and "A Journal of Recollection," late 1933– , Marsden Hartley Collection, YCAL. Published as *Somehow a Past: The Autobiography of Marsden Hartley.* Edited by Susan Elizabeth Ryan. Cambridge, Mass.: MIT Press, 1997.

"As to John Marin, and His Ideas." In *John Marin: Watercolors, Oil Paintings, Etchings:* 15–18. Exh. cat. New York: Museum of Modern Art, 1936.

"On the Subject of Nativeness—A Tribute to Maine." In *Marsden Hartley: Exhibition of Recent Paintings, 1936.* New York: An American Place, April 20–May 17, 1937. Digital copy available at http://libmma .contentdm.oclc.org/cdm/ref/collection /p16028coll4/id/19434. Reprinted in *On Art by Marsden Hartley,* edited by Gail R. Scott: 112–15. New York: Horizon Press, 1982.

"The Six Greatest New England Painters." *Yankee* 3 (August 1937): 14–16.

"This Country of Maine," 1937–38, Marsden Hartley Collection, YCAL. Published in *Marsden Hartley: Race, Region, and Nation,* by Donna M. Cassidy: 301–5. Hanover, N.H.: University Press of New England, 2005.

Androscoggin. Portland, Maine: Falmouth Publishing House, 1940.

Sea Burial, Poems. Portland, Maine: Leon Tebbetts Editions, 1941.

Selected Poems. Edited by Henry W. Wells. New York: Viking Press, 1945.

SELECTED GENERAL REFERENCES

An American Place, New York. *Marsden Hartley: Exhibition of Recent Paintings, 1936.* Exh. cat. New York: An American Place, April 20–May 17, 1937.

Barnett, Vivian Endicott. "Marsden Hartley's Return to Maine." *Arts Magazine* 54, no. 1 (October 1979): 172–76.

Barry, William David. *Maine: The Wilder Half of New England.* Thomaston, Maine: Tilbury House Publishers, 2012.

Bischof, Libby, and Susan Danly. *Maine Moderns: Art in Seguinland, 1900–1940.* Exh. cat. Portland, Maine: Portland Museum of Art; New Haven: Yale University Press, 2011.

Burlingame, Robert. "Marsden Hartley's *Androscoggin:* Return to Place." *New England Quarterly* 31, no. 4 (December 1958): 447–62.

Caffin, Charles H. "New and Important Things in Art: Latest Work by Marsden Hartley." *New York American,* April 17, 1916: 8. Reprinted in *Camera Work,* no. 48 (October 1916): 59–60.

Carbone, Teresa A., ed. *Youth and Beauty: Art of the American Twenties.* Exh. cat., Brooklyn Museum; Dallas Museum of Art; Cleveland Museum of Art. New York: Skira Rizzoli; Brooklyn: Brooklyn Museum, 2011.

Cassidy, Donna M. *Marsden Hartley: Race, Region, and Nation.* Hanover, N.H.: University Press of New England, 2005.

Coates, Robert M. "Marsden Hartley's Maine." *The New Yorker* 24 (October 30, 1948): 85–86.

———. "The Art Galleries—Hartley and Maurer." *The New Yorker* 34 (December 20, 1958): 83–85.

———. "The Art Galleries—Marsden Hartley." *The New Yorker* 35 (January 30, 1960): 69–70.

Corn, Wanda M. *The Great American Thing: Modern Art and National Identity, 1915–1935.* Berkeley: University of California Press, 1999.

Denenberg, Thomas, Amy Kurtz Lansing, and Susan Danly. *Call of the Coast: Art Colonies of New England.* Exh. cat. Portland, Maine: Portland Museum of Art; Old Lyme, Conn.: Florence Griswold Museum; New Haven: Yale University Press, 2009.

Dennis, James M. *Renegade Regionalists: The Modern Independence of Grant Wood, Thomas Hart Benton, and John Steuart Curry.* Madison: University of Wisconsin Press, 1998.

[Devree, Howard.] "Marsden Hartley." *Magazine of Art* 33, no. 4 (April 1940): 228, 233.

Dow, Arthur Wesley. *Composition: A Series of Exercises in Art Structure for the Use of Students and Teachers.* New York: Baker, 1899.

Downtown Gallery, New York. *Marsden Hartley: Pictures of New England by a New Englander.* Exh. cat. New York: Downtown Gallery, April 26–May 15, 1932.

Ferguson, Gerald, ed.; essays by Ronald Paulson and Gail R. Scott. *Marsden Hartley and Nova Scotia.* Exh. cat., Mount Saint Vincent University Art Gallery, Halifax; Art Gallery of Ontario, Toronto. Halifax: Mount Saint Vincent University Art Gallery, 1987.

Flanner, Hildegarde. "Reviews: Poems of a Painter." *Poetry* 68, no. 4 (July 1946): 220–24.

Greenberg, Clement. "Review of Two Exhibitions of Marsden Hartley." *The Nation,* December 30, 1944. Reprinted in *Clement Greenberg: The Collected Essays and Criticism,* vol. 1, *Perceptions and Judgments, 1939–1944,* edited by John O'Brian: 246–48, no. 89. Chicago: University of Chicago Press, 1986.

Griffey, Randall R. "Marsden Hartley's Late Paintings: American Masculinity and National Identity in the 1930s and '40s." PhD diss., University of Kansas, Lawrence, 1999.

———. "Marsden Hartley's Lincoln Portraits." *American Art* 15, no. 2 (Summer 2001): 35–51.

[Hartmann, Sadakichi]. "Unphotographic Paint: The Texture of Impressionism." *Camera Work,* no. 28 (October 1909): 20–23.

Haskell, Barbara. *Marsden Hartley.* Exh. cat. New York: Whitney Museum of American Art, 1980.

Hokin, Jeanne. *Pinnacles & Pyramids: The Art of Marsden Hartley.* Albuquerque: University of New Mexico Press, 1993.

Homer, William Innes. *Alfred Stieglitz and the American Avant-Garde.* Boston: New York Graphic Society, 1977.

———, ed. *Heart's Gate: Letters between Marsden Hartley & Horace Traubel, 1906–1915.* Highlands, N.C.: Jargon Society, 1982.

Hutchinson, Elizabeth. *The Indian Craze: Primitivism, Modernism, and Transculturation in American Art, 1890–1915.* Durham, N.C.: Duke University Press, 2009.

Intimate Gallery, New York. *Hartley Exhibition.* Foreword by Lee Simonson. Exh. cat. New York: Intimate Gallery [Room 303], Anderson Galleries Building, January 1929. Digital copy available at http://cdm16028.contentdm .oclc.org/cdm/compoundobject/collection /p16028coll4/id/19275/rec/27.

Jewell, Edward Alden. "Art in Review: Pictures of New England by Marsden Hartley on View at the Downtown Gallery." *The New York Times*, April 26, 1932: 24.

Kornhauser, Elizabeth Mankin, ed. *Marsden Hartley*. Exh. cat., Wadsworth Atheneum, Hartford; Phillips Collection, Washington, D.C.; Nelson-Atkins Museum of Art, Kansas City, 2003–4. Hartford, Conn.: Wadsworth Atheneum Museum of Art, 2002.

———. "Marsden Hartley and Folk Art." *The Magazine Antiques* 163, no. 1 (January 2003): 150–57.

Levin, Gail. "Marsden Hartley." In *The Advent of Modernism: Post-Impressionism and North American Art, 1900–1918*: 96–99. Exh. cat., High Museum of Art, Atlanta; Center for the Fine Arts, Miami; Brooklyn Museum; Glenbow Museum, Calgary. Atlanta: High Museum of Art, 1986.

———. "Marsden Hartley's 'Amerika': Between Native American and German Folk Art." *American Art Review* 5, no. 2 (Winter 1993): 120–25, 170–72.

———. "Photography's 'Appeal' to Marsden Hartley." *Yale University Library Gazette* 68, no. 1/2 (October 1993): 13–42.

Lewiston Daily Sun. "World of Art — Interprets New England." *Lewiston Daily Sun*, June 3, 1932: 4.

Lewiston Saturday Journal. "Edmund Marsden Hartley of Lewiston, a Student and Painter of Nature." *Lewiston Saturday Journal*, December 29, 1906: 9.

Life. "Marsden Hartley: Fame Finally Catches Up to Poet-Painter of Maine." *Life*, June 16, 1952: 84–89.

Ludington, Townsend. *Marsden Hartley: The Biography of an American Artist*. Boston: Little, Brown, 1992.

———. *Seeking the Spiritual: The Paintings of Marsden Hartley*. Exh. cat., Ackland Art Museum, University of North Carolina at Chapel Hill; Babcock Galleries, New York. Ithaca, N.Y.: Cornell University Press, 1998.

———. "Marsden Hartley on Native Ground." In *Modern Art and America: Alfred Stieglitz and His New York Galleries*, edited by Sarah Greenough: 401–15. Exh. cat. Washington, D.C.: National Gallery of Art; Boston: Bulfinch Press, 2000.

McCausland, Elizabeth. "Marsden Hartley Shows His Recent Paintings." *The Springfield (Mass.) Sunday Union and Republican*, March 17, 1940: 6.

———. *Marsden Hartley*. Minneapolis: University of Minnesota Press, 1952.

McDonnell, Patricia, ed. "Marsden Hartley's Letters to Franz Marc and Wassily Kandinsky, 1913–1914." *Archives of American Art Journal* 29, no. 1/2 (1989): 35–44.

Monroe, Harriet. "Puck in the Boulevards," review of Hartley's *Twenty-Five Poems*. *Poetry* 23, no. 2 (November 1923): 105–7.

Newsweek. "The Recluse and the Refugee." *Newsweek*, November 13, 1944: 107–8.

R[iley], M[aude]. "Death Takes Hartley." *Art Digest* 18, no. 1 (October 1, 1943): 5, 29.

Robertson, Bruce. *Marsden Hartley*. New York: Harry N. Abrams; Washington, D.C.: National Museum of American Art, Smithsonian Institution, 1995.

Rosenbaum, Julia B. *Visions of Belonging: New England Art and the Making of American Identity*. Ithaca, N.Y.: Cornell University Press, 2006.

Rosenfeld, Paul. "The Paintings of Marsden Hartley." *Vanity Fair* 18, no. 6 (August 1922): 47, 84, 94, 96.

———. *Port of New York: Essays on Fourteen American Moderns*. New York: Harcourt, Brace, 1924.

Schjeldahl, Peter. "The Searcher: Marsden Hartley's Eloquent Restlessness." *The New Yorker* 78 (February 3, 2003): 93–94.

Schwartz, Sanford. "A Northern Seascape." *Art in America* 64 (January–February 1976): 72–76.

Scott, Gail R. *Marsden Hartley: Visionary of Maine*. Exh. cat., University of Maine, Presque Isle, and four other Maine venues, 1982–83. Presque Isle: University of Maine, 1982.

———, ed. *On Art by Marsden Hartley*. New York: Horizon Press, 1982.

———, ed. *The Collected Poems of Marsden Hartley, 1904–1943*. Santa Rosa, Calif.: Black Sparrow Press, 1987.

Setina, Emily. "'Mountains Being a Language with Me': Marianne Moore, Marsden Hartley, and Modernist Revision." *Modernism/Modernity* 22, no. 1 (January 2015): 153–82.

Smith, Roberta. "Review/Art: Hartley's Later Works Show a Talent Distilled." *The New York Times*, June 29, 1990: C15.

Somehow a Past: The Autobiography of Marsden Hartley. Edited by Susan Elizabeth Ryan. Cambridge, Mass.: MIT Press, 1997.

Time. "Maine Man." *Time* 44, no. 21 (November 20, 1944): 50.

Turner, Elizabeth Hutton; essays by Elizabeth Garrity Ellis and Guy Davenport. *Americans in Paris (1921–1931): Man Ray, Gerald Murphy, Stuart Davis, Alexander Calder*. Exh. cat., Phillips Collection, Washington, D.C. Washington, D.C.: Counterpoint, 1996.

Voorhies, James Timothy, ed. *My Dear Stieglitz: Letters of Marsden Hartley and Alfred Stieglitz, 1912–1915*. Columbia: University of South Carolina Press, 2002.

Walker, Hudson, Elizabeth McCausland, and Mary Bartlett Cowdrey. "Marsden Hartley: Hudson Walker's Recollections of the Artist in a Tape-Recorded Interview Conducted by Elizabeth McCausland and Mary Bartlett Cowdrey." *Archives of American Art Journal* 8, no. 1 (January 1968): 9–21.

Weber, Bruce. *The Heart of the Matter: The Still Lifes of Marsden Hartley*. Exh. cat. New York: Berry-Hill Galleries, 2003.

Weinberg, Jonathan. *Speaking for Vice: Homosexuality in the Art of Charles Demuth, Marsden Hartley, and the First American Avant-Garde*. New Haven: Yale University Press, 1993.

Wiegand, Charmion von. "Opinions under Postage: Our Readers—The Strongly Native American Art of Marsden Hartley." *The New York Times*, April 14, 1940: x9 (section 9).

Wilkin, Karen. "Marsden Hartley: At Home and Abroad." *The New Criterion* 6 (April 1988): 23–28.

Wolff, Theodore F. "Coming Home to Maine." *Christian Science Monitor*, March 21, 1980: 15.

INDEX

Note: The abbreviation MH refers to Marsden Hartley. *Italic* page numbers refer to illustrations.